The
Big Book
of
Drawing

The BIG BOOK

Published in the United States by Watson-Guptill Publications, an imprint of the Crown Publishing Group, a division of Random House, Inc., New York.
www.crownpublishing.com

Originally published in Spain as *El Arte del Dibujo* by Parramón Ediciones, S.A., Barcelona, in 2008. Copyright © 2008 by Parramón Ediciones, S.A.. World Rights.

Library of Congress Cataloging-in-Publication Data

Sanmiguel, David.
[Arte del dibujo. English]
The big book of drawing: an introduction to essential materials and techniques/ Text for the Work, David Sanmiguel. – First American edition.
 p. cm.
"Originally published in Spain as *El Arte del Dibujo* by Parramón Ediciones, S.A., Barcelona, in 2008."
ISBN 978-0-8230-8567-5 (pbk.)
1. Drawing—Technique. 2. Drawing materials. I. Title.

NC730.S27613 2012
741.2 – dc23
 2011046972

Design by TK

Printed in China

Text for the Work: David Sanmiguel
Exercises for the Work: Josep Asunción; Vincenç Ballestar, Almudea Carreño, Mercedes Gaspar, Gabriel Martín, Ramon Noé, Esther Olivé de Puig, Joan Sabater, and David Sanmiguel
Photographs for the Work: Estudio Nos & Soto; Parramon files

10 9 8 7 6 5 4 3 2 1

First American Edition

of
Drawing

WATSON
GUPTILL

CONTENTS

4

INTRODUCTION

Creativity can be a spontaneous and unexpected impulse, but most often it is the result of hard work. In any of its forms, it is the channel through which artists conceive and execute their work.

Drawing is the foundation of the visual arts and an essential tool for the communication and expression of artistic ideas. It has always been the central discipline for learning art, and today's most outstanding artists continue to see it as the axis and engine of their work. Every work of art has its origin in drawing and, very often, this is also its culmination.

This book is the most complete compendium of the materials, procedures, and techniques of artistic drawing. Its four sections focus on different themes in drawing, and compile technical and practical questions that artists face, whatever their degree of experience or professional skill.

The book can serve as a practical manual, as a reference book, or as a source of suggestions and inspiration, thanks to the wide number of works reproducing every theme and style that it contains.

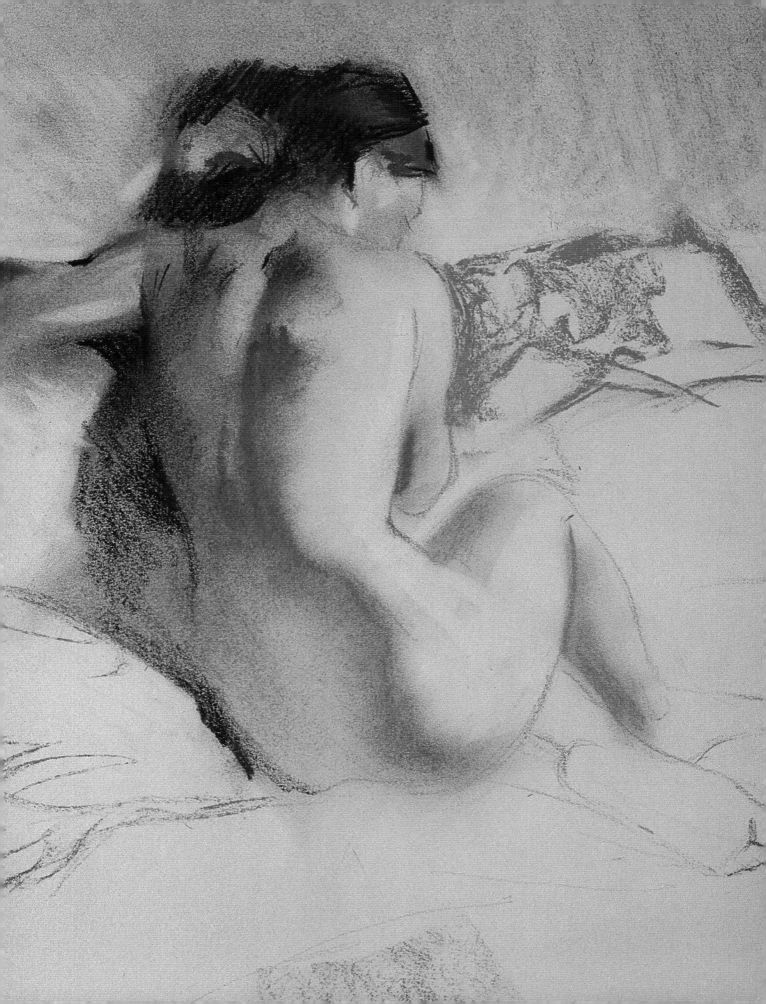

Drawin
IN
BLACK A

- **Pencil Drawing**
- **Drawing in Charcoal**
- **Drawing in Sanguine**
- **Drawing in Ink**

Drawing is the most primitive form of artistic expression. Even writing has its origins in signs that, in fact, are drawings. A piece of coal was the first drawing medium and this was and is a single-color medium. Black on white is the simplest form of artistic expression and is the nucleus from which this book sets out.

Charcoal and pencil are the two fundamental drawing materials. Almost all drawing other materials derive from them. It can even be said that, by mastering these two materials, artists can cover most drawing techniques. Apart from charcoal and pencil drawing, this section studies drawing in sanguine and India ink, two classic materials that are just as widely practiced as the other two.

The following pages exhaustively cover these basic materials, their history, origins, and manufacture, along with all their varieties, paying special attention to the many different results that artists can achieve by using them.

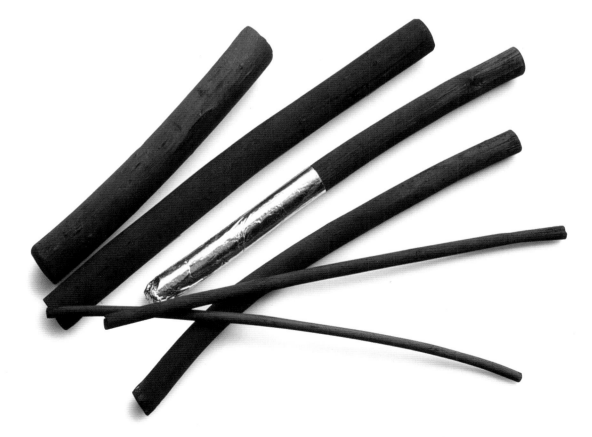

g
ND WHITE

PENCIL DRAWING

*T*he classic pencil has a graphite "lead." The first pencils were manufactured in England in the mid-sixteenth century. The primitive pencil was a piece of graphite wrapped in sheepskin. As its use spread through Europe, different versions were created until Italian artists developed a wooden casing that made it easier to handle. Graphite was cut into sheets, which were then cut into sticks and squeezed into long grooves in wood battens. Serial manufacture of pencils did not start until the mid-eighteenth century, at the dawn of the Industrial Revolution.

Adolf Von Menzel (1815-1905), *Figure studies.*
The J. Paul Getty Museum

Pencil lead: the graphite pencil

Graphite is a shiny lead-gray mineral discovered in 1564 in Borrowdale, England. At first it was thought to be a type of lead, until, in 1779, the Swedish chemist Karl Wilhelm Scheele proved that it was crystallized carbon. In 1789, the German geologist Abraham G. Werner named it graphite due to its use as a writing medium. The confusion with lead continues today. We still refer to "pencil lead" as "lead," instead of graphite.

Graphite is a mineral (crystallized carbon) that is oily to the touch and that leaves a dense mark when rubbed against a hard surface.

COMPOSITION OF PENCIL LEADS

At the end of the eighteenth century, innovative pencil manufacturers developed a way to make modern graphite leads by mixing crushed graphite with potter's clay and cooking the mixture to make it stronger. The greater the proportion of clay, the harder the lead. The lead's thickness ranges around 2.5 mm in most.

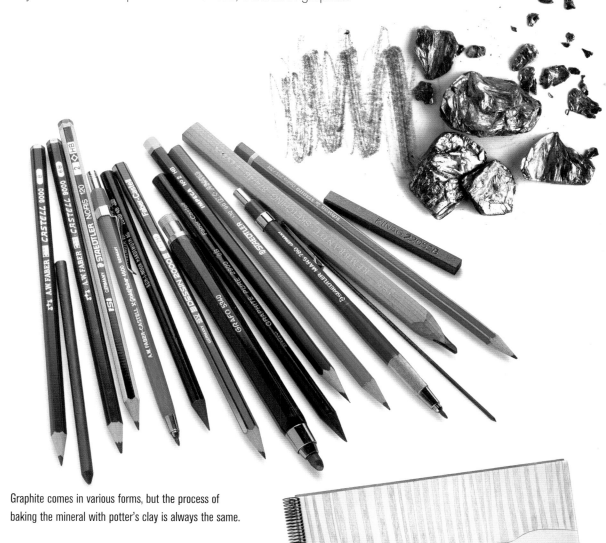

Graphite comes in various forms, but the process of baking the mineral with potter's clay is always the same.

Graphite sticks and pencil leads are actually made of mineral and potter's clay in various proportions.

With graphite you can draw lines, strokes and marks, as delicately as you please and without strong contrasts.

Hard and soft lead pencils

A hard lead provides a fine delicate, and precise stroke and sharpens much more easily than a soft lead. The latter, however, are more useful in drawing that depends on the agility and force of the strokes (drafts, studies, sketches, or drawings with very apparent shadows). All manufacturers make pencils of varying grades of hardness, with a maximum of 20 different grades.

Range of of hardness

The number on the side of a pencil indicates the hardness of its lead. The higher the number, the harder the lead. Writing pencils usually run from 1 to 4. In higher quality varieties, the letters H (hard) or B (soft) accompany numbers showing the level of hardness or softness. Some writing pencils may have the letter F, which means that the tip can be sharpened a lot (indicating hard lead). HB, which can be translated as "neither hard nor soft", describes intermediate leads that are most suitable for writing.

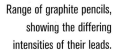

Range of graphite pencils, showing the differing intensities of their leads.

The difference in stroke intensities are considerable when hard pencils are combined with very soft pencils (with a very dark stroke).

A professional range of pencils can include thirteen different values, as shown in this spectrum.

Artistic drawing and technical drawing

Artists seldom use hard lead pencils, whose stroke is too tenuous for most studies, drafts, sketches, elaborate drawings, etc. Precise, technical drawing, which demands accurate strokes and minimal visual ambiguity, relies on the hard lead pencil. The thin line of a highly sharpened hard lead fully satisfies the requirements of technical drawing.

CEDAR

Cedar is the wood with which pencils are made. It is soft enough to allow for sharpening and is resistant enough to ensure the pencil's quality. These days, the vast majority of pencils made throughout the world are manufactured with wood from the Californian cedar, a tree that is constantly replanted and, therefore, ecologically sustainable.

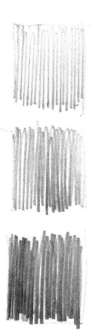

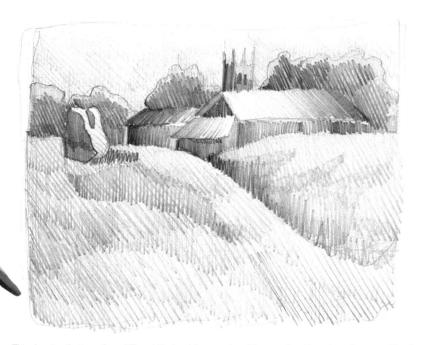

This drawing features four different kinds of line, produced by pencils with various degrees of hardness.

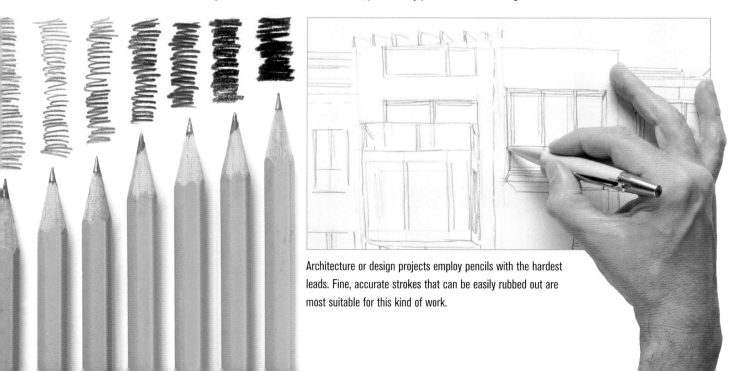

Architecture or design projects employ pencils with the hardest leads. Fine, accurate strokes that can be easily rubbed out are most suitable for this kind of work.

Varieties and applications

Graphite leads are divided into two groups: those which artists insert into refillable pencils and those handled as a conventional pencil. The former range between 1 mm (or even less) and 6 mm thick. They are usually sold in three or four levels of hardness, depending on the manufacturer. Leads that do not insert into a refillable pencil sharpen easily, and their hardness ranges from four to six (depending on the manufacturer).

Various ways in which graphite is available to artists: pencils, leads, and sticks, all manufactured in differing hardnesses.

Pencils

Stick for refillable pencil

Hexagonal stick

Rectangular sticks

Conventional refillable lead pencil

Refillable pencil for thick lead

"All lead" pencils

Graphite sticks and leads

The advantages of graphite combined with potter's clay are clear in the many varieties of graphite sticks and leads. The firmness of leads made by modern procedures does not require a wooden casing and allows for solid mineral pieces of varying size and shape. The advantage lies in the absence of the wood: the thinnest leads do not require sharpening and the thickest produce a density of stroke above that of any pencil. It also makes it easier to extend gray marks by applying the flat stick to the paper.

WATER-SOLUBLE GRAPHITE

Water-soluble graphite pencils contain a water-soluble thickener. This means that strokes can be diluted with a damp paintbrush. In recent years, there has been an increasing tendency to manufacture water-soluble versions of all kinds of graphite leads and sticks. Currently, all brands manufacture this type of pencil.

"All lead" pencils are sticks of graphite without a wood casing (they may have a fine covering of plastic), and are available in five or six different grades of hardness.

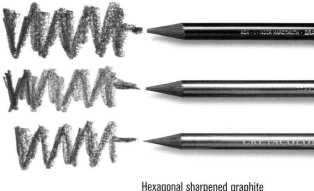

Hexagonal sharpened graphite sticks in three different levels of hardness.

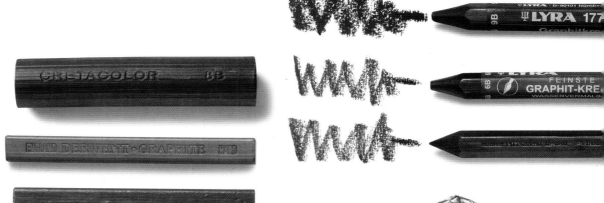

Thick sticks of graphite in round, square, and rectangular cross-section

Refillable pencils facilitate work with graphite leads of various sorts.
The most practical ones carry a thick lead that permits either a fine or a dense line.

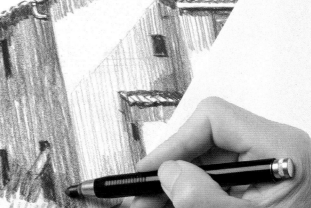

Working with graphite pencils

The technique of graphite pencil drawing is purely intuitive and contains no secrets. However, using the pencil in specific ways can help artists achieve desired results. For each kind of work, there are specific methods for creating soft lines, thin lines, and appropriate ways to hold the pencil. These, and other important issues that arise when working with graphite pencils are explained below.

Ways of holding the pencil

When using the pencil as a writing instrument, gripped near the tip, it is easier to control the details and accuracies of line, but you may lose a sense of the overall image. If you hold a pencil at a higher position, cupped in the inside of your hand, you can draw broad strokes confidently. This is the best way to begin a drawing and establish its framework. To achieve shadows and intense grays with soft leads, hold the pencil very close to its tip, and press the lead flat against the paper.

"All lead" pencils can achieve fine strokes by applying their tip to the paper.

When the tip becomes blunt with use, the stroke of the "all lead" pencil becomes much thicker.

The pencil stroke varies in thickness, depending on whether it is applied at the tip or inclined against the paper.

Wear and tear may cause beveled edges that facilitate drawing with thick lines.

The sharp edges of sticks with a square or rectangular cross-section can draw very thin lines.

Blurring and rubbing out

Using a "scumble," or stump, helps blur an intense mark of soft graphite and achieves grays and shades of color without leaving any traces of strokes. However, some artists choose to blur directly with their fingers in order to better control the shading. Rubber erasers can easily rub out graphite, but a dirty eraser may stain the paper. To avoid doing so, clean the eraser by rubbing it on a separate piece of paper before use. If the details to be rubbed out are very small, you can cut a piece off the rubber eraser to use the edges. If the drawing is far underway, or almost finished, place a piece of paper under the detail to be rubbed out, which will protect other areas from the eraser. After each use of the eraser, eliminate the bits of rubber with a soft brush or fan paintbrush. It is very important that no remains are left on the finished drawing, as they will continue to erase the part of the drawing on which they lie.

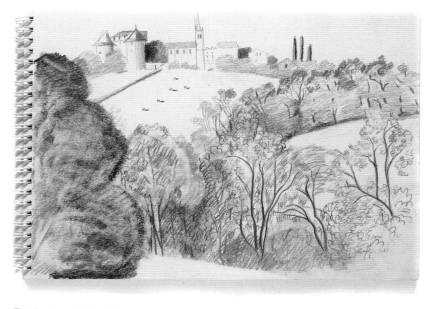

This drawing exhibits different pencil strokes, cross-hatching, and lines, along with spots of blood-red crayon and charcoal.

Here, the differences in stroke respond to various angles of the pencil on the paper.

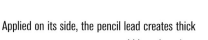

Working with the tip of the pencil allows for the most precise strokes.

Applied on its side, the pencil lead creates thick and blurred strokes.

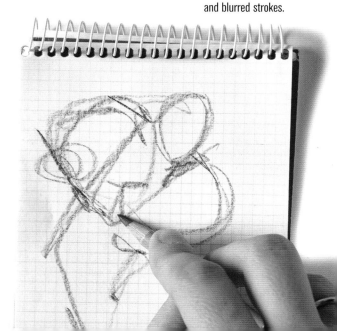

Lines, hatching, and marks

In a drawing based on lines with no shadows to accompany them, the entire presence of the drawing relies on the turns and directions of these lines. This means there must be an additional purpose for these lines that goes beyond strictly describing the subject. Hatching refers to groupings of juxtaposed or superimposed lines that create zones of shadow varying in intensity. In pencil drawings, marks and denser areas are the result of thicker and denser hatching.

Drawing based solely on the line of a soft pencil. Graphite lends itself very well to this unadorned treatment of form. Work by Ramon Noè.

Line

Line characterizes drawing techniques that rely on fine strokes, a style widely seen in pencil drawings.

Hatching

Hatching is a peculiar method for capturing a subject. Not only can hatching convey value or hue in a composition, but it can also suggest texture. Hatching in several different directions provides a work with rich tonal value, describing the character of the surfaces represented.

This landscape achieves shading by hatching with parallel lines that vary in their thickness and intensity.

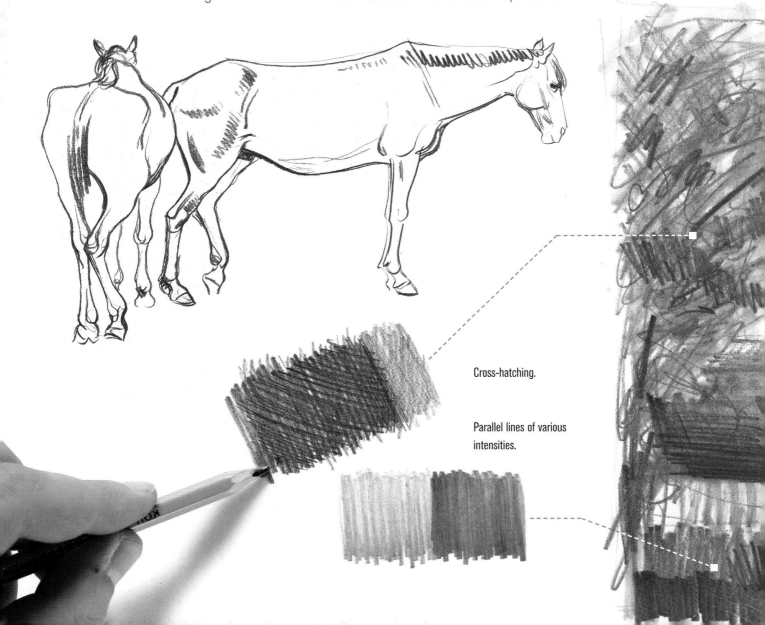

Cross-hatching.

Parallel lines of various intensities.

DETAILS IN THE SHADOWS

A drawing with hatching always exhibits textural density in its shadows. This creates the impression that the drawing contains much more visual information, much more detail than what is present in reality. This is one of the attractive features of drawings with hatching, slowly and patiently worked drawings, which allow the artist to accurately calculate the value of each light and each shadow.

The values of marks

The density of strokes, depending on their distance from each other, determines the intensity of the shadows they describe. Because hatching can be achieved with vertical, horizontal, or diagonal lines of any intensity, it can create a wide range of values. In addition, each area of hatching creates a texture that adds a unique characteristic to the drawing; even the darkest shadows are never completely black and retain clarity and distinction in their strokes. Similarly, lighter areas are not completely white.

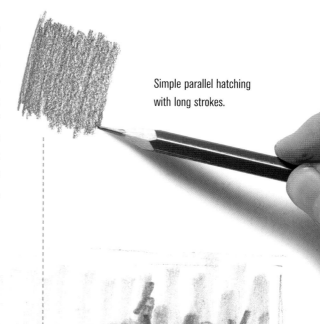

Simple parallel hatching with long strokes.

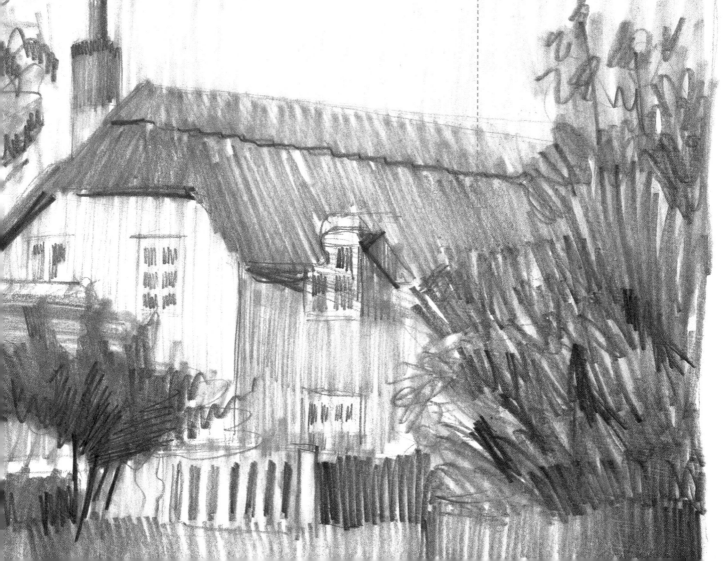

Supports for pencil drawing

Like all paper designed for artistic purposes, drawing paper must be completely acid-free to ensure conservation and avoid yellowing. In professional circles, drawing paper is fine-grained laid paper, manufactured in glossy finishes. Each drawing medium requires a particular kind of paper. However, graphite, because of its oily nature, works well on almost all kinds of surfaces.

Paper with a medium grain suitable for sketching with graphite.

Glossy or coated paper

Hot-pressed paper (HP) has an extremely smooth surface. As a support for graphite, it provides a wide range of grays and yields desirable results when blending lines. Coated paper is still smoother than glossy paper and possesses a certain brightness that combines well with the oily and shiny character of graphite.

Smooth paper is the most suitable for drawing with graphite pencils.

Fine-grain paper

This category includes all kinds of sketching paper, which is almost always available in booklet form and widely used for drawing outlines. Fine-grain supports require lightweight paper (between 60 and 150 grams), which is suitable for work with graphite pencils, especially if soft leads are used.

Brown paper and wrapping paper are cheap and viable supports for drawing with graphite leads.

OTHER SUPPORTS

Graphite is equally amenable to wood or cloth. Most supports are suitable for graphite, provided that they are not too rough or too dark. If graphite is used as a drawing medium before painting, it is important to keep in mind that the graphite's lines, especially when the graphite is soft, usually remain visible under the layer of paint when the latter is not very thick.

There are many notebooks and sketchpads suitable for graphite. Some artists even use conventional lined notebooks.

Recycled paper, craft or low-quality paper

The oily consistency of graphite allows for its use on irregular or low-quality paper with a waxy surface (brown paper). Such supports can serve for trial runs or sketches with no pretension to being correct or finished works: paper that the artist can comfortably use in large amounts.

Newspaper is a thin support, suitable for sketches and outlines.

DRAWING IN CHARCOAL

*C*harcoal is nothing other than plant carbon and its use goes back to the very origins of humanity. Cave paintings demonstrate that plant carbon, powdered and thickened, most likely with saliva, was used to create drawings. This testifies to the long lasting, durable nature of charcoal in both sketches and finished works.

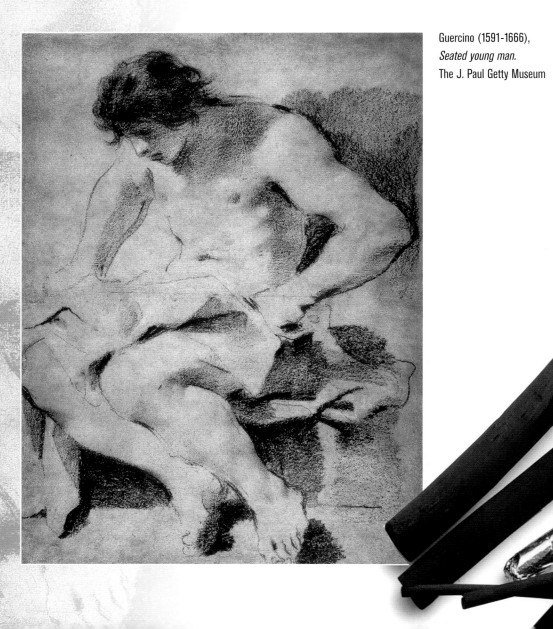

Guercino (1591-1666),
Seated young man.
The J. Paul Getty Museum

Charcoal

Charcoal is made from willow, lime, or walnut tree branches, specially selected so as not to include knots, and is burned very slowly so that all the wood carbonizes equally on the surface and the inside. The branches must have no knots so that no hard particles scratch the support when the charcoal is used in a drawing. Charcoal is a substance that is dry to the touch and leaves a very dark gray, almost black, matte line. Because it consists of fine carbonized particles, it can be spread over the support (usually paper), blurred, and can produce various gradations of gray.

Charcoal is plant carbon, made by burning small branches. The slow combustion it undergoes makes it useful for drawing.

CHARCOAL DUST

Many artists also use powdered charcoal as a shading medium. Charcoal stubs that are too small to use can be ground in a coffee-grinding machine for subsequent use, and can be applied to paper inside a cotton cloth.

Varieties

Charcoal is available in various thicknesses, depending on the size of the branches used for manufacturing it. It ranges from sticks measuring 3 or 4 mm to 4 cm in diameter. Naturally, the diameter determines the width of the stroke, although it is feasible to achieve fine lines with thick pieces of charcoal by drawing on the edge formed by rubbing the tip against the support. Some manufacturers provide thick pieces of charcoal (irregular cuts from willow trunks) that are useful for large-scale work.

Wearing away the tip of a charcoal stick creates sharpened edges that produce fine lines.

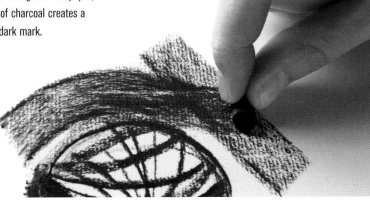

Pressed flat against the paper, a stick of charcoal creates a broad, dark mark.

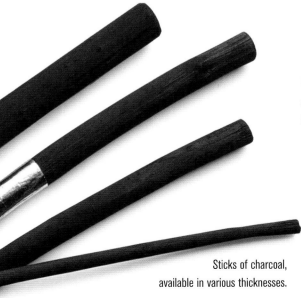

Sticks of charcoal, available in various thicknesses.

Charcoal leads, sticks, and pencils

Any type of charcoal that is not a carbonized piece of wood is a combination of powdered carbon (or black pigment) and a thickener. Today there are many varieties of thickened carbon that are sold as pencils, leads, or sticks. The ingredients of charcoal may vary significantly, and may include pigments, soot, clay, or graphite. Often, they contain no carbon, which makes them more similar to pastels than charcoal. The basic difference between charcoal pencils and pastels lies in the greater density and stability of the line (the thickener fixes it to the paper) and the greater hardness and homogeneity of leads and sticks available.

The intensity of thickened carbon in leads or sticks allows for greater contrast and density of line.

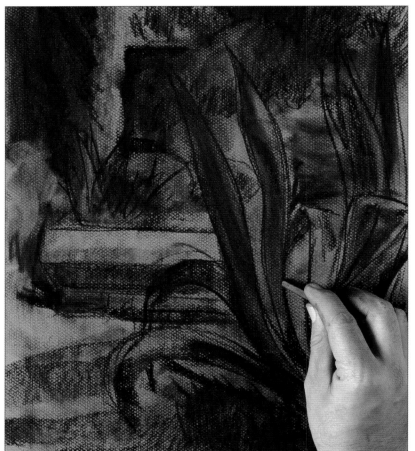

Leads and sticks

These can have a cylindrical or square shape. They usually contain more oil than pencils, due to their high level of graphite. Their stroke is intense and velvety, adheres very well to the paper, and is hard to rub out. Most manufacturers sell sticks that range between three to four degrees of hardness.

OILY PENCILS

Some artists prefer these oily pencils, originally created for lithography, because of their intense, permanent line and the ease with which the tip can be sharpened. The pencil's casing is, in reality, a fine strip of wood rolled around the lead. This covering unrolls with the aid of a piece of string as the lead diminishes.

Pencils

Carbon that is thickened with clay and graphite and packed into a wooden casing achieves a stable, dark stroke, and is available in differing degrees of hardness, depending on the amount of clay it contains. Pencils with thickened carbon leads are brittle and hard to sharpen, with a performance similar to pastel pencils. More oily pencils with pigments thickened with graphite have a softer stroke and are easier to sharpen. Manufacturers who produce sticks of thickened carbon also make pencils from this same material.

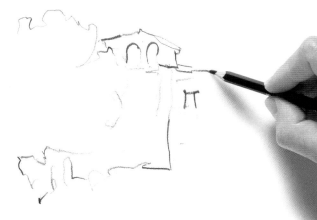

The carbon pencil provides a thicker and darker stroke than charcoal. Its stroke is much more intense than the softest of graphite leads.

Carbon pencils and sticks handle as easily as a conventional pencil, although their strokes have a much darker tone.

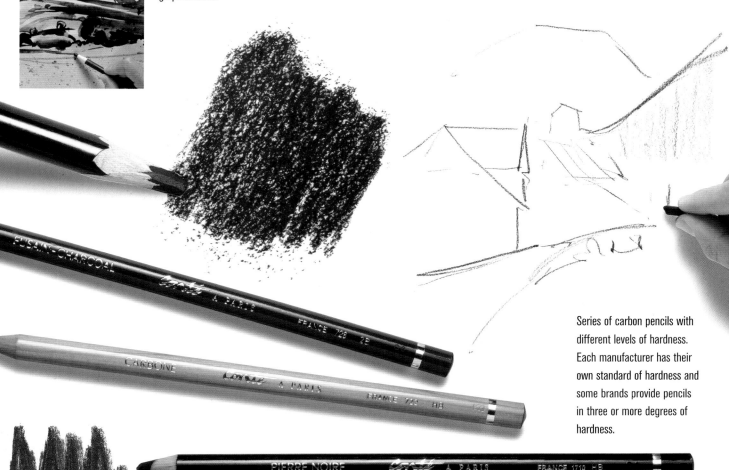

Series of carbon pencils with different levels of hardness. Each manufacturer has their own standard of hardness and some brands provide pencils in three or more degrees of hardness.

Using charcoal

Because it is a medium that provides more coverage than pencils do, charcoal permits many more effects than pencil, while still providing considerable opportunities for detail. Its tone scale (from soft gray to light black) is broad, and can be spread, blended, and handled with the fingers. As it is undoubtedly a "dirty" medium, it requires larger formats than pencils do and greater care in handling. These are some features to keep in mind when drawing with charcoal.

Lines and marks

Charcoal strokes are much thicker than those produced by graphite pencils. When drawing, the texture of the paper sharpens the tip of the stick, creating edges that artists use to obtain much finer and more accurate lines. They can also easily create straight lines if artists lay the sticks flat on the paper and move them in a vertical direction. Drawing horizontally in the same position will easily produce wide strokes.

Creating lines, marks, and blurring areas are the fundamental techniques of charcoal drawing. This work illustrates its possibilities.

Lines and straight lines can be drawn with charcoal by working on the tip itself or by placing the stick flat on the paper.

In the light background the spots have been blended.

In these drawings you can appreciate the result of applying the charcoal flat to the paper or using the tip.

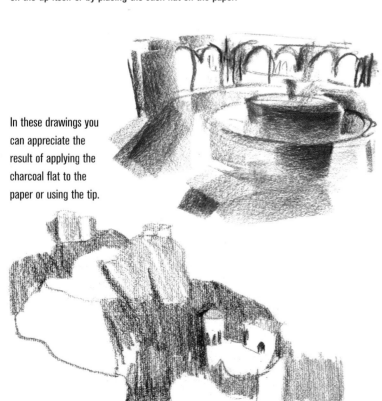

Here, the lines are partially blended.

THE IMPORTANCE OF THE SUPPORT

The nature of the paper used greatly determines the response of the charcoal. Low quality paper yields poor results and looks dirty, since the charcoal particles do not stick well to the surface or do so irregularly. High quality paper has a slightly creased surface that traps the carbon particles and allows for a wide range of tones.

Blending

Charcoal can be blended with a scumble, a rag, or fingers, which broadens its range of possibilities. Once the charcoal blurs, its tone lightens, which is almost the only way of achieving gradients of color, since the change in intensity caused by merely changing the pressure of the charcoal on the paper is scarcely noticeable. The possibilities of blending are much greater with sticks of natural charcoal than with carbon pencils or pressed carbon sticks.

The artist's hand is the basic tool for blending charcoal.

Soft marks achieved by applying the stick on its side.

Lines obtained by drawing with the tip of the stick.

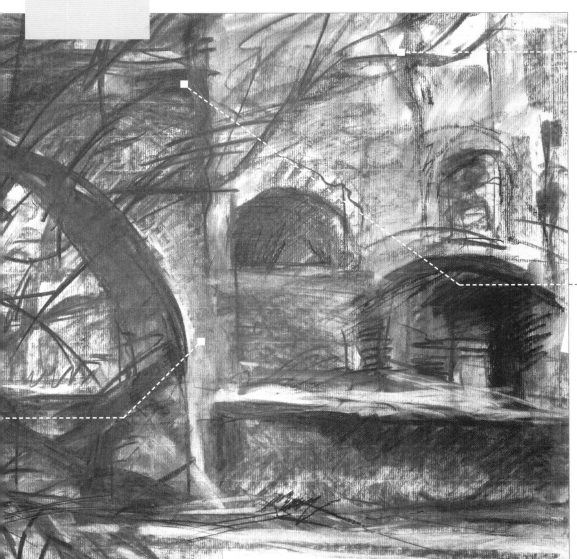

Accessories for charcoal drawing

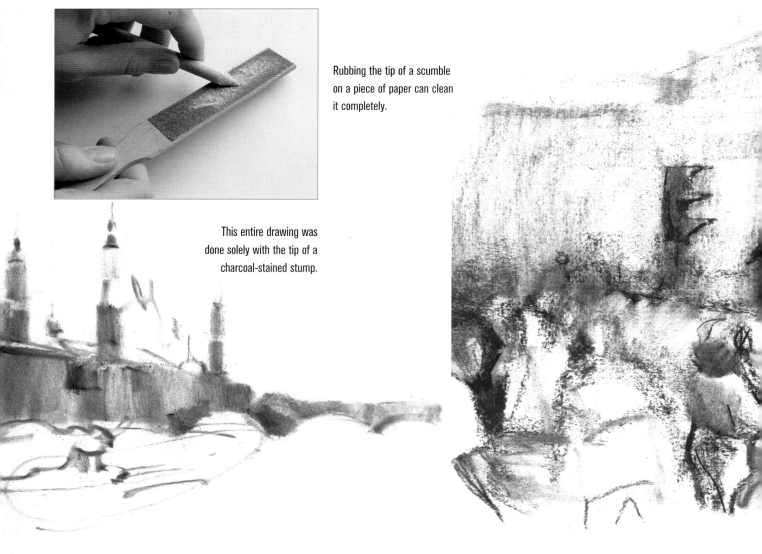

Charcoal requires no other materials than a piece of paper and the charcoal itself, but most artists also use rags, scumbles and erasers to obtain effects and nuances that would be difficult to achieve any other way. These tools yield excellent results and broaden the possibilities of this very elementary medium.

The scumble is an absorbent paper cylinder that spreads the charcoal and stains the paper with a broad, diffuse stroke.

The scumble

Correct use of the scumble, or stump, involves seeing it as a genuine tool for drawing beyond blurring, something like a "paper finger." Scumbles, unless they are brand new or very clean, always stain. Artists must use them to shade, highlight, and nuance, not just to extend previously drawn marks. In the drawing below, the scumble develops all the tones in the work from just a few charcoal lines.

Rubbing the tip of a scumble on a piece of paper can clean it completely.

This entire drawing was done solely with the tip of a charcoal-stained stump.

FIXING THE CHARCOAL

Charcoal must always be fixed to the finished drawing, because its particles alone will not adhere to the paper, and, little by little, will loosen from the support. An ancient method of fixing a drawing was to spread linseed oil over the stick before drawing. The oil, once dry, fixes the charcoal permanently. This method, however, is only feasible in drawings in which the artist does not blend lines.

The Eraser

The fact that charcoal does not adhere well to the support makes it very easy to rub out and erase. Malleable erasers are essential tools, as they not only correct mistakes, but also open up whites in a mark or blurred area, restoring the color of the paper after drawing on it. You can also draw with an eraser; it can lighten tones, develop details, and illuminate parts of a drawing. Like the stump, the eraser becomes a veritable drawing medium in the hands of a skilled, resourceful artist, and surpasses its corrective purpose.

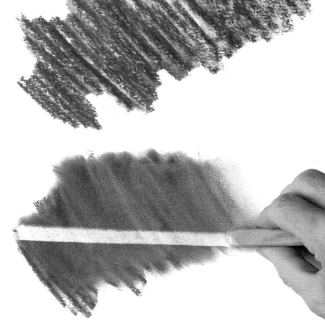

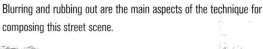

Blurring and rubbing out are the main aspects of the technique for composing this street scene.

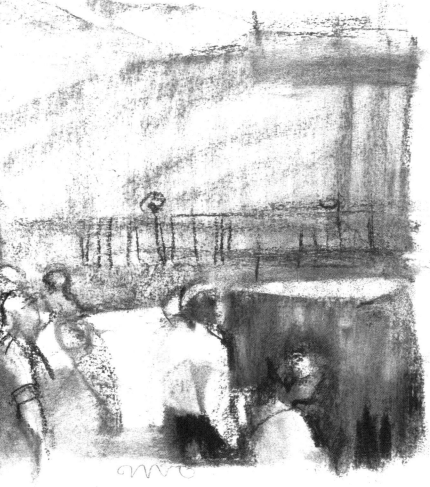

The rubber eraser cuts through this area of charcoal. It is more effective than the malleable eraser, though it is also more abrasive.

Malleable erasers are very flexible and absorb diffuse charcoal spots well, but are not useful in rubbing out intense lines.

Supports for drawing with charcoal

Charcoal lines on three different kinds of paper; fine-grained, coarse-grained, and laid paper, respectively.

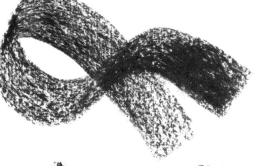

Three examples of watercolor paper of different grains, and the effect of charcoal marks on them.

The finish of a charcoal drawing depends, to a great extent, on the paper used. The larger the grain of the paper, the more intense the lines will be, since more particles will lodge in the crevices of the grain. Charcoal is an entirely natural product that does not incorporate any thickener to hold it together, which means that a fixative is required to keep the particles from loosening over time.

Creased papers

All paper with a creased surface is suitable for charcoal drawing with charcoal. The grain determines the result: the larger the grain, the harder it is to achieve a thorough, detailed finish. In general, very large works require very rough paper. Smooth or glossy papers with a fine grain are not suitable for charcoal drawing since the particles do not adhere to their surface and the lines become very faint.

Ingres-type paper

This is laid paper with a medium grain. Laid paper retains lines left by the wire mesh of the mold with which paper is manufactured. It is traditionally used in charcoal work, with thickened carbon or sanguine. Its special texture has just the right level of hold to retain the charcoal or chalk particles while still allowing for ample shading.

Sketching paper

This is perfectly suited for charcoal drawing, provided that you do not seek a finish that is very densely colored or very rich in shading. Its light grain prevents a lot of lines from accumulating. However, the paper deteriorates or tears with excessive erasing.

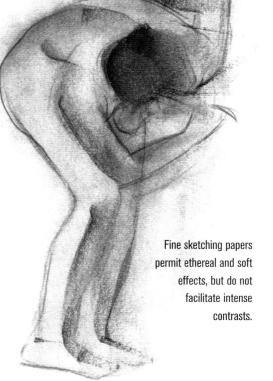

Fine sketching papers permit ethereal and soft effects, but do not facilitate intense contrasts.

Colored papers, if they are not too dark, are a viable option for charcoal drawing, especially for those that include lightly colored highlights. Drawing by Mercedes Gaspar.

Charcoal drawing on thick-grained paper by David Sanmiguel.

DRAWING WITH SANGUINE

*T*he term, "sanguine," is used to describe a lead of an earthy red color, iron oxide red, used by the artists since the Renaissance. It is a natural pigment that, while unsuitable for making paint because of its low inking power, is highly appreciated by artists for the warmth of its color in drawings in which it is used alone or in combination with other media. It is sold as pencils (pastel pencils with a sanguine lead), leads, sticks, and as a dust.

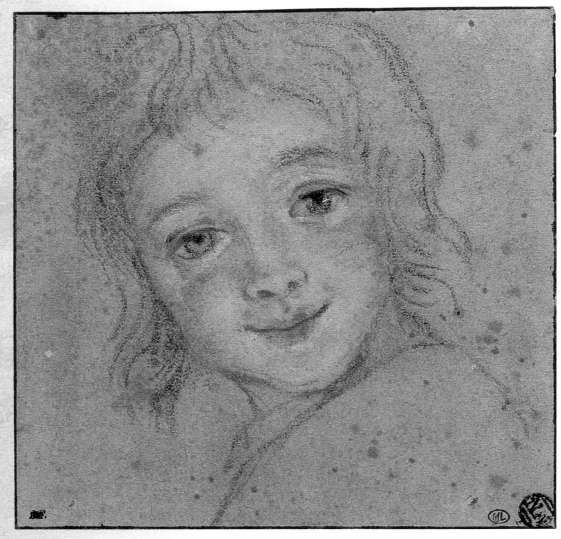

Antoine Coypel (1661-1722),
Study of a girl's head,
The Louvre.

SHARPENING SANGUINE PENCILS

Pencils, leads, and sticks have a soft lead and, therefore, seem to necessitate drawing with thick lines. However, with care, a blade and a little patience, a sanguine pencil's lead will sharpen very finely. It will be much easier to sharpen again if you leave a good amount of the lead exposed, since it wears down quickly. A metallic lead protector helps to conserve the supply of lead.

Every manufacturer uses slightly different pigments in its sanguine pencils. Some brands sell sanguine in three different tones.

Artists who like sanguine's special warmth use pencils and sticks indiscriminately.

Sanguine's reddish color and its slightly diffuse line always create harmonious works.

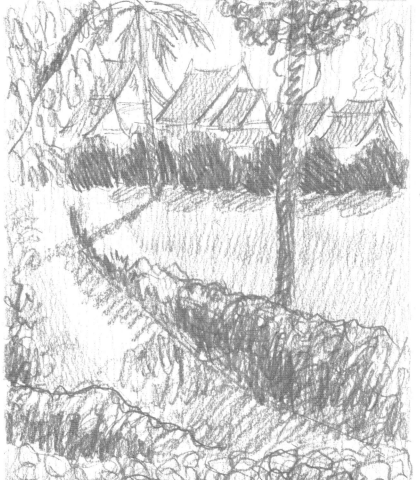

Sanguine pencils

Most sanguine pencils are a variation on pastel pencils; they are composed of a pigmented lead, thickened with clay, and encased in cedar wood. However, today, various brands have introduced varieties of sanguine that include mixed leads, watercolor pencils, and oil pencils. The reddish tone of their line characterizes sanguine pencils and continues to be the alternative color of artistic drawing, aside from graphite's gray and charcoal's black.

Colors of sanguine

Those who love to draw in sanguine know very well that every manufacturer makes sanguine in a slightly (and sometimes not so slightly) different color. Their color ranges from raspberry red to reddish orange. The same manufacturer may even sell sanguines of the same name that vary in color due to slight differences in the batch of pigment being used. Therefore, it is important to check the color of the stick or pencil before purchase.

Sanguines and chalks

Chalk is a white or gray limestone rock formed during the Cretaceous period. It has a very fine grain that leaves a mark when rubbed against a hard surface, and has been used for drawing since ancient times. In general, sticks of hard pastel with a square shape are referred to as chalks. However, more specifically, chalks also display a range of dark colors, traditionally seen in drawings that employ the technique of chiaroscuro.

Sanguines and chalks are the best color complement to charcoal drawings. Work by Joan Martí.

A harmonious range of single-color chalk sticks.

Chalk sticks

The most common chalks are square, with a shape and size identical to that of a conventional hard pastel color. This is the most traditional form of chalk. For single-color drawing, artists usually use traditional hues: sanguine, sepia, white, or black.

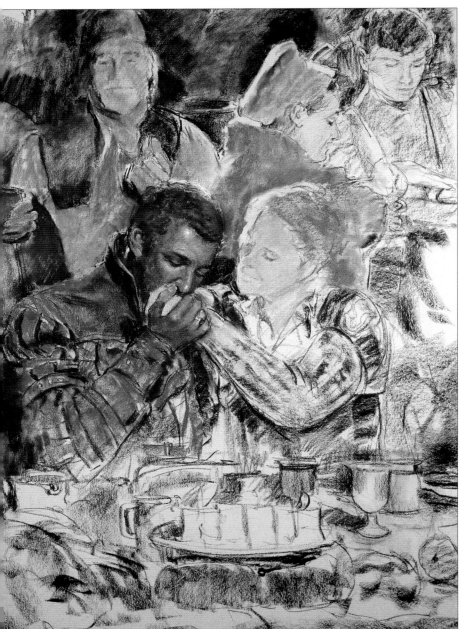

Charcoal and chalks are fully compatible and their mixtures and combinations always produce harmonious tones.

WHITE CHALK

This is, in effect, a white color stick that does not originate from chalk, but, instead is made from white pigment (usually titanium oxide), thickened with clay, and, depending on the variety, a small amount of powdered pumice stone. It is useful for highlighting charcoal or carbon drawings, and can work in combination with other chalks.

Sepia pencils and sticks

The color of sepia pencils comes from the bladder of the sepia mollusk, and, traditionally, its use was limited to ink drawing. By extension, the name also refers to the leads of pencils with a color similar to this original sepia, but which are, in reality, made with a natural pigment of the iron oxide family (in general a toasted or natural earth color). As with sanguine (with which it is usually appears in lightly colored drawings), sepia is available in pencils, leads and sticks.

In pencil, lead or stick, chalk functions exactly the same way as sanguine.

Brown and gray tones

Chalk sticks offer tones in an array of traditional and commonly used tones, but also represent shades of gray between black and white, and ranges of sepia tones between sanguine and black. This range allows artists to fine tune the tonal range in their drawings, and provides them with more extensive options.

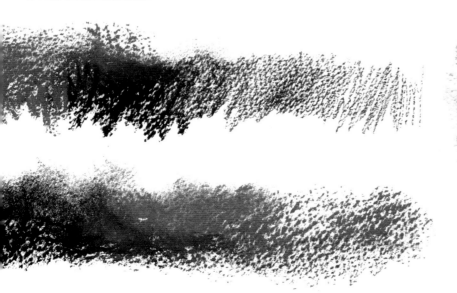

Artists who practice single-color drawing with chalk use sepia.

Basics of drawing with sanguine

Sanguine is a very interesting, single-color drawing medium. It produces a broad range of tones, but its color makes it much softer and more luminous than charcoal. It usually yields the best results with subjects involving the human figure. Sanguine can work with many other drawing mediums. Normally, it appears in combination with charcoal or pastels.

Sanguines, sepia chalks, and white chalks were used in this drawing. The combination of the three hues is perfectly harmonious and it stands halfway between a single and multi-colored drawing.

Drawings with sanguine and chalks

As they are hard pastels, sanguine and chalks are generally better suited to works in which the subject itself is a priority over the color of the drawing. Even so, the color effects of chalks are in no way substandard. They can be blurred, blended into each other, applied on top of each other and can cover the paper almost as much as any other pastel. Classical drawings in this medium usually employed combinations of white chalk, sepia, sanguine and black chalk. These colors are more than sufficient for drafts, sketches, and works that do not require a thorough development of color.

The drawing stump provides atmospheric results that accentuate the soft, warm tendency of sanguine.

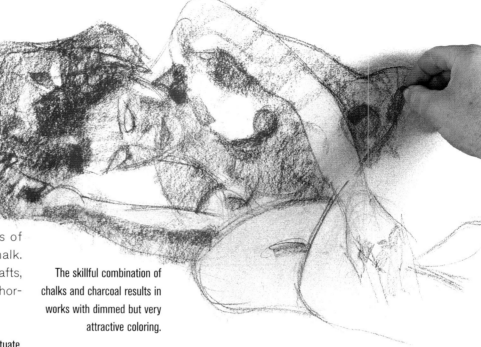

The skillful combination of chalks and charcoal results in works with dimmed but very attractive coloring.

Strokes, Blending, and marks

Despite the thickness of its lead, sanguine is a very delicate drawing medium. Its tone will not produce shadows that are very dark. Rather, works done in sanguine feature medium tones, resulting in a very warm and attractive tonality. Those who employ sanguine pencils usually work from lines and strokes that hatching builds up to achieve convincing shading. Those who like to use sticks normally start with broad strokes and thicker lines, creating effects that characterize pastel painting.

All sanguine or chalk drawings are amenable to the use of a drawing stump.

Supports for drawing with sanguine

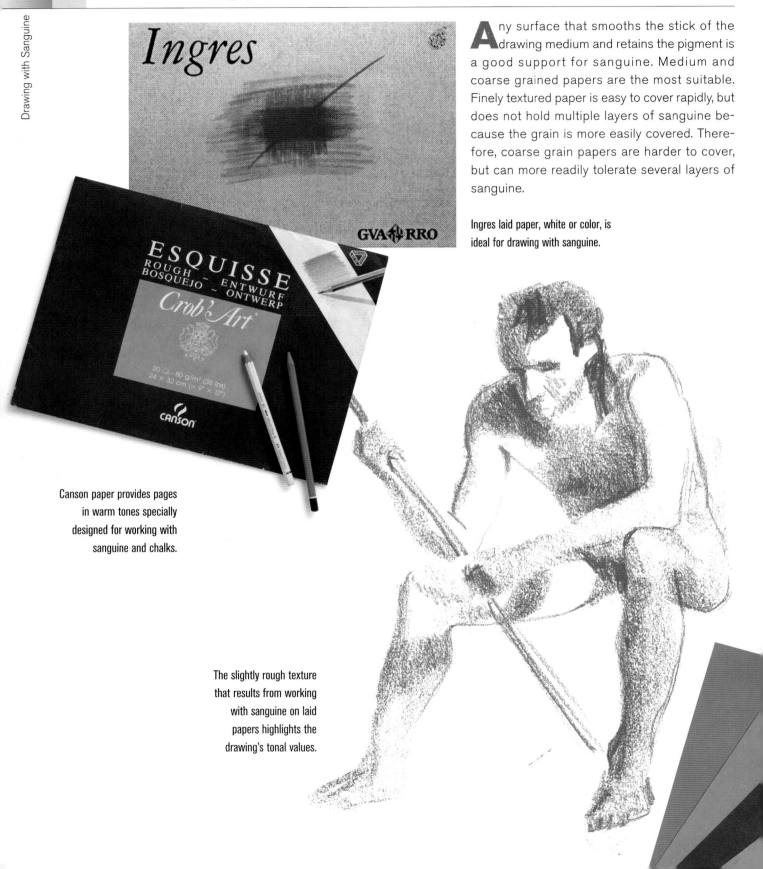

Any surface that smooths the stick of the drawing medium and retains the pigment is a good support for sanguine. Medium and coarse grained papers are the most suitable. Finely textured paper is easy to cover rapidly, but does not hold multiple layers of sanguine because the grain is more easily covered. Therefore, coarse grain papers are harder to cover, but can more readily tolerate several layers of sanguine.

Ingres laid paper, white or color, is ideal for drawing with sanguine.

Canson paper provides pages in warm tones specially designed for working with sanguine and chalks.

The slightly rough texture that results from working with sanguine on laid papers highlights the drawing's tonal values.

COLORED PAPERS

Sanguines produce a more harmonious result when drawn on colored papers. Artists can either purchase or dye paper to their preferred color. A traditional method involves moistening the paper with an infusion of tea, which leaves a permanent coloring that is soft, agreeable, and harmonizes very well with the color of sanguines and chalk in general.

Canson papers

One of the most common painting papers is the Canson Mi-Teintes, a quality paper that is 65% cotton and has a different texture on each side. It is manufactured in a range of colors that includes soft grayish hues, solid reds, yellows, and blues. This paper is sold in two dimensions and also in sketchbooks in a harmonious range of colors (sienna, ochre, grays, etc.).

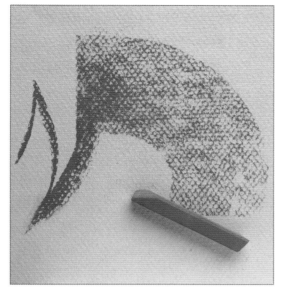

The particular texture of Canson paper is clear in this staining with sanguine.

Pale colors are those that best respond to the earthy coloring of chalks. Work by Joan Raset.

Laid papers

The fine texture of laid paper is an excellent support for sanguine drawings, especially when using pencils to create delicate lines and strokes. Laid papers are available in various hues. Grays and pale ochre colors are the most suitable for sanguine drawing.

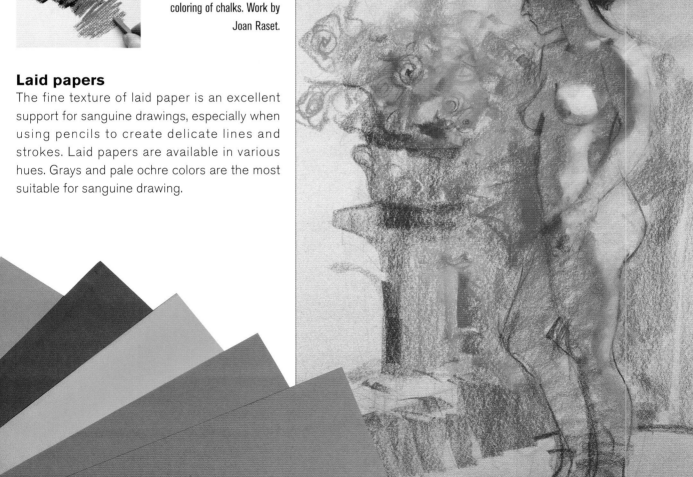

DRAWING IN PEN AND INK

*I*nk, when used as a drawing medium, can allow for various drawing techniques depending on the instrument of application. The nib is the most common, but canes, brushes, or conventional writing pens are also effective in creating ink drawings. Depending on which is used, results vary from the most meticulous and detailed examples of workmanship to spontaneous, unexpected effects produced by marks, washes, and experimentation with line.

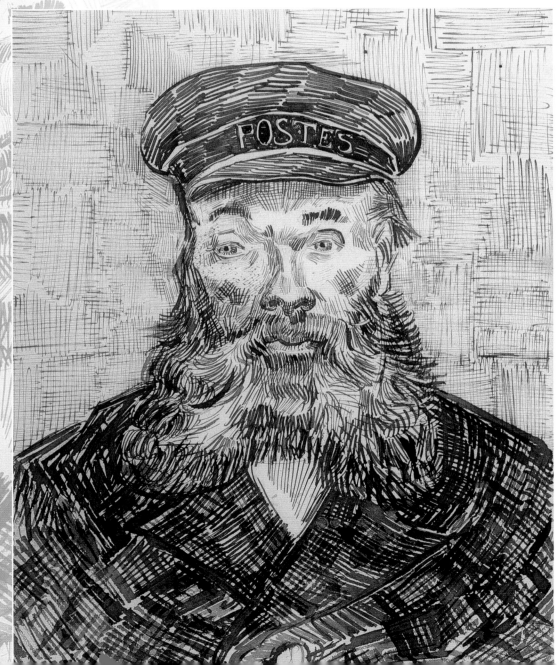

Vincent van Gogh (1853-1890),
Portrait of Joseph Roulin.
The J. Paul Getty Museum.

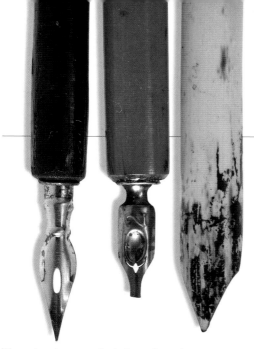

Nibs and reed pens are the instruments most commonly used in ink drawing.

Lithographic pen with replaceable ink cartridge specially designed for artistic drawing.

Calligraphic style

The fineness of the nib stroke typically calls for more line density. Single, isolated lines can appear too faint. Therefore, to build up a drawing, the artist must employ hatching and overlaying of lines or look for graphic resources close to calligraphy: figures inscribed with a flourish, arabesques, filigree, etc. This second option allows the fantasy and inventiveness of the artists to come into play, since, as well as creating the shadows and particular representations of the subject, they engage themselves in an authentic creation of linear shapes. These resources are essential, because they reinforce and enrich a manner of drawing that otherwise might remain at the level of crudely schematic forms.

Control of line

When you are drawing with any pen, nib, or reed pen, the line is very fine and permanent. Drawing with ink does not allow for tentative strokes or marks to be later rubbed out or covered up with thicker, more definitive lines, as other drawing media permit. In short, ink strokes require greater confidence. Continual practice and an understanding of the possibilities and limitations of the medium are the only ways to achieve successful pen and ink drawings.

Various steel nibs for artistic drawing, accompanied by their characteristic strokes.

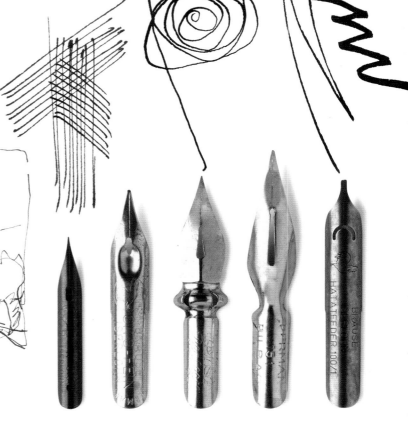

India ink and its varieties

Ink is one of the traditional mediums of artistic drawing. In the East, its origin goes back to around 600 B.C. In the West, the ancient Romans used India ink, and, since that time, it has been used continuously as a writing and drawing medium. Today, we can buy varieties of both Western and Eastern inks. In addition, modern manufacturers have introduced a complete range of pigmented colored inks.

Anthony van Dyck (1599-1641), *The Burial*. The J. Paul Getty Museum.

Samples of various black and colored inks. From top to bottom: India ink, sepia ink, black ink for lithographic pens, blue ink for lithographic pens, pigmented ink, ink made of synthetic dyes, and ink of plant colorants.

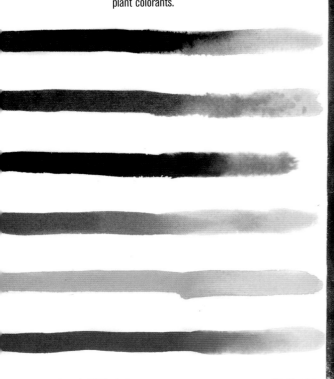

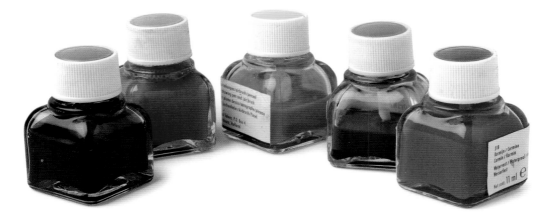

COLORED INK

In its composition, colored ink is the same as (or very similar to) black ink, but uses dyes instead of black pigment, as pigments of other colors make its consistency irregular and remove transparency from ink marks. Colors are indelible, but not permanent, meaning they become discolored after very long exposure to light.

India ink

India ink is the most ancient of black inks. In fact, its origin is Chinese, made from a process that mixes coal, soot, oil, and gelatin. It is water-soluble and, as such, its concentration can be graduated. Traditional India ink comes in solid tablets that can be diluted by rubbing them with some water on an inkstand made of a special stone. Although the name of India ink is used for all black inks, most conventional black inks are really complex chemical compounds. Most artists use black ink in its liquid form, which is manufactured with carbon and shellack and is not water soluble when dry.

Original India ink comes in solid bars that produce liquid ink when rubbed with water on an inkstand made of a special black, finely textured stone.

India ink is water-soluble. Once dry, it is indelible and insoluble.

Writing and calligraphic inks

Modern writing inks, invented for loading fountain pens, were developed in the first decades of the twentieth century, with the goal of finding quickly drying, alcohol-based substances that did not require blotting paper. Calligraphic inks incorporate pigments (dark) or plant dyes (transparent) and are sold in a variety of colors.

Writing ink is available in inkpots that can be applied to a drawing with a brush.

Drawing with a nib

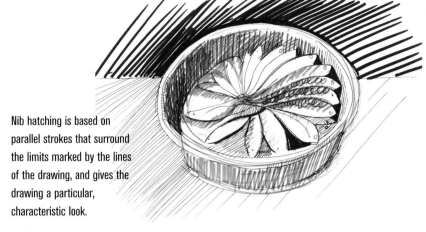

Nib hatching is based on parallel strokes that surround the limits marked by the lines of the drawing, and gives the drawing a particular, characteristic look.

Metal nibs did not appear until the end of the eighteenth century. Until then, artists used goose feathers as drawing instruments. Classic metal nibs are sold individually and insert into plastic or wood penholders. A large number of models are available: flat, pointed, and round nibs, as well as those with special calligraphy tips.

The graphic interest of nib drawings lies in the wealth and variety of strokes, details, and filigree that bring the subject to life, such as this one by Gabriel Martín.

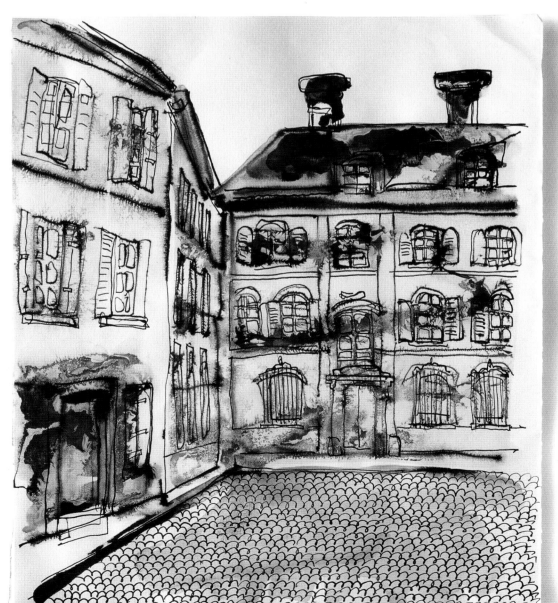

Hatching is the fundamental (and sometimes sole) resource of the artist to create effects of *chiaroscuro* and volume. Drawing by Gabriel Martín.

Handling the nib

There are a great variety of nibs, but those best suited for drawing have a straight or oval-shaped tip, since curved, flat, or cut ones are designed for calligraphic work. The nib's stroke only varies slightly in thickness. By exerting pressure on it, the tip opens and lines become a bit thicker. These small variations are enough to give emphasis and character to a drawing. Naturally, nib drawing requires constant reloading from the inkpot and controlling the amount of ink loaded.

These three samples show different varieties of hatching with a nib. Note the variations in density in the three drawings.

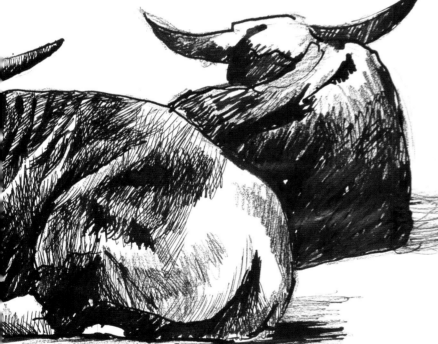

Nib hatching and crosshatching

Nib hatching refers to those simple highlights or shading of shapes, based on brief parallel nib-strokes. Crosshatching is the accumulation of ordered strokes in different directions superimposed on each other to create shaded areas. Drawings created with a nib allows for a richness of detail and graphic density. The visual grace and density of nib drawings lies in the skillful distribution of lines against the white of the paper.

Drawing with reed pens

Reed pens, beveled at one end, are good instruments for ink drawing. The most sophisticated ones have a metal tongue on the inside that assists ink reloading.

The reed pen may look like a rather crude medium, but when used correctly gives delicate and lively results.

Reed pens

Reed pen strokes vary in thickness depending on which side of the cane's tip touches the paper. When held like a fountain pen, the cane's stroke is thick and continuous, varying according to the pressure exerted. If placed on its side, the stroke of the tip becomes finer and is less stable, since any wavering means that more of the side comes into contact with the paper, increasing the thickness of the stroke. Reed pens hold much less ink than nibs, requiring constant dabs in the inkpot.

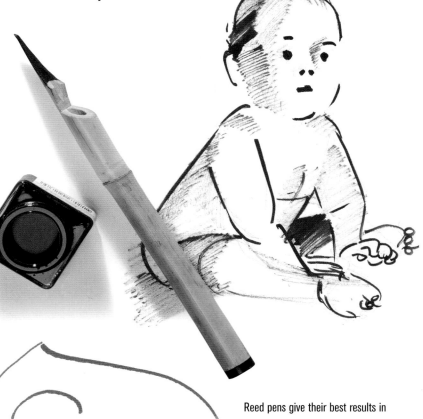

Hatching with the reed pen loaded with little ink.

Hatching achieved with the reed pen loaded with undiluted ink.

Reed pens give their best results in drawings with thick shadows and a multitude of linear details.

Reed pen strokes must be quick and simple: their immediacy, not accuracy, is the aim.

Low-intensity strokes

The combination of fine and thick strokes can alternate with "blurred" strokes and lines that cover a small area and are faded due to scarcity of ink. Whereas nibs suddenly stop drawing when their ink load ends, reed pens leave a steadily diminishing line that artists can take advantage of for certain effects. These effects can be achieved by emptying the ink onto another piece of paper until the brush mark reaches the desired effect. These factors make reed pen drawing one of the most versatile ink drawing methods available today. It is a technique that lends itself to a contemporary aesthetic.

Reed pen strokes vary slightly in thickness, but may vary greatly in intensity, depending on how much ink the pen carries.

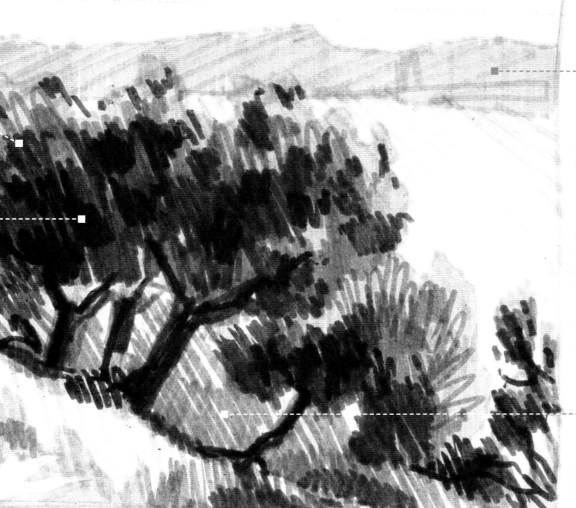

Hatching created with ink diluted in water, using little ink in the quill nib (almost dry).

This drawing shows how reed pens used with sepia ink in various water solutions can create a wide range of effects. The two value squares next to the drawing clearly show the range of values in this drawing.

Hatching created by diluted ink and an ink-laden reed pen.

Drawing with brushes

In Far Eastern art, brushes are used more as a drawing medium than as a painting medium. The modern brush-and-ink drawing practiced today by so many Western artists comes from Eastern influence. It is a drawing tool especially well suited for sketches and observations from nature. The freshness of the final result compensates for all the imprecision of the brushstroke. Brush drawings have an incomparable immediacy and spontaneity almost impossible to achieve with any other medium.

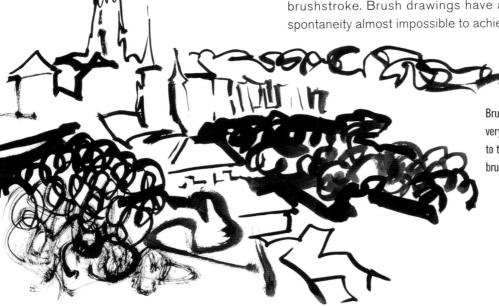

Brushes offer a highly variable stroke, from a very fine line achieved with the tip of the hairs to thick marks made by crushing the ink-laden brush on the paper.

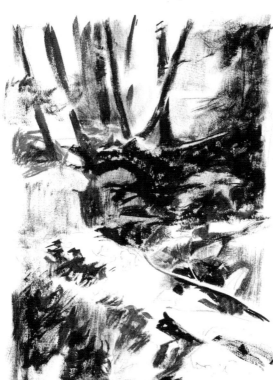

Working on creased papers with little ink on the brush results in a textured effect known as "dry brush."

This work recalls an Eastern aesthetic. Japanese wash painting is, in fact, brush drawing, where the shape of the ink's mark expresses everything.

THE WASH

Ink can be replaced by a watercolor for very harmonious drawings in which warmer nuances soften the pure graphic contrast of black and white. Sepia wash is one of the traditional techniques of ink drawing that is as close to painting as drawing is.

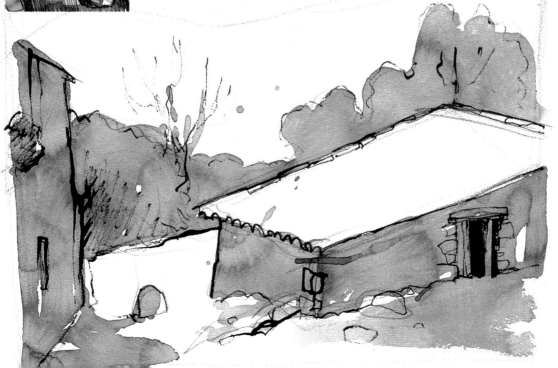

Technical factors

The flexibility of a brush results in strokes that are irregular. Drawing with a brush demands an efficient method. It does not allow for correction, and an accumulation of lines confuses and spoils the result. The artist must be able to develop the subject rapidly, looking for direct expression and suggestion of forms in just a few brushstrokes.

Drawing process

If you have not had much practice with a brush, it's best to sketch the drawing in pencil beforehand to ensure the correct underlying structure and composition. Once you begin applying the ink, the process must be rapid and unwavering. The greater or lesser density of the medium used determines the fluidity of the brushstrokes. A very fluid ink diluted in water can create shapes quickly by linking brushstrokes together, working in a cursive style, and reducing shapes to spontaneous flourishes. Denser inks produce drier strokes and a less fluid construction of form.

Ink applied to a brush is ideal for sketches from nature: it is the most immediate and rapid of all drawing mediums. Work by Vicenç Ballestar.

The lines of this work were resolved with a nib. The interiors of the shapes used sepia ink highly diluted in water.

Papers for ink drawing

Papers for drawing with a nib can't be very rough, as this would make it difficult to create solid lines. Surfaces can't be soft or spongy either, as this would make the surface too absorbent and the edges of a pen line bleed and lose their crispness. Glossy paper is the best for this technique. When using a reed pen, the paper must have a textured surface, as this type of pen functions best by rubbing across the paper rather than quickly gliding over it.

When working with washes and pen nibs, it's best to use heavier weight paper (at least 140 lbs.). You can use watercolor paper, provided that its surface is not excessively rough.

Coated paper

Smooth, coated papers are the most suitable for nib or reed pen drawing, since these kinds of pens can glide over it easily. There are sketchpads especially designed for drawing with a nib. In general, any smooth and nonabsorbent paper is suitable for nib or reed pen drawing.

Paper for conventional nib drawing must be coated or fine-grained, so as not to hinder the free flow of the ink on the support.

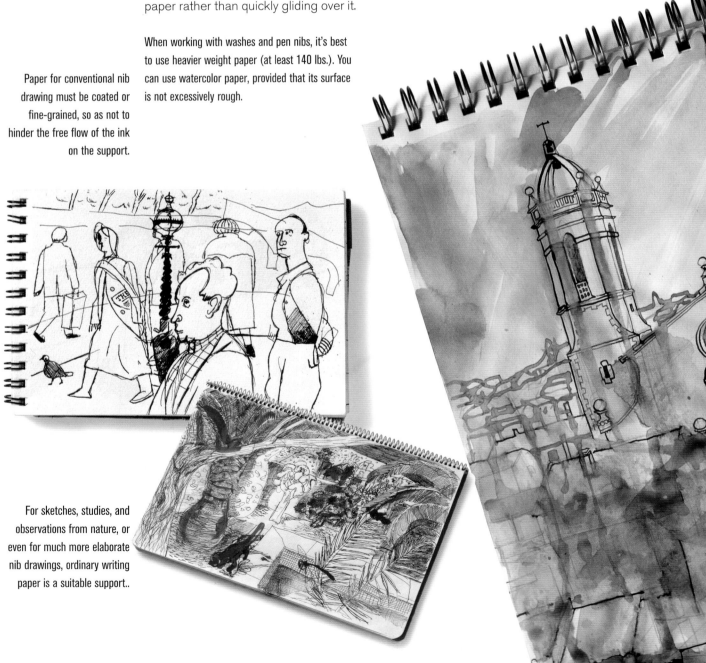

For sketches, studies, and observations from nature, or even for much more elaborate nib drawings, ordinary writing paper is a suitable support..

Japanese paper

This is a very light paper manufactured with long, rice-based fibers, which makes it highly absorbent and appropriate for drawing with a brush. It is the traditional paper of Japanese washes, and, due to its growing popularity in the West, is increasingly sold in art supply stores as individual pieces or in sketchbooks.

Watercolor papers

Very fine-grained watercolor papers give excellent results in ink drawing with both nib and brush. Because of their high absorbency, finishes are very matte and reinforce the strong graphic presence of black ink. If you work with single-color washes, these papers increase the tonal register of drawings because of their particular ability to accept marks and strokes that are highly diluted in water.

Sketchbook of very delicate Japanese paper, specially manufactured to use as a support for works using a wash technique in India ink known as *sumi-e*.

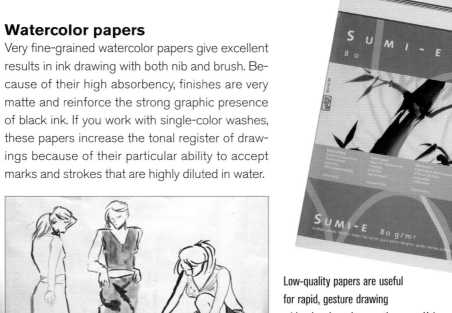

Low-quality papers are useful for rapid, gesture drawing with a brush, as long as they are not too absorbent or porous.

Using reed pens with textured papers can give interesting results.

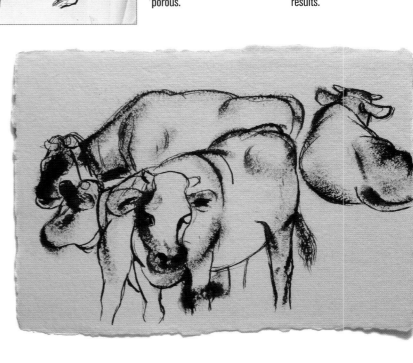

Drawing

- Crayons
- Pastels
- Colored Inks
- Markers

If drawing is essentially an artistic discipline based on line and massing, then we must include all the media related to this definition, including crayons, pastels, marker pens, and colored inks. Many of these materials are of contemporary practices, compared to the more fundamental charcoal and graphite sticks. However, their use has won acceptance from artists thanks to the broad range of creative possibilities they offer.

Some of these could be considered painting media in their own right. For example, works in pastel sometimes resemble paintings rather than drawings. But their technical basis, consisting of lines and strokes of color, is still based on drawing techniques. Although the boundaries between drawing and painting may blur, in this book, we should still address these colorful materials that lend themselves so well to the practice of drawing.

All the works studied and reproduced in this chapter appear as drawings under a more or less colorful appearance. Even the works that look contemporary, done with marker pens or colored inks, remain faithful to the traditional parameters of the discipline..

with
COLOR

DRAWING WITH CRAYONS

Crayons are not only a drawing tool for children, but also contain multiple possibilities as an artistic drawing medium. Colored strokes offer accuracy and subtlety, difficult qualities to attain with media that requires a more rapid work habit. Combining and mixing colors involves a technique and simple production process similar to that of graphite pencils. In addition, crayons can also be an interesting complement to other materials, as they combine easily with other media.

Crayons enable a detailed finish and thorough evaluation of a subject that goes beyond the scope of most drawing and painting mediums. Work by Mercedes Gaspar.

Properties

The crayon's fundamental properties are its ease and immediacy of use. They handle exactly like graphite pencils, but offer a softer, glossier, and much less oily finish. They require no auxiliary media or materials other than paper and the pencils themselves. It is an ideal tool for smaller works, since crayons offer less coverage than other mediums. However, they can provide a work with a great amount of detail and a stability of color.

Their ease of handling and the sharpness and luminosity of their colors have made crayons a common medium for children's drawings.

In the fields of illustration and technical drawing, they are a valuable tool because of their accuracy, especially when combined with watercolors or gouache colors.

Consistency of leads

Crayons' leads consist of pigments that are thickened and cooked with kaolin, a type of clay, and mixed with wax. The pigments are the same as those used in the manufacture of all the colors of other pictorial procedures (watercolor, oil, pastel, etc.) However, crayons have less covering power than other mediums, since kaolin, which allows the tip to be sharpened and makes the crayon's tip strong, prevents the pigment from spreading freely over the support, limiting the possibilities for lines and hatching.

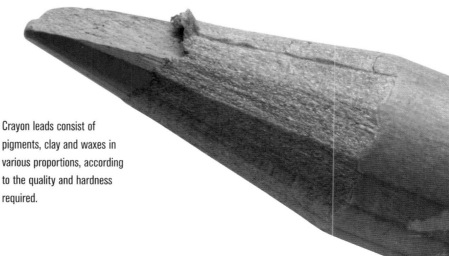

Crayon leads consist of pigments, clay and waxes in various proportions, according to the quality and hardness required.

Varieties and forms

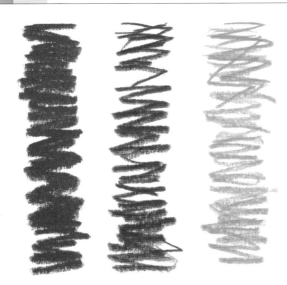

Crayons' quality depends on the quality and quantity of pigment used in their manufacture. Crayons for school use contain low quality pigments in a lower proportion. In addition, these crayons contain a small amount of wax, giving them a lower covering power.

High quality crayons leave a slightly earthy line of intense color that covers areas of the paper well. They can be sharpened to very sharp tips and the cedar wood encasing their leads is soft, yet resistant.

Types

The major manufacturers of crayons offer many varieties, from cases with twelve colors to luxurious wallets of almost a hundred different colors. All of these crayons can also be bought individually. Some manufacturers provide crayons of two different degrees of hardness. Hard crayons are most appropriate for work of professional quality, as they can be sharpened much better and conserve their tip longer. Semi-hard crayons (there are no truly soft crayon leads) are very useful for covering large areas in a uniform color.

The density of stroke between crayons with soft and hard lead is noticeably different, and is a decisive factor in performing various tasks. Crayons with water-soluble leads are usually hard.

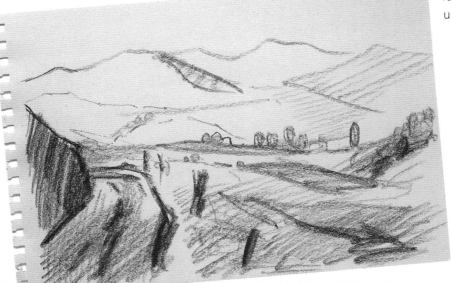

Crayons with a soft lead have a quality of stroke that is similar to that of a soft-lead graphite pencil (especially if a dark color is used). Drawing by Óscar Sanchís.

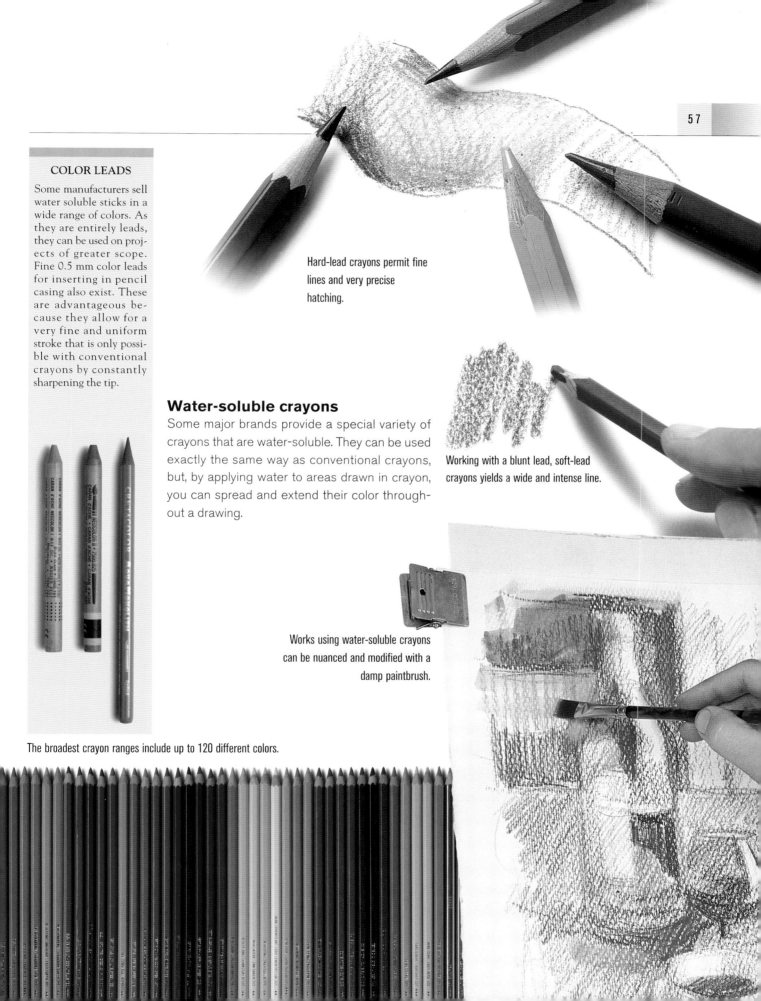

COLOR LEADS

Some manufacturers sell water soluble sticks in a wide range of colors. As they are entirely leads, they can be used on projects of greater scope. Fine 0.5 mm color leads for inserting in pencil casing also exist. These are advantageous because they allow for a very fine and uniform stroke that is only possible with conventional crayons by constantly sharpening the tip.

Hard-lead crayons permit fine lines and very precise hatching.

Water-soluble crayons

Some major brands provide a special variety of crayons that are water-soluble. They can be used exactly the same way as conventional crayons, but, by applying water to areas drawn in crayon, you can spread and extend their color throughout a drawing.

Working with a blunt lead, soft-lead crayons yields a wide and intense line.

Works using water-soluble crayons can be nuanced and modified with a damp paintbrush.

The broadest crayon ranges include up to 120 different colors.

Drawing techniques

In comparison with other drawing techniques, crayons perform best in works of a small scale. They are not amenable to large formats and yield their best results when creating detail, without the major visual effects that charcoal, pastels and ink demand. The interest and indubitable charm of the technique lies in this limitation, as it obliges the artist to work carefully, delicately, and sensitively.

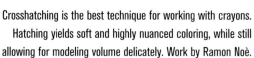

Crosshatching is the best technique for working with crayons. Hatching yields soft and highly nuanced coloring, while still allowing for modeling volume delicately. Work by Ramon Noè.

Strokes and color

Drawing with crayons also involves coloring. The appearance of the color will depend, for the most part, on the stroke used. Fairly separate strokes that cross each other but do not cover the surface the paper create soft colors. The accumulation of strokes can be rapid and spontaneous or thought out in advance and based on overlaid hatching. When drawing with crayons, tones must never be highly saturated, but vast areas of color can be achieved by pressing the lead of the crayon flat against the paper.

COLOR RESERVES

Color reserves result from coloring around white shapes with a darker tone, thereby placing them in a reserve as is done with watercolor. This way of working requires being able to imagine the effect beforehand, knowing that the base color has to be light enough to keep the tonal richness alive. Cutting out shapes on a dark color, however many light tones are used, hardly varies or enriches the tones of the first color.

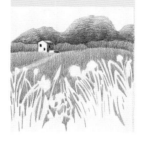

The meticulous, precise, and agile line of the crayon can become the characteristic feature of the work, creating dynamic rhythms and strokes that describe the form and evoke an atmosphere at the same time. Work by Gemma Guasch.

Blending with gray or white

Crayons have a particular nature due to the composition of their leads. This involves the possibility of blending strokes by drawing with light gray or white over another color or other colors. The slightly waxy consistency of the lead dominates the low coloring power of the white or gray hues and blends the strokes together, while hardly being affected by the gray or white. Some brands manufacture special crayons for this process.

White crayons can be used to blend the strokes of a color, reinforcing its tone while hardly affecting its hue. "Colorless" crayons, like the one in the image, are specially manufactured for this task.

Mixing and combining colors

Rather than mixing, we should talk of overlaying colors, since the physical mixing of crayons is never completely possible. Layering colors on top of each other to produce different colors is a fundamental concept of color theory. The primary colors, yellow, blue, and red, when overlaid, produce the secondary colors: orange (yellow and red), green (yellow and blue), and violet (red and blue). Artists always use wide ranges of crayons (precisely to avoid constant mixing) that include primary and secondary colors.

However, drawings still often require layering two colors to create a third.

In theory, it is possible to obtain all the colors by combining only the three primary ones. In practice, there are many limitations to this and all artists working with crayons use quite a wide selection of colors.

The results of combining colors are different, depending on the use of either open hatching (separate strokes) or very close hatching. In the latter, color is much denser and the texture of the paper is more visible.

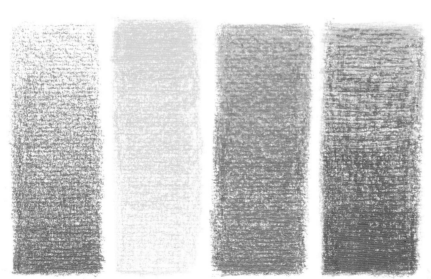

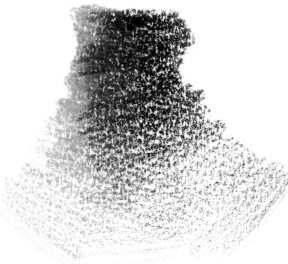

Layering colors

When layering colors, light colors must be placed on top of dark ones. This is because light colors have a lower capacity for coverage, allowing the base color to remain slightly visible, a necessary condition for achieving the resulting color. If, for example, we layer red on yellow, the resulting color will merely be a red slightly tinged with yellow. However, if we layer yellow on top of the red, orange will appear in full force.

Whatever kind of hatching an artist uses, the steps from a color to its combination with other colors must be soft and gradual.

Mixtures with water-soluble crayons

Though drawing with water-soluble crayons belongs to the realm of painting, it is worth mentioning this technique here. Water-soluble crayons offer a new option for color mixing aside from the typical overlaying of colors. This process involves obtaining a mixture of pigments by dissolving colors into water. The mixtures are not created separately on a palette with these crayons, but directly on the paper. The water dissolves the strokes and produces the desired color or result.

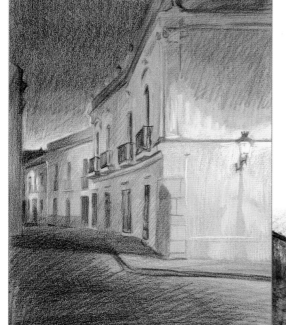

Soft lead crayons can also work in combination with colored supports; the paper's tone will not be visible on the lighter areas. Work by Óscar Sanchís.

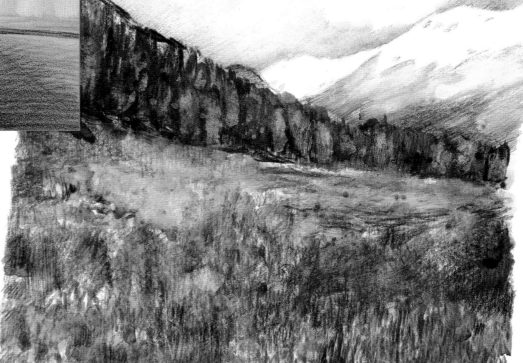

Water-soluble crayons enable artists to diversify the characteristic textures of a work done with crayons. Work by Mercedes Gaspar.

Paper for crayons

The amount of liquid involved in drawing with water soluble crayons requires paper that is thicker than normal drawing paper. The ideal paper for crayon is paper that could just as well be used for watercolor painting.

Most paper suitable for drawing with graphite leads is also suitable for crayons. There are two exceptions to this general rule: colored supports and very glossy or waxy ones. Intensely colored papers are not suitable for work with crayons, since crayons' strokes, which are too tenuous, will still expose the color of the paper underneath. Off-white or slightly gray paper is a very good support, but more intense colors that are more intense than these are not advisable. Glossy or waxed surfaces are resistant to the rather dry stroke of crayons and should be avoided.

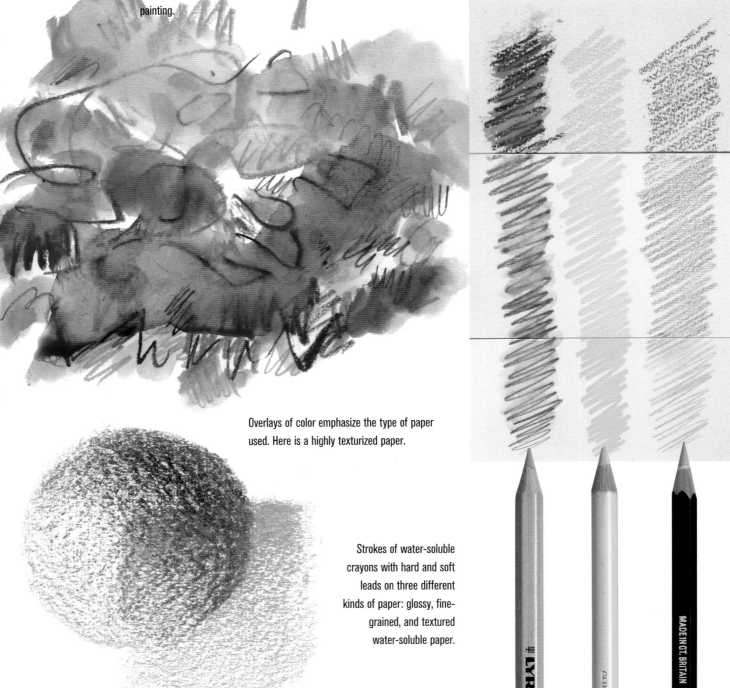

Overlays of color emphasize the type of paper used. Here is a highly texturized paper.

Strokes of water-soluble crayons with hard and soft leads on three different kinds of paper: glossy, fine-grained, and textured water-soluble paper.

Smooth surfaces allow for softer and more uniform finishes.

The paper's grain

The best surface for crayons is smooth paper or paper with a light or very light texture, but never a glossy surface. The fine stroke of crayons demands surfaces that allows for fluidity and transformation of line. Since crayons contain their own thickener, the support does not necessarily need to be rough in order to retain the pigment particles. Such roughness is usually more hindering than helpful. In addition, a thick grain gives the drawing a rough texture that may be undesirable, unless roughness is the artist's goal. If the artist uses water soluble crayons, it may be appropriate to choose slightly rough paper to mimic the effect of the watercolor.

Pale colors are well suited to subjects in which white plays a prominent role. Work by Gabriel Martín.

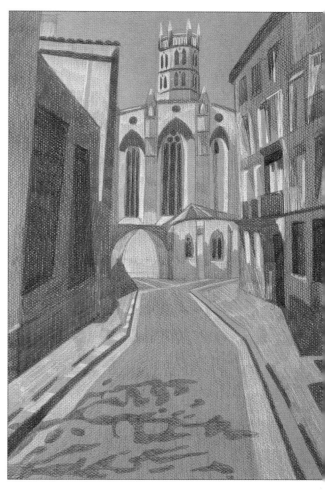

Finishes vary a lot, depending on the paper employed. In general, papers that are hard and very smooth are ideal supports.

Smooth paper.

Laid paper.

Water-soluble paper.

Soft craft paper.

DRAWING WITH PASTELS

*P*astel painting originates in the sanguine or white chalk used by Renaissance artists. They were not yet pastels, but the way they were used (on white or colored paper) was very similar to pastels. Multicolored sticks appeared in the eighteenth century, used by some French and Italian portrait painters. But it was the impressionist painters who really popularized pastels by using them for both color studies, sketches, and in more finished works. Since then, pastel has become one of the most widely accepted materials by both amateurs and professionals.

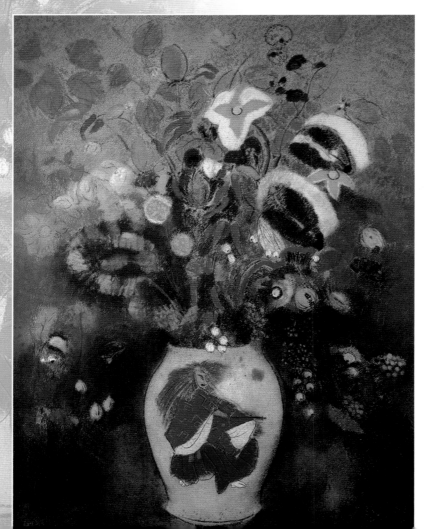

Odilon Redon (1840-1916), *The Japanese Warrior Vase.* Pastel is an opaque, densely colored medium that highlights the pure contrasts of color.

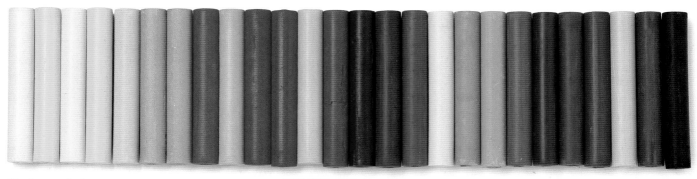

Color mixtures

Pastel drawing does not necessitate mixing color. The broadest ranges of pastels provide artists with all (or almost all) the hues and tones they require. If, despite this, an artist desires a very special hue, they may attain it by mixing directly on the paper. This can be done on any support, except those with a highly glossy or oily surface.

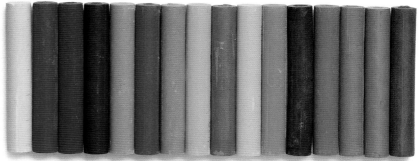

Pastels normally available in cylindrical sticks, except for hard pastels. Their ranges are very extensive, with some brands producing hundreds of colors.

Opacity and stability

Pastel painting is completely opaque and provides full coverage without revealing the support or color over which it is applied. Pastel is also very stable: it does not break or crack over time, nor does it yellow or darken. However, it is sensitive to excess light and may discolor over the years if exposed to very direct and intense lighting.

Pastel is a completely opaque medium with high coverage. However, if it is applied softly, the background of the paper will still be visible.

Pastels are a both drawing and a painting medium. Stroke, mark, drawing, and color are inseparable. Work by David Sanmiguel.

Nature of dry pastels

The name, pastel, comes from the word "pasta" or paste, which refers to the thickener with which pastels are manufactured: paste consisting of pure pigment thickened in a slightly adhesive gum (usually methyl cellulose) with a minimal amount of additives or extra components. Some artists think that this is the purest medium, since no filler or vehicle intervenes between the color and the support. Pastel is the most direct of all pictorial procedures; it does not require drying time, the color it produces is exactly the same as that of its stick, and it does not require any processing or preparation prior to use. These characteristics are common to all types of pastel. The only difference between various types of pastel is their hardness.

Soft pastels consist of virtually pure pigment, with the addition of just a small amount of thickener.

Soft pastels

These are the highest quality pastels, since the amount of pigment in them is very high. These sticks wear down very easily upon rubbing them on the support and leave very intense marks of color due to the accumulation of pigment on the paper. A softness is due to a smaller amount of thickening gum used in their manufacture. Their cylindrical shape and abundance of different tones characterize soft pastels. Such abundance is due to the fact that manufacturers add loads of white or similar product to make their colors opaque and to lighten the tone. A very small minority of craft manufacturers produce sticks of almost pure color, with the sole addition of a small amount of finely ground pumice stone to increase their grip on the paper.

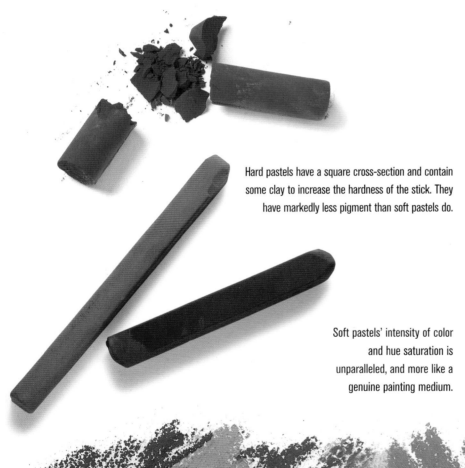

Hard pastels have a square cross-section and contain some clay to increase the hardness of the stick. They have markedly less pigment than soft pastels do.

Soft pastels' intensity of color and hue saturation is unparalleled, and more like a genuine painting medium.

Hard pastels

At first glance, they appear thinner and usually have a square cross section. Whereas soft pastels are pure, thickened pigment, hard pastels are produced by cooling the pigment slightly with a bit of potter's clay. Thanks to this hardness, they can sharpen (to a certain degree), and can draw much finer lines than the thick strokes of soft pastel. Their hardness also makes them suitable for colored drawing. As a counterpoint to these advantages, they produce markedly less tonal saturation than soft pastels.

Marks created with hard pastels are always much less dense than those created with sticks of soft pastel.

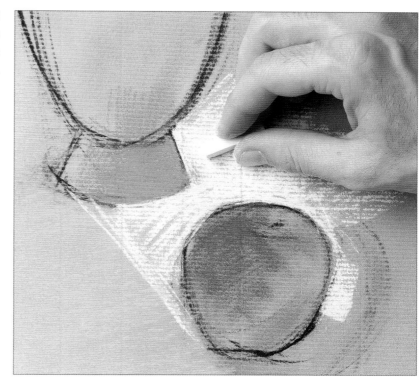

While soft pastels are ideal for spotting and blurring, hard pastels create lines.

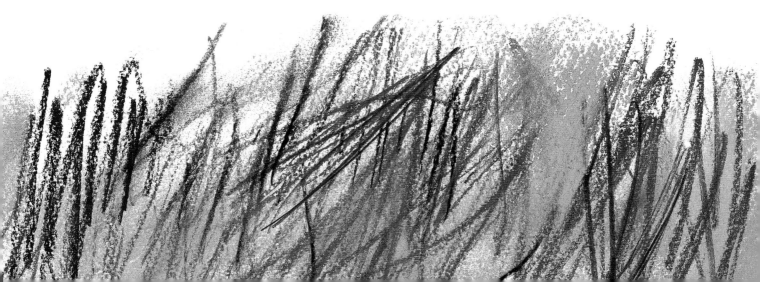

Ranges and varieties of pastel

Ranges of pastel colors vary according to the brand. Specialized manufacturers use dozens of different pigments to manufacture sticks and produce various blends of each pigment. In many cases, they mix pigment with chalk or white pigment in one or two different proportions, which gives rise to one or two lighter variations of the original pigment. Other shades result from mixing with black and produce darker versions of the same color. The possibility of mixing pigments with each other allows some manufacturers to create hundreds of vibrant colors.

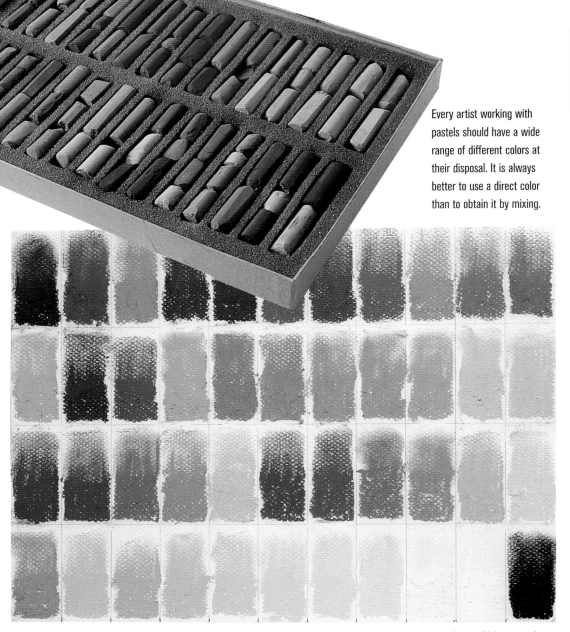

Every artist working with pastels should have a wide range of different colors at their disposal. It is always better to use a direct color than to obtain it by mixing.

For each pigment, manufacturers make lighter versions (by mixing the pigment with white) and darker ones (by mixing with black or another dark color).

Range of colors sufficient for any work. Most pastel artists have specific preferences for certain colors over others, which means that their palettes may have more shades of a particular segment of the color spectrum.

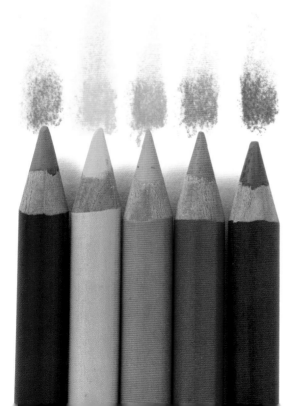

Pastel crayons

These instruments are crayons (a little thicker than normal ones) whose lead is a stick of hard pastel, harder than any other kind of pastel. This prevents it from breaking under the slightest pressure and enables it to sharpen like any crayon. They produce clean, clear lines. Pastel artists usually employ them in sketches, small-format drawings, or in the profiling and detailing of bigger works.

Combination of pastels

All professional pastel users own pastel crayons of three varieties: soft pastels for vibrant colors and covering large areas, hard pastels for the first stages of a drawing, details, and all kinds of grays and gradients that necessitate the presence of the stroke, and pastel crayons to outline the details, touch up, and finish off the drawing in its final stages.

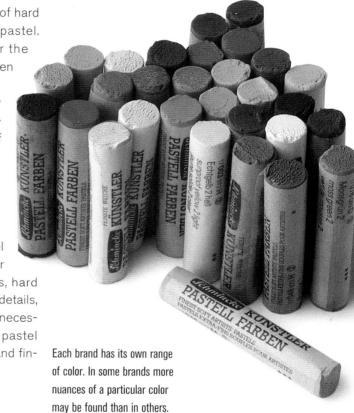

Each brand has its own range of color. In some brands more nuances of a particular color may be found than in others.

Pastel crayons are much softer than conventional color crayons and their leads are much more brittle.

Lines, marks, and mixing color

Artists apply pastels directly to paper rather than mixing them on a palette. This does not mean that, on occasion, we cannot mix colors with fingers or superimpose them on top of each other to create optical mixes (only appearing as a different color from a distance). A clean, bright result depends on moderate finger mixing, because the more it is mixed, the dirtier, grayer, and less transparent the color will become.

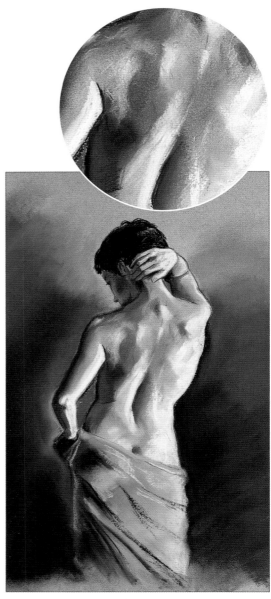

In contrast with freer and more spontaneous drawing, artists can also work meticulously to refine the subject and achieve very developed surfaces that suggest volume. Nude painted by Vicenç Ballestar.

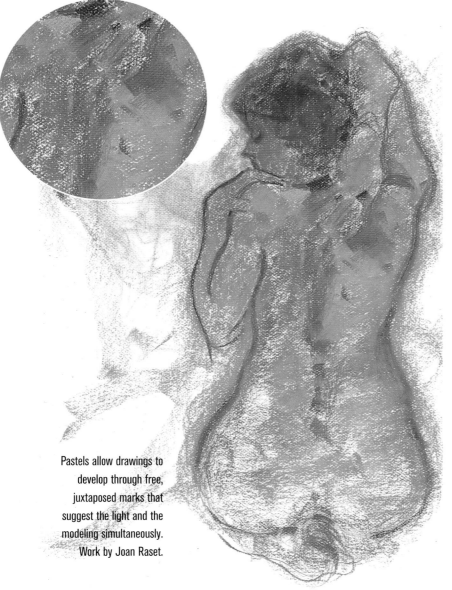

Pastels allow drawings to develop through free, juxtaposed marks that suggest the light and the modeling simultaneously. Work by Joan Raset.

COLOR DISTRIBUTION

Although you may have many different colors on hand, maintaining an organized palette is still necessary. This is for practical reasons; on one hand, it helps artists find a color easily; on the other, it prevents pastels from dirty by coming into contact with other colors.

Pure colors

Mixing colors only works well when there are not a lot of different tones in a drawing. The purity of tones and their direct presence on the paper, along with the vivacity of colored lines and marks, justifies using the pure colors of pastel. Excessive mixing contradicts the intrinsic properties of the pastels, one of which is the extreme vibrancy of their color. Their vibrant color is unsurpassable by any other medium. Instead of layering colors on top of another, try juxtaposing different hues to suggest a blend of color.

Free strokes

Instead of mixing colors, the pastel artist can apply them directly on the paper in small strokes, and marks, almost like an impressionist painting. In working through strokes, the lower layer of colors, including the color of the paper, appear through these strokes, creating a natural harmony between these layers.

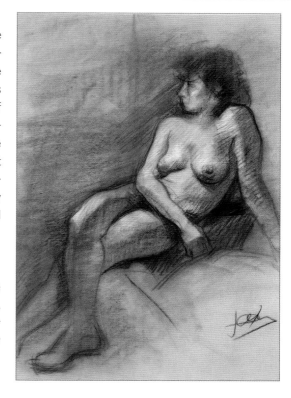

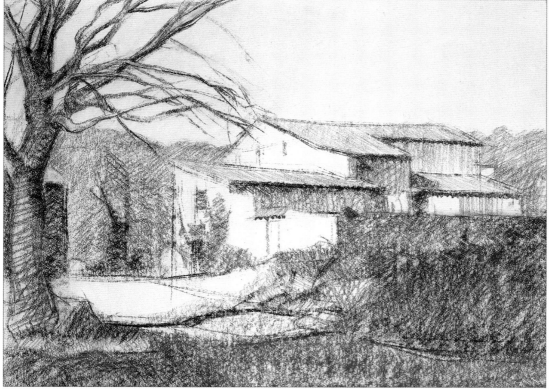

Pastel permits a direct translation of the drawing into color. The artist thinks in terms of drawing, but uses resources that are really those of painting. In this work by Miquel Ferrón, strokes and spots suggest a desire for line and color that is peculiar to all genuine drawing artists.

Pastel painting is basically drawing. Marks are not independent of lines, and, as it appears in this landscape, the play of contrasts characterizes all drawing techniques based on the counter-position of light and dark. Work by Joan Sabater.

Fixing and correcting pastels

Pastel drawings are quite fragile, in terms of their composition and conservation. They are difficult to correct, and brusque handling or careless storage will mar their appearance. It is key to make corrections by rubbing out and recomposing, and to stabilize the pigments on the paper.

Malleable erasers are useful for rubbing out a very fine layer of pastel. To erase areas of denser color that cover more, it is better to use rubber erasers.

Rubbing out pastels

As excessive rubbing of a pastel drawing affects the grain of the paper and the adherence of the pastel's pigment, it also leads to lifeless results. However, it is possible to detach the pigment from the paper without harming the work. At the start of the drawing or even when it is well advanced, some methods of detaching the pigment are possible. Rubbing a color with a clean rag or piece of cotton will detach the color from the paper. We can also loosen the pigment with fingers or, of course, with the malleable or rubber eraser. Exercise caution when using an eraser, as these can destroy the texture of the paper if not used gently.

To rub out completely dense pastel strokes, you have to be persistant with the eraser. At first, it will only spread the color; only after continuing with a delicate erasing motion will the strokes successfully detach.

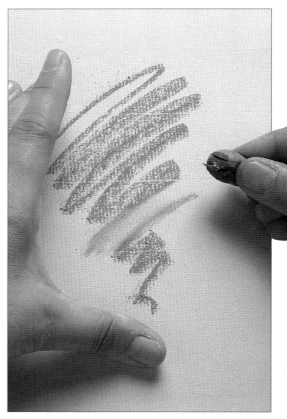

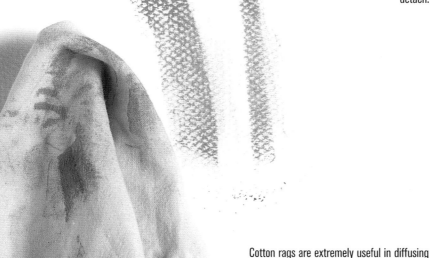

Cotton rags are extremely useful in diffusing and reducing the intensity of pastel marks.

Fixing pastel

Tradition urges not to fix pastel painting, although there are many practical reasons to do so. Currently, the market provides artists with top quality fixatives. These are available in aerosols that do not stain, nor alter the colors of your pastel drawing. Matte aerosols should be used, as their finish will not disrupt the texture or appearance of a drawing. After applying a very thin layer of fixative, it will still be possible to correct colors. When creating a work with many layers of color, it is advisable to apply the fixative to each layer while working before moving on to the next.

PAINTING ON FIXED PASTEL

If you want to draw with one color on top of another pastel color and prevent them from mixing, you can fix the first color to the paper before adding a second color. You can still go back and blur or blend these colors; the fixative creates a texture on which the pastel adheres very well, even better than on unmarked paper.

Once a spot is rubbed out, the paper remains slightly stained. It is impossible to recover its original whiteness, especially if vibrant colors are involved.

Pastel must be fixed very carefully. It requires several thin layers of fixative. It is important to let each layer dry before applying the next.

Oil pastels

Like dry pastels, oil pastels are color sticks. The difference lies in the thickener of the pigments: in oil-based pigments, thickeners can be waxes or oils. Wax crayons are usually associated with schoolwork, and were, in fact, invented for this purpose, while oil sticks and oil pastels are suited for professional work. Oil pastels can be of very high quality today, and they are ideal for drawings that require a wide range of vivid colors; their viscous texture and variety of pigments allows them to deliver dense strokes of some of the most vibrant colors.

Turpentine will dilute wax marks, which you can blend by rubbing fingers over them. As the marks are highly sensitive to heat, the temperature of fingers slightly melts them.

Sticks of wax pastel are usually smaller than oil pastels, which are available in large sticks that allow very thick lines to be drawn.

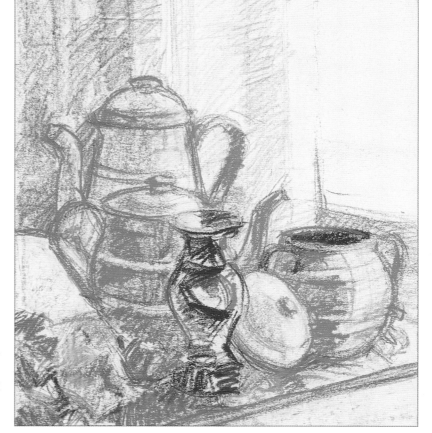

When used simply, color wax crayons give very light-filled, cheerful effects, as this work by Mercedes Braunstein shows.

Colored wax crayons

These originated in the 1920s, when a Japanese teacher, Kanae Yamamoto, first manufactured sticks of colored wax for school use. They are composed of pigment thickened with a mixture of paraffin, stearic acid, and coconut oil that allows the color to spread easily. They are not water-soluble, but can be dissolved in solvents such as turpentine. Because they are waxes, they are very sensitive to heat, including that which fingers produce. Color surfaces are transparent, luminous, and are hard to blend unless the colors are diluted or melted into each other. Water soluble waxes, made with a water soluble thickener called glycol, are widely manufactured today.

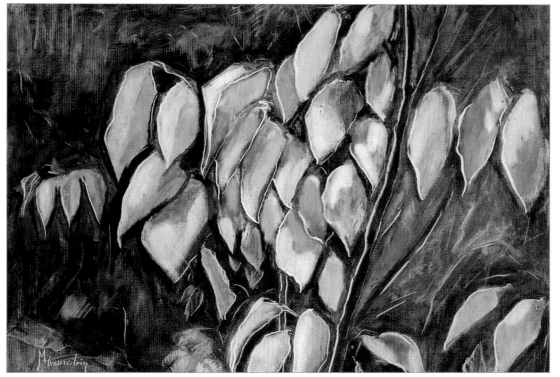

Waxes and oily pastels in general contribute to "special" effects of transparency and texture. In this work, a sharp instrument has scratched over the colors. Work by Mercedes Braunstein.

Unlike oil pastels, wax pastels do not dry out, so an aerosol fixative or layer of latex is necessary in order to prevent them from smudging.

Oil pastels

These are a high-quality offshoot from wax crayons. The sticks adhere excellently to almost all surfaces. Some varieties (oil in sticks) include drying oils to complete drying. Unfortunately, the color ends up drying in the stick, too, unless its storage isolates it from air after each use. The high amount of oily thickener they contain prevents dried colors from cracking.

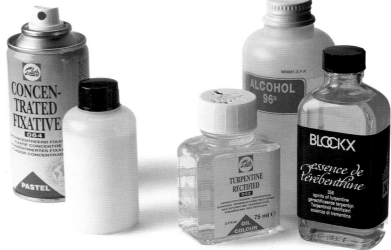

Supports for drawing with pastels

Paper for pastel drawing must have at least a slightly rough surface so that the pastel can adhere to it; the rougher the paper, the more pigment will accumulate, and the lines and marks will look more saturated. Professional pastel artists employ a wide variety of paper that ranges from the most conventional drawing paper to watercolor sheets with a large grain. In addition, some paper is specially treated with a special mordant to bind the pastel to the paper. Any paper is suitable for pastel drawing, except glossy or very smooth paper.

Pastels can be applied to any paper with a bit of texture. The result changes markedly from finer to rougher paper: there is always greater color saturation with a thicker texture.

Smooth paper

Finely-textured paper that is never totally smooth (card, recycled paper, or wrapping paper) provides for rapid coverage as it offers little resistance to the marks of the stick. These supports stain easily, as pastel slides well over them, but it is hard to paint several layers on top of each other because the grain will disappear after the first layer. When this occurs, the pigment particles find no roughness on which to attach, the paper does not retain them and the color flakes off after its application. Therefore, this kind of paper is only suitable for studies, sketches or work that requires very little composition and only a few applications of color.

Colored paper greatly helps to achieve harmony when working in a single range or searching for the most intense contrasts (between colors themselves and between colors and the color of the support).

HANDMADE PAPER

Handmade papers offer endless varieties of textures, tones, and sizes that multiply the options of the pastel artist, although not all of them are suitable for this purpose. Their artisanal finish, with uneven edges or irregularities of texture, makes them very attractive. In addition, the high quality of the materials used in manufacture and the absence of industrial chemical components make them highly recommended. However, they can also be very expensive.

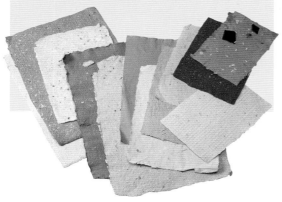

Rough paper

On roughly textured paper with a thick grain, it is more difficult for the color to fully cover all the small hollows that texture the surface. Therefore, it is easier to work in successive layers, which produce richer artistic results. Canson's multicolored paper is ideal for artists because of its texture and range of various colors. There are also special kinds of paper that rely on cork dust to capture pigment, making a fixative unnecessary.

Laid paper has a light texture with characteristic lines suited to grip color particles.

Canson paper is most popular among pastel artists who appreciate its characteristic texture. It is available in a broad range of colors.

Textured or engraved cardboard is a suitable support for pastels.

Some pressed wood makes a good support, although, in general, it requires preparation beforehand and proper priming.

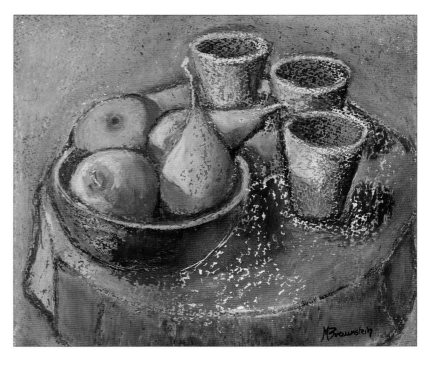

Oily pastels can be applied to all kinds of paper. Thick paper, like watercolor paper with a rough texture, adds a supplementary interest. Work by Mercedes Braunstein.

Colored inks consist of pigments or dyes. The latter are much more light-filled and transparent. The colors may be permanent, meaning they cannot be rubbed out or dissolved once dry, but they will discolor after prolonged exposure to light. The more transparent the coloring used to manufacture the ink, the shorter the permanence of the ink. The more transparent the ink is, the more it will discolor. In general, the fullest and most luminous ranges of colors are the most susceptible to color loss over time.

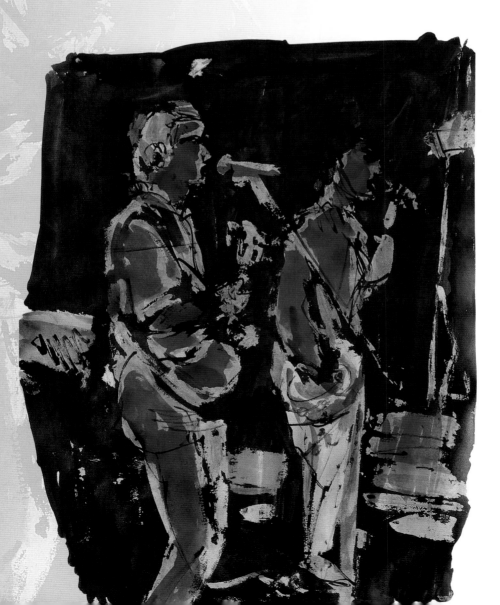

Colored inks are very similar to watercolors, although they are most notable for creating strong contrasts, rather than delicate nuances. Work by Josep Asunción.

The materials used for drawing with colored ink are very similar to those used in watercolor painting: the same or similar paper, water (distilled, in this case), brushes, and nibs or reed pens.

WHITE INK

White ink exists, although this seems to contradict the idea of drawing ink. Naturally, this ink requires dark paper, as is seen in the illustration by Mercedes Braunstein shown here.

Indelible and removable colors

All color ink is water soluble, although many inks are indelible. This means that, once dry, they remain permanently fixed to the paper, and, unlike watercolors, cannot be diluted again. Some inks can only be dissolved in distilled water, since tap water will separate the pigment from the thickener. To ensure the correct way to dilute ink, read the manufacturer's instructions.

Water does not affect indelible ink once it has dried. The image shows a piece of paper stained by ink and submerged in water. If this mark had been made with watercolors, it would almost be completely dissolved.

Colors running

Inks cannot be rubbed out unless the surface of the paper is rubbed with a blade, which is not a feasible method for eliminating areas any bigger than a small stroke. White paint (gouache, for example) can eliminate mistakes made with India ink. But such paint is not usually a good option for covering mistakes in drawings with colored ink, especially those inks that are dye-based. In most cases, colored inks run on the surface of the white paint, even when the white is applied over dry ink.

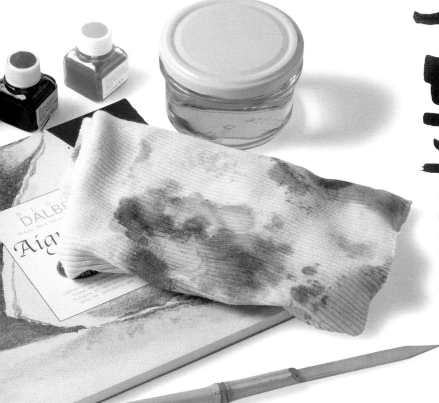

Running occurs when a spot of colored ink is covered with gouache: the color stains the white paint and becomes visible on the surface.

Samples of color of a full range of inks. Some manufacturers provide many more colors, but this selection is more than sufficient for general practice.

Mixing color

Drawing with colored ink has the same characteristics as drawing with India ink, with the sole exception that it requires a certain order and organization in your work process. Inks can mix with each other, but require great attention to avoid dirtying and muddying the colors. To maintain cleanliness during the process, it is best to use two nibs and alternate between light and dark inks. The nibs can be inserted in the same handle.

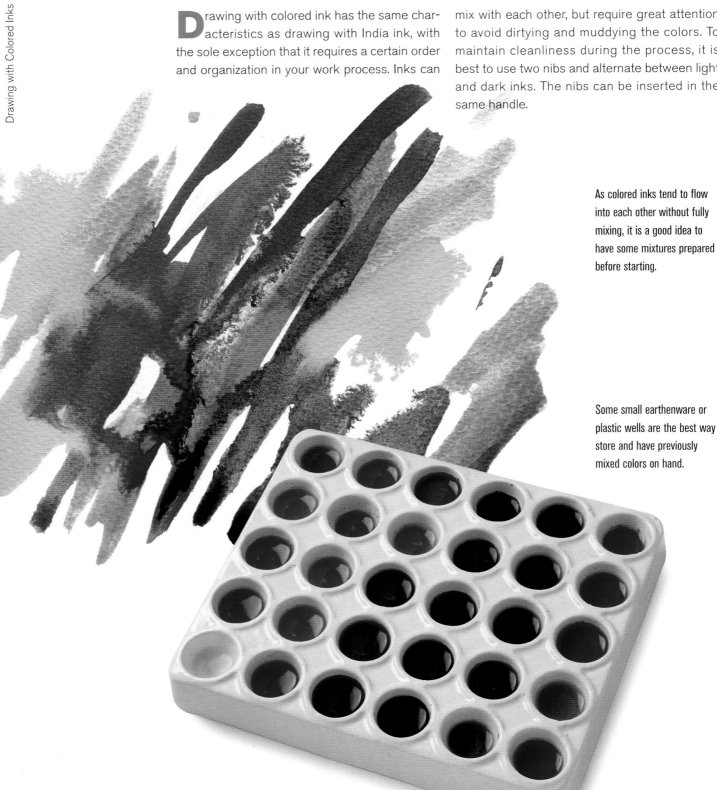

As colored inks tend to flow into each other without fully mixing, it is a good idea to have some mixtures prepared before starting.

Some small earthenware or plastic wells are the best way store and have previously mixed colors on hand.

Multi-colored cross-hatching and prior mixtures

Cross hatching consisting of different colored lines can be a way to achieve an optical mix, provided that these lines are not very thick. If the color stroke is very dense, its combination with other strokes will create darkening effects rather than mixtures of color. It is preferable to work with mixtures made ahead of time, such as small amounts of ink mixed in small pots that have perhaps been diluted with water. There are "palettes" with a number of wells for mixing color this way.

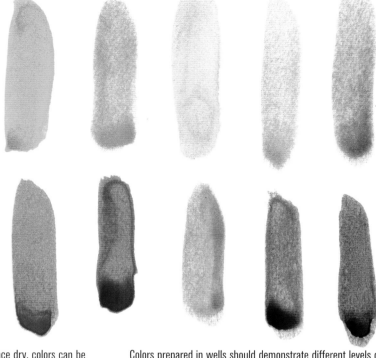

Once dry, colors can be overlaid, creating transparencies that serve as the best color optic "mixtures" that inks can offer.

Colors prepared in wells should demonstrate different levels of saturation by successively diluting the same color more and more. This will create a subtle harmony in the drawing's colors.

Colored inks have a saturated tonality that produces lighter values with each successive dilution.

Lines and brushstrokes

Combining lines and brushstrokes is one way to draw with colored ink. These brushstrokes can be highly saturated (without diluting the ink), or highly diluted in water. Colored inks have a certain transparent quality that is similar to watercolors when applied with a brush. However, they are more saturated and less resistant to light than watercolors. Using a brush to apply ink is similar to drawing with a nib or reed pen on damp marks, or spreading water with a brush over strokes of ink that are not yet dry. In both cases, ink spreads fluidly, creating diaphanous results and an overall richness.

Washes

Just like black ink, colored inks only require brushes and various amounts of water to gradate their tonal intensity.

Washes with colored inks look like watercolors, but also exhibit marked differences. Most ranges of inks available on the market are much more limited than ranges of watercolor, and diluting inks in water has certain drawbacks that working with watercolors does not entail.

Thinning color

When creating ink washes with a brush, it is necessary to dilute the ink in order to achieve a more transparent color. The amount of water must be just right: too little water will hardly affect the color, while too much will wash out the color. It is a good idea to have a medicinal dropper (sometimes included in the lid of the bottle) to be precise when adding water to colored ink.

An almost-single-color wash done with colored ink by calibrating the solution of ink and water very carefully. Work by Joan Sabater.

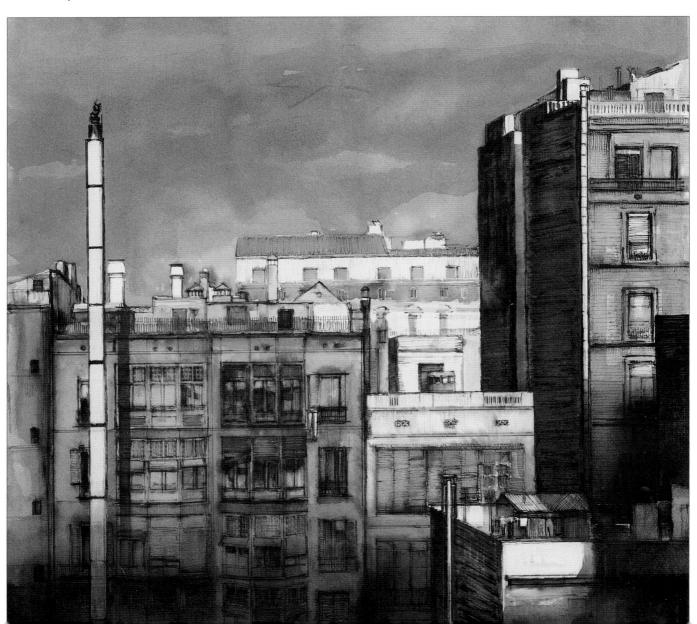

Direct mixtures

Mixing color directly on the paper is an option for colored ink washes, but too many layers of ink will produce very dark and undefined hues. In addition, dye-based inks do not mix well (worse than watercolors), and some colors may flow into others unintentionally, creating multicolored water rather than actual mixtures of color. .

TRANSPARENCY

Placing one color of ink on top of another when the first color has dried fully usually yields desirable results, since dye-based inks are very transparent and indelible. The effects are intense and luminous.

The washes in this drawing used a limited range of inks. The drawing benefits from a control over the tone and level of dilution for each ink. Work by Mercedes Braunstein.

Mixtures made directly on the paper cause unforeseen, chance results that may result in new ideas and directions of the work.

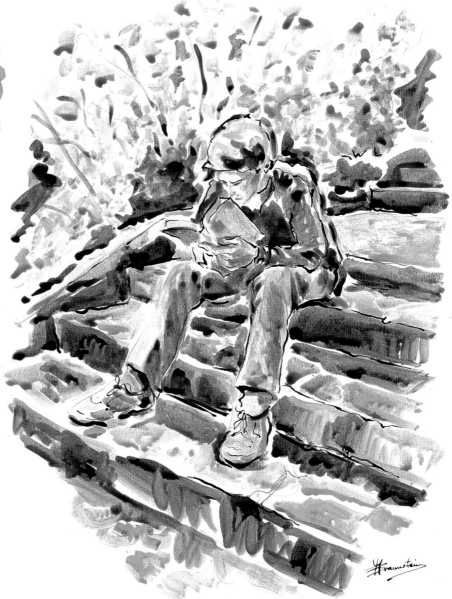

An energetic and expressive ink wash based on small contrasts produced by direct application of ink. Work by Gemma Guasch.

Paper for colored inks

All the kinds of paper that are suitable for drawing with black ink are also suitable for colored ink. In fact, the drawing instrument rather than the medium itself determines this. Nibs require smooth and rigid supports, where-as brushes need more absorbent paper. Whatever the tool, the support must have the right degree of absorption so as not to hinder the work.

Smooth papers provide the opportunity to create surfaces with a very homogenous color, as well as those with a delicate, faded cover created by a sponge. Work by Gemma Guasch.

Smooth paper

The low porosity of smooth paper is conducive to working with nibs. The metallic tips slide easily over the support, yielding precise lines. These surfaces are suitable for working with hatching, as the lines do not bleed once applied, thereby guaranteeing the clarity and precision of the hatching. This kind of paper is not as amenable to brushwork, since thicker marks made with a brush can form puddles and slow down the drying process.

Fine-grain watercolor paper yields good results with colored inks. Besides the highly saturated colors the inks produce, a colored ink drawing on watercolor paper resembles a watercolor painting. Work by Josep Asunción.

Watercolor paper

Watercolor paper is best for brush drawing with colored ink. Watercolor paper with a moderate grain and absorbency gives the best results when used in combination with colored inks, a medium that has many of the same properties as watercolor.

Thick-grain watercolor paper absorbs more ink and the colors are less luminous, but the overall work acquires greater depth, density and texture. Work by Josep Asunción.

Rough or craft paper lends itself to experimentation with textures, absorption and finishes. This work by Gemma Guasch goes beyond drawing and fully enters into the realm of non-figurative painting.

DRAWING WITH MARKERS

Originally, markers were conceived for illustration or advertising work, which required intense colors, clear contours, and ink that was compatible with photolithographic reproduction. Similarly, markers provide artists with an agile, direct way to draw lines, though making spots and stippling with them is more laborious. Today, although computers have displaced markers for technical purposes, they are still widely used in artistic drawing.

Markers are an agile, uncomplicated drawing medium. They do not need sharpening and carry their ink inside. Many artists use them for outlines or sketches, but they can also be used in patiently constructed drawings, such as this one by Josep Asunción.

Function

A marker is a cylinder of metal or plastic that contains a synthetic fiber sponge soaked in ink. Ink rises by to the tip of the pen through a filter or polyester wick with furrows that let the ink flow to the tip. This is the inside of a conventional marker for drawing. Fine-tip pens designed for writing contain liquid or semi-liquid ink that reaches the tip by force of gravity.

The mechanics of a marker are very simple: its cylinder contains an ink-soaked wick that comes into contact with a thin piece of polyester or felt (the tip of the pen) which carries the ink to the paper by capillarity.

The use of marker pens

Markers are a very effective and practical medium for color or black and white sketches. The ink dries quickly, solidifying the line and coloring wide surfaces in a clean and uniform tone. As its ink is self-feeding, it needs no additional tools to sharpen its tip. In addition, colors can be drawn on top of each other, as they do not run or change tones over time. The finishes of the drawings created with markers vary depending on the ink employed, but it is usually semi-opaque or transparent with almost perfect homogeneity of tone and marked luminosity in their color.

This studio is full of markers. Color ranges are very broad and the artist can find the right color without having to mix two different colors.

There are many varieties of markers as specialist manufacturers provide considerable ranges. Drawing with markers requires nothing other than the pens and paper.

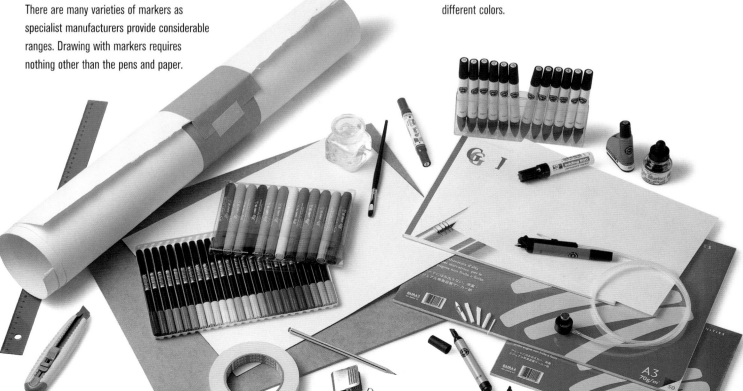

Varieties and uses of markers

Although there are special versions, nearly all markers can be divided into two groups: water-based and alcohol-based. The latter is available in most colors (up to 500), which means that artists can avoid the complex task of mixing. However, the most common markers are those used in schools. These are water-based and, despite looking very simple, can still make complex sketches.

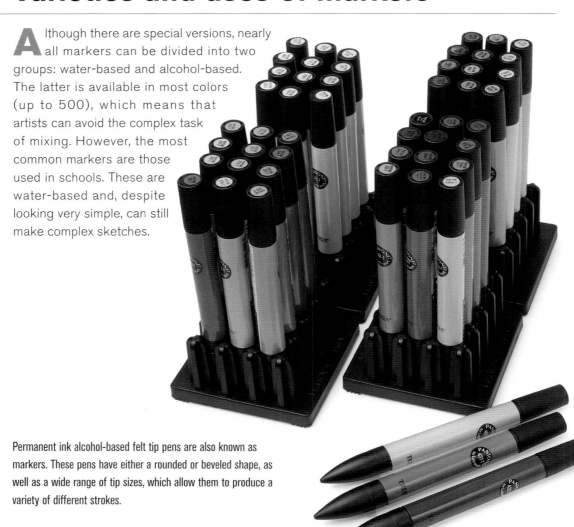

Permanent ink alcohol-based felt tip pens are also known as markers. These pens have either a rounded or beveled shape, as well as a wide range of tip sizes, which allow them to produce a variety of different strokes.

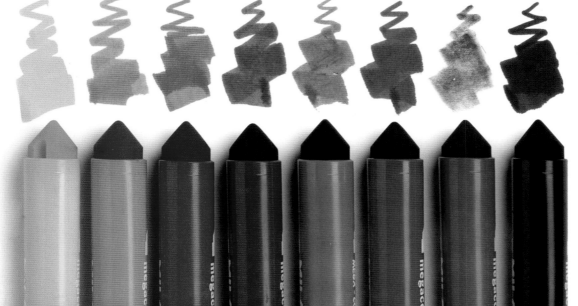

Water-based markers with a thick point are suitable for school use and are also useful for medium or large-scale sketches.

The various models of alcohol-based markers include double-tipped pens. At one end they have a fine, round tip, while at the other they have a beveled tip for drawing thick lines.

Alcohol-based markers

The ink they carry is usually a colorant diluted in xylene, an alcohol, which evaporates and dries rapidly. Once dry, the ink is indelible (it can tolerate other colors drawn over it without its color running or mixing), but fleeting; works done in marker pen do not tolerate sunlight well and discolor. Tones are usually transparent, meaning that these markers yield their best results on white surfaces, which lend luminosity to the color.

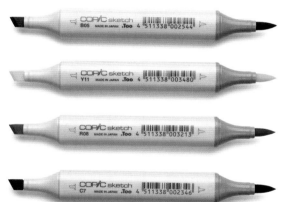

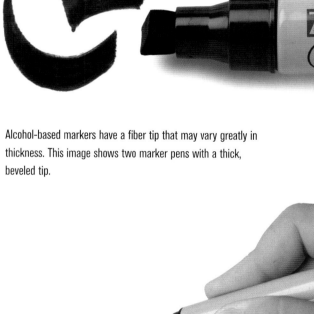

Alcohol-based markers have a fiber tip that may vary greatly in thickness. This image shows two marker pens with a thick, beveled tip.

Water-based markers

Water-based markers are for children's use. Strokes dry more slowly, and some colors may change when applied on top of others. They are also suitable for making sketches and studies. Some manufacturers sell water-based markers that are loaded with a pigment similar to gouache. This type of ink makes their color opaque, and yields excellent results in works that require solid, homogenous blocks of color.

In these images you can appreciate the lines that the edge of the tip held flat, in a perpendicular position, can achieve.

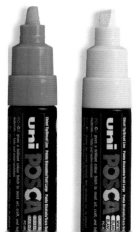

There is a special kind of water-based markers: a pen with an opaque stroke. These markers are loaded with diluted gouache, which allows for light tones on colored surfaces.

Techniques for drawing with markers

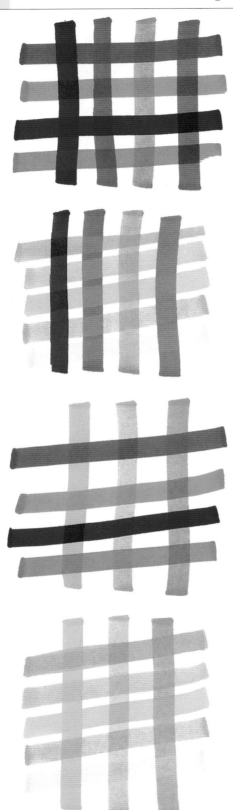

Like crayons, markers can draw over each other, with solid strokes of color. In general, they are not amenable to excessive mixing unless (if they are water soluble), they are diluted with water. Even so, dark colors always dominate light ones. Because the color of markers and the thickness of their stroke does not depend on how much pressure is exerted by the artist, each marker yields only one tone. Thus, it is necessary to have a set of markers that encompasses a wide range of colors.

Direct mixtures

Direct color mixtures involve putting one color on top of another. This technique is practical when working with colors in the same range or when darkening tones. It is not effective when seeking a homogeneous mixture (one in which two superimposed colors yield a third color). Creating direct mixtures with markers tends to darken and muddle tones.

If you are trying to darken a tone, creating a direct mixture with markers is an effective way to do so. Beginning with the color you would like to darken, apply another tone on top of it, usually a darker one. This will result in a darker, opaque color.

When working with colors in the same range, ones that are similar in tone and ink, direct mixtures are perfectly viable because there is not a wide margin for dirtying the coloring or obtaining an unwanted color.

Mixtures with water-soluble markers

Like water soluble crayons, markers that contain water soluble ink can lead to results similar to those of watercolors. However, in the case of marker pens, inks are much more intense, less transparent, and less suited to the effects of a wash. You should only dilute small areas of marker, and it is not advisable to apply excess water in trying to spread color.

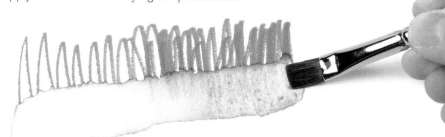

RESERVES

Reserves are a common way to define and outline shapes against a dark background. The reserve respects the delicate shades in a technique with colors that provide little coverage. This resource demands foresight of the artist in their work process, anticipating and respecting the areas on which they will work with pale shades.

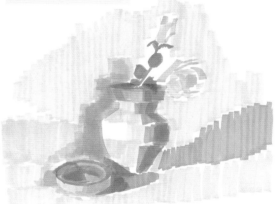

Hatching with strokes is a fundamental technique of drawing with markers. The transparency of the color means that overlays create darker areas and avoid the potentially mechanical style to which this technique can lead.

Used in small areas of the drawing, water-based markers produce effects very similar to those of watercolors. These effects become less exciting when trying to spread large washes of dissolved color.

Employed with energy and freedom, the strokes of markers enliven the surfaces of the drawing, appearing to be a combination of a crayon and ink drawing. Work by Josep Asunción.

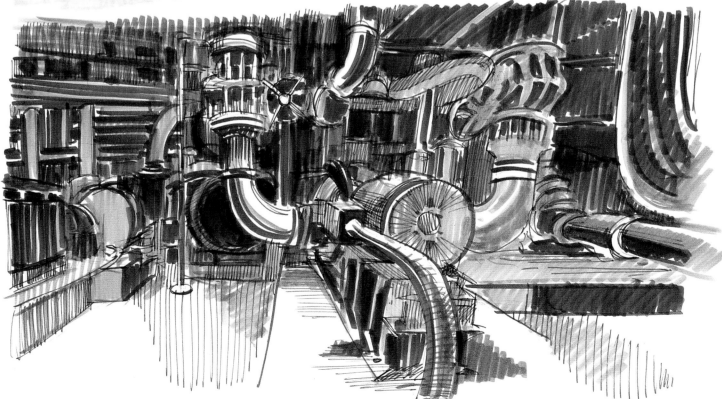

Writing and lettering tools

We place the fine tip tools normally used for writing and creating more precise works under the category of marker pens. There are numerous varieties on the market that use water-based inks, alcohol, oil inks, and gels that change color upon coming into contact with the air. Lithographic pens or marker pens with a calibrated tip allow for lines of a constant thickness and perfect stability. In general, ballpoint and lithographic pens offer a neutral, steady line, but their ease of use and wide variety of colors make them very appealing to artists.

The common ball-point pen is one of the most economic tools used for drawing. It works on almost any surface and is very agile in drawing sketches.

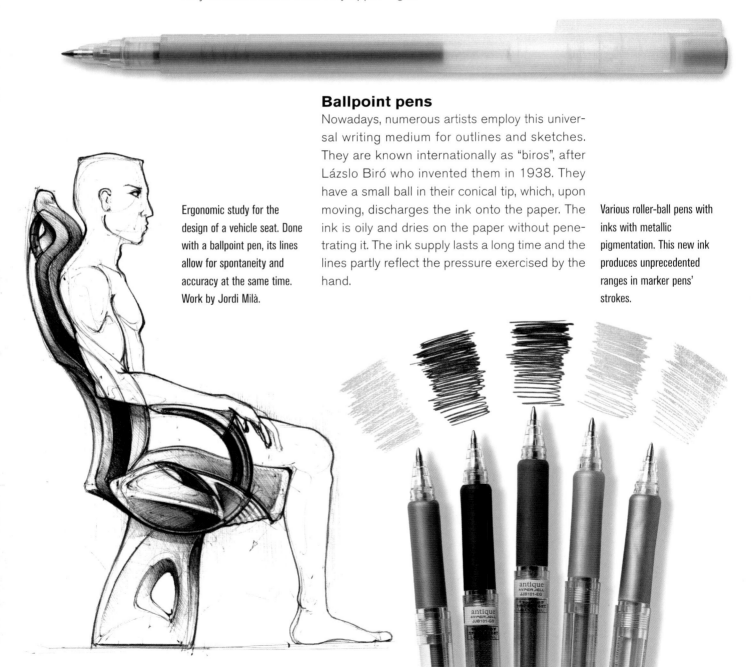

Ballpoint pens

Nowadays, numerous artists employ this universal writing medium for outlines and sketches. They are known internationally as "biros", after Lázslo Biró who invented them in 1938. They have a small ball in their conical tip, which, upon moving, discharges the ink onto the paper. The ink is oily and dries on the paper without penetrating it. The ink supply lasts a long time and the lines partly reflect the pressure exercised by the hand.

Ergonomic study for the design of a vehicle seat. Done with a ballpoint pen, its lines allow for spontaneity and accuracy at the same time. Work by Jordi Milà.

Various roller-ball pens with inks with metallic pigmentation. This new ink produces unprecedented ranges in marker pens' strokes.

Rollerball pens

Rollerball pens developed from ballpoint pens and seek to combine the benefits of the latter with the softer stroke of lithographic pens. A rollerball's mechanism features a ball contained at the end of a conical tip. Their water-based and more fluid ink, which renders them lighter to handle and thicker in stroke, distinguish rollerball pens from ballpoints. Its ink, normally pigmented, delivers a livelier in color and penetrates the paper's fibers, making it more permanent. It discharges more ink than a ballpoint and runs out of ink more quickly.

Many creators use lithographic pens for inking the cartoons in comic strips. Their line is clean and maintains a constant thickness.

Fine needle-point: lithographic pens

Lithographic pens are lettering tools with a calibrated tip in various sizes. They have a cylindrical, nylon tip similar to a needle whose line is softer, more accurate, and usually finer than lines produced by more conventional rotating pens, also giving them the name of "fine-point pens." Their ink is normally a pigmented black, which means that the stroke gives an intense black, very similar to that of India ink. This intensity and the softness with which they slide over the paper makes them attractive to many artists.

Needle-point lithographic pens with a standard line ranging from 0.2 to 0.8 mm thick.

Lithographic pens or fine-point marker pens favor detailed drawing, but also produce good results in sketches and outlines.

Lettering instruments are widely used in drawing comics. Their ease of use and cleanness of result make them irreplaceable.

Supports for drawing with markers

Paper is the only support for drawing with markers. The paper must be smooth, glossy, or have a very fine grain for all marker pens with alcohol-based inks. Water-based markers work successfully with conventional papers. These papers can even be slightly rough if the artist seeks a visual effect other than the stark graphic nature associated with drawing in this medium. The thickness of the paper is not as important as it is to other drawing mediums, since alcohol-based inks barely penetrate the surface of the paper, and water-based inks do not contain enough solvent to warp the piece of paper.

Paper for drawing with markers is always white or, at least, off-white.

Paper has a very smooth surface, which is also suitable for drawing with markers. It is available in small or medium-sized sketchbooks.

Bristol paper is a good support for drawing with markers. Its surface is glossy and a heavier weight than most papers.

Paper for alcohol-based markers

The ideal paper for markers with an alcohol-based ink is typically glossy in order to achieve finishes without irregularities, which would have been caused by small variation in the sheet's grain. The thickness of the paper that is ideal for markers ranges between 70 and 90 gsm, meaning it is quite a fine, light paper. Semi-transparent paper that permits certain translucent effects is also available. The ink of the marker will not penetrate the paper. Instead, it dries on the surface of the paper very rapidly. Finishes are smooth and any examples of cross hatching will be transparent, revealing all successive layers of line.

Paper for water-based markers

Any paper that is not excessively fine is suitable. Fine-grain watercolor papers weighted at 300 gsm give the best results. This weight is important when diluting ink, as well as when working with markers to create special effects, as well as when working with marker pens in a more traditional manner. The same applies to the paper recommended for working with opaque marker pens that are loaded with gouache. Papers that are textured or have a thick grain are only advisable when seeking deliberately imprecise or textural results.

Water-based marker pens require a slightly absorbent paper to ensure the rapid fixing of color on the surface. Smooth papers cause unforeseen puddles and muddled effects.

Alcohol-based markers require smooth or glossy papers to conserve an even, consistent stroke, and to achieve a smooth, luminous effect.

A small amount of the paper's texture is visible when working with marker pens. The effect can be very interesting for work that does not demand a perfectly smooth finish.

When working with fine tip water-based markers, it is important to avoid thick-grain paper. Smooth watercolor paper is the best choice.

DRAWING

- Objective drawing
- Drawing in perspective
- Modeling and shading
- Studies, and sketches
- Subjective drawing

This section details the methods required to complete a drawing: from blocking in shapes, to creating perspective, as well as techniques for shading and modeling. It is divided into five parts, each of which discusses a drawing style. The techniques an artist employs in a work strongly depend on their own expressive intentions, which define a particular stylistic and creative tendency. Thus, an artist inclined to represent subjects precisely and realistically will avoid techniques that obscure a clear and faithful representation of a subject. Contrarily, an artist who pursues subjective expression will not follow the rules of perspective and objective drawing.

Studied individually, the basic techniques of drawing come across in a new light. Although individual methods, they are all related to particular styles and ways of working. In exploring these different styles, readers will be able to rapidly identify the styles, techniques, and subjects that are closest to their own interests and tendencies.

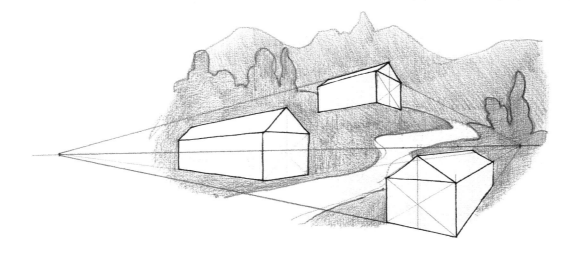

Techniques

OBJECTIVE DRAWING

Objective drawing is a neutral description of a subject, and strives to capture the natural appearance of this subject accurately. Strict description of the most significant aspects of the subject characterizes objective drawing, which ignores circumstantial features such as light or the appearances of surfaces (which always depends on the light. Therefore, objective drawing is essentially linear, defined by realistic contours, scrupulous details and very precise strokes commonly seen in technical or mechanical drawings.

Albrecht Dürer, *Six goblets*, (1501-1550). Accurate and meticulous lines that,
while faithful to the subject, maintain their own vitality.

Objective drawing describes the basic shape of objects, employing essentially linear mediums that only describe the contours of the subject.

Objective Drawing **99**

The essential and the secondary

We perceive real objects as full of details and changing appearances (their shadows and lights, their shape varying according to the point of view, etc.). Not everything can, or should, be visible at the same time. The idea is to "see" this drawing beforehand, hidden as it is under visual information of every kind. This information includes lights and shadows, perspectives, flat and curved surfaces, diverse materials, colors, shiny parts, transparent bits, etc. All this distracts our attention from what is really crucial. The characteristic appearance of an object makes it interesting, and permits us to identify it at once.

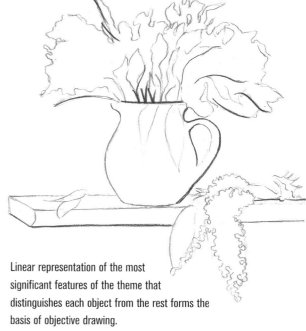

Linear representation of the most significant features of the theme that distinguishes each object from the rest forms the basis of objective drawing.

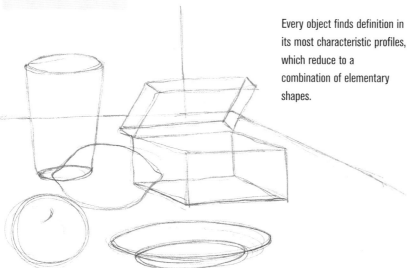

Every object finds definition in its most characteristic profiles, which reduce to a combination of elementary shapes.

The synthesis of shapes

There is scarcely any need to know how to draw to achieve this: a lemon will be an ellipse with two protuberances at its ends; the silhouette of an apple recalls a heart; a glass is a transparent tube, wider at the top etc. The simpler the drawing, the easier it will be to recognize the object. The goal is to reduce the representation of each object to a shape that immediately communicates the object's particular form.

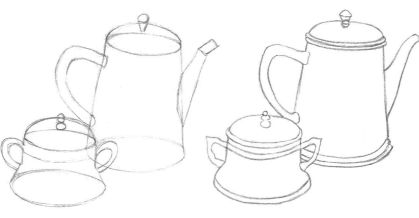

The search for the essential in the theme demands a representation of basic contours and profiles, without references to the light or other fleeting aspects. In this case, the drawing ignores the complexity of the play of shiny spots and reflections on the surfaces of the model.

Stencils and ruled patterns

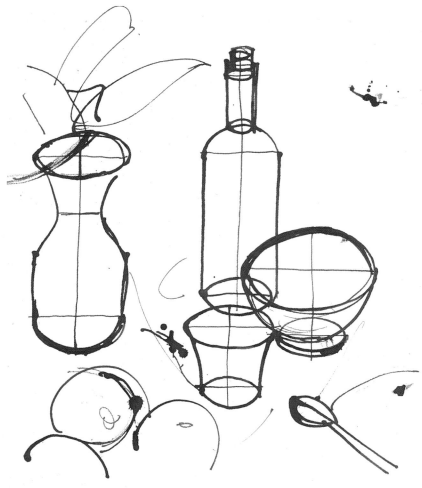

Proportion, the dimensions of shapes and the general organization of the drawing are easier to achieve with the help of stencils, transparent paper or any linear framework that enables the artist to compare some lines with others, calculate distances and adjust proportions. Such transparent paper can simply be a closely woven grid of right-angled lines (a ruled pattern), the diagonals on the paper, or two straight lines (vertical and horizontal) that cross in the middle of the piece of paper.

The drawing of symmetrical objects involves drawing, their line of symmetry.

Symmetrical objects pose difficulties for inexperienced artists. To center the drawing on the paper and achieve symmetry, you simply need to trace the diagonals and the vertical axes on the drawing paper.

PATTERNS AND
SYMMETRIES

Exercises in drawing sym-
metrically can be prac-
ticed with real objects,
free interpretations of
these objects, or imag-
ined objects. Any line
drawn by chance on
arithmetical paper is easy
to repeat symmetrically if
we decide the position of
a vertical line separating
the two halves.

Patterned paper

It is easier to achieve symmetry and accurate proportions in the drawing if you use patterned paper. Simply by counting the squares on the transparent paper, you can achieve perfect symmetry and the correct proportions. By practicing this exercise, you will soon be able to draw objects reduced to their essential shapes, and in the right proportions, by freehand. Pages from exercise books or quadrille-ruled graphing paper are very useful for this purpose.

Line of symmetry

Most, though not all, objects are symmetrical. When drawing on arithmetical paper, perfect symmetry results from counting squares to both sides of a symmetry line drawn in the center of the drawing paper. These symmetry lines are useful both for drawing on transparent paper and on paper without guidelines.

Quadrille paper is particularly useful for copying other images of the same or different size. The constant proportions of the squares gives the artist precise references of each place on the drawing.

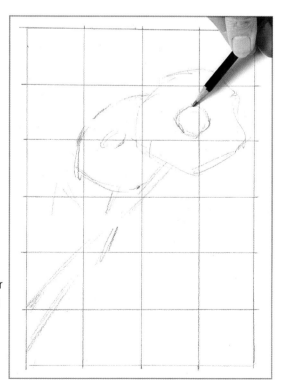

To faithfully translate a printed image into a drawing, draw a ruled grid on a copy of this image. Draw the same grid on the piece of paper on which your drawing will appear, copying the visual information as it appears in each square. When the drawing is complete, erase the lines of the ruled grid.

Elementary forms and geometry

Engraving by Lorenzo Sirigati (*The practice of perspective*, 1596), which shows five regular polyhedrons. The elementary shapes are the best general way of tackling proportional representation of objects.

Some of the elementary solids are prisms, cylinders, cones, spheres, etc. These shapes are, in some way, the general shape of any subject's form. Drawing them correctly is the essential step prior to mastering the form. Once these elementary shapes are understood, it is much easier to move to the full drawing of each element. This process, called blocking in, is the simplest and most practical way of tackling the representation of any still life with some guarantee of success.

The representation of objects through regular shapes is obvious when these objects already have these shapes. The slight geometrical adjustment of the shape means that each part will have the right proportion within the overall composition.

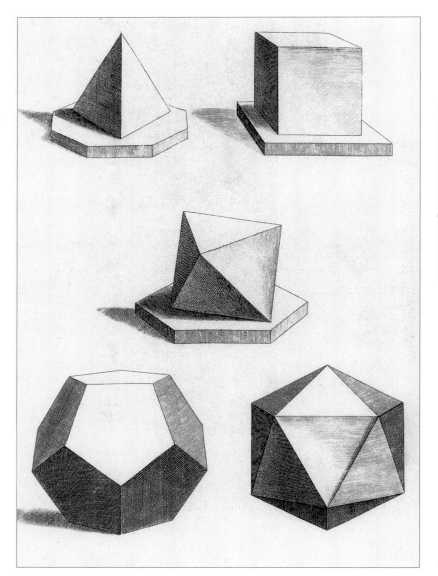

Drawing Process

Patterned paper facilitates drawing simple shapes on paper with guidelines, but, by keeping the hand steady, it is also possible to draw on conventional drawing paper with no need to use transparencies. The first step is to draw the contour lines while taking care to keep the size of each piece in the right proportion. Circles and ellipses can follow after tracing perpendicular reference lines. Going over all the visible lines again with more energetic strokes completes the drawing.

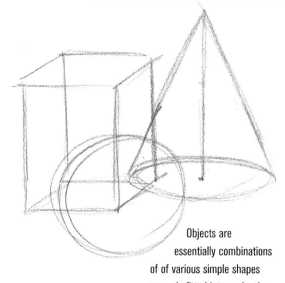

Objects are essentially combinations of of various simple shapes properly fitted into each other.

If the artist is able to draw the basic forms in the correct proportions by freehand, they can also represent any other shape.

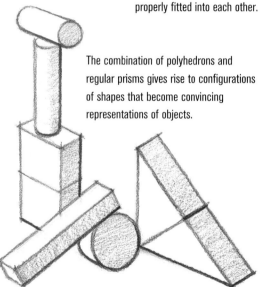

The combination of polyhedrons and regular prisms gives rise to configurations of shapes that become convincing representations of objects.

Combining simple shapes

Representing different aggregates or assemblies of shapes seen from different angles makes drawing simple solid objects exciting. Each combination may suggest the shape of a three dimensional object or simply compose an interesting grouping that inspires a composition. Drawing from just one elementary body (a tetrahedron) is easy and useful to master, as it highlights the fact that objects are simply more or less complex groupings of shapes.

Blocking in the drawing

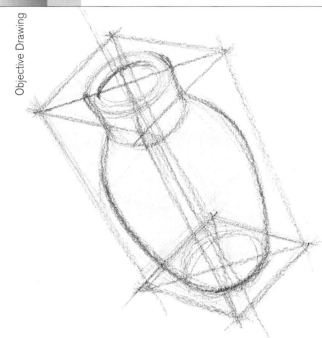

Blocking in means dividing the drawing into geometric segments. This is exactly what has to be done as a step prior to drawing any real object. These segments must be right for the shape and size of the subject, a condition that requires planning before blocking in the drawing. This way of working ensures that the proportion and position of each subject are correct before its actual contours are drawn.

Blocking in means drawing the geometrical shape (flat or otherwise) that best contains the shape of the object to be drawn. In this case, a prism captures the overall height and width of the vase.

The groupings of objects or complex groups are blocked in as simply as possible, and must include the general dimensions and the overall shape of the subject.

The next step from the blocked in shape to the representation of the object is to adjust the contours of each part to the general shape, which leads to the completed drawing. Work by Mercedes Gaspar.

The process of blocking in the drawing

The first step is to draw the appropriate diagram of the solid object: a tetrahedron, a cylinder, a pyramid, a cone, etc. Keep in mind that the diagram's limits and dimensions must correspond to those of the subject to be blocked inside of it. With this done, continue to adapt the contours of the object inside as if it were wrapped in paper or cloth: we do not see its details, but can guess at its general shape. Once this approach is complete, all the details can characterize the motif, with the certainty that all the general dimensions are correct.

Blocking in simple objects

In general, one or two simple shapes are sufficient to block in any simple object (bowls, kitchen utensils, fruit, etc.) Cylinders and ovals are the most common shapes. Regardless of the shape used, the most important thing is that the drawing is correct and shows no deformities, in order to maintain the drawing's objectivity. Similarly, the correct proportion of the blocked in shape—the relationship between its height and width—is a decisive factor in the correct outcome of the drawing.

In this example of blocking in, the vertical and horizontal lines that have allowed the ordered distribution of all the objects in the composition are visible.

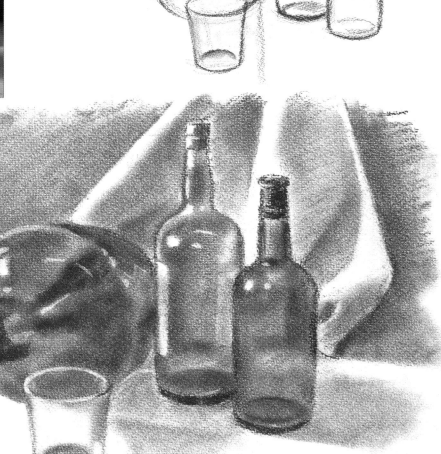

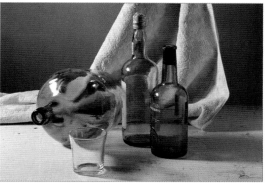

All the shapes in a conventional still life are conducive to blocking in through a balanced and correctly proportioned assembly of simple shapes.

Elaboration on the work can feature more or less detail, but the drawing can only sustain this if it has been properly blocked- in to begin with.

Process of blocking in the drawing

Although the concept of blocking in does not depend on the drawing technique chosen, putting it into practice does depend on the type of drawing that is sought. It is also necessary to distinguish between stroke and line; line is a continuous mark that may include bends and many changes of direction, while a stroke is a short mark in just one direction. These distinctions will be useful in studying the types of blocking in that work with different types of drawings.

The blocking in of this figure mixes with its real contours because of a drastic simplification of the anatomical features, a characteristic that charcoal exaggerates. Work by David Sanmiguel.

Blocking in with strokes

One of the simplest and most effective methods of blocking in involves using small pieces of charcoal to trace simple shapes from thick strokes. You can place a piece of charcoal flat on the paper to create very wide strokes. Once the shapes for blocking in the drawing have been established, a soft pencil or a charcoal Conté pencil can define the real contours of the subject by drawing over these charcoal strokes. Even after rubbing over everything with a cotton cloth at the end, the fine line drawing remains and stands out over the larger, more general shapes.

Blocking in with charcoal is always energetic. The strokes construct simple forms that outline the subject with highly contrasting profiles. Work by David Sanmiguel.

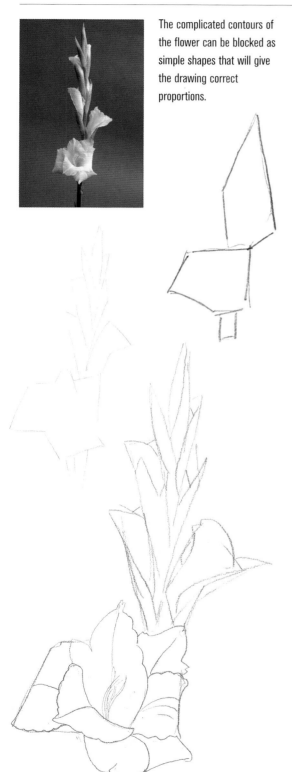

The complicated contours of the flower can be blocked as simple shapes that will give the drawing correct proportions.

Blocking in with pencil and pen boxing

Blocking in with lines is less effective than blocking in with strokes, which provides the drawing with a certain complexity. The artist needs to work to build up the shapes and contours of the drawing in detail; the drawing's geometric origin will be less obvious if strokes block in the initial drawing. This is particularly true when creating a drawing with a medium that produces very fine strokes, such as nibs, or pencils with harder leads.

When working with a pencil, stepping from the general to specific aspects of the shapes should be fluid. It should not be necessary to rub out the blocking in of the drawing or its initial framework—these lines should integrate into the final drawing. The step from the general shape to the specific profile of the theme is, when working with a pencil, much more continuous, so that, without having to rub out the prior blocking, its lines integrate perfectly into the final drawing.

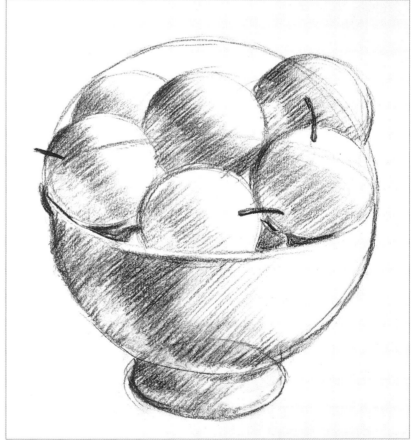

The insistence on strokes in the order of geometrical shapes does not distract from the delicacy of the drawing's framework, which is based on a selection of ordinary shapes. Work by Óscar Sanchís.

Descriptive lines

Objective drawing is linear work. The line encloses all the figurative information and grace of the subject. In this type of work, the drawing medium is extremely important, as lines and strokes determine the character and emphasis of the drawing. While charcoal provides a thick, warm, and not very accurate stroke, nibs give a cold, accurate, and precise stroke. Normally, beginners would start with pencils, preferably with a soft lead, which provide a dark, thick stroke.

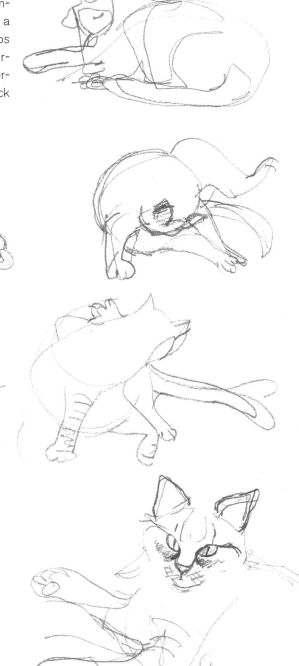

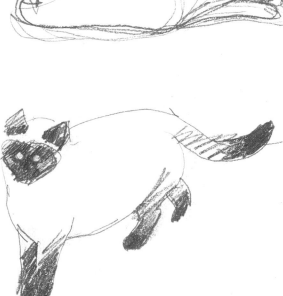

In this subject, the line is an unbeatable method for conveying the movement, dynamism and the grace of the animal's shape. Work by Mercedes Gaspar.

Lines and strokes

Despite their formal similarity, lines and strokes are different aspects of drawing. Lines define precise and closed contours, whereas strokes suggest open shapes. A stroke is an accent that suggests an essential feature of a shape. The type of stroke may vary a lot: it can be angular, like a comma, curved, etc. Normally, its shape repeats throughout an entire drawing.

In this landscape, everything has been resolved almost without the pencil leaving the paper. The drawing is practically one continuous line. Work by Mercedes Gaspar.

Drawing Composition

The lines of the drawing not only permit the definition of the contours, but also organize the drawing within the paper's limits. The longest strokes of a drawing are those that mark its basic directions and establish the framework for the rest of the shapes in the work. The distribution of master lines in the drawing must establish various, well-marked directions, avoiding constant reiteration of the same orientation.

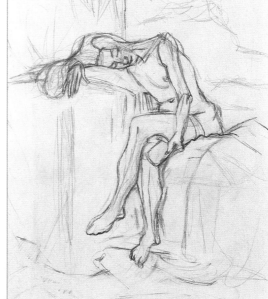

Human figures are also subject to interpretation through lines alone. This style reveals human anatomy in a rhythmic and stylized way. Work by David Sanmiguel.

Composing and blocking in with pencil

This exercise, composed by Almudena Carreño, shows the process of constructing a drawing from the geometrical framework of the subject to its final development. These stages are common to all drawing work, and are demonstrated on these pages in detail. The blocking in that was earlier described is now put into practice.

THE SUBJECT

STAGE 1:

GEOMETRICAL
BLOCKING IN

1. The axes of symmetry of the piece of paper are very useful guidelines for adjusting the boxes of the objects in a centered composition, and for keeping them proportional to the size of the paper.

If we take out the lights and shadows, the folds and other tiny details, the subject becomes very simple. Mental abstraction from secondary features is an essential step for mapping out the drawing.

2. The proportions of the blocked-in objects are essential for achieving a drawing that echoes the actual contours and shapes of the subject. Lines must be as simple as possible, avoiding unnecessary details. The pencil employed in this drawing is an HB.

3. Maintaining the simplicity of line, draw the main stalks of the flowers, establishing their general proportion to the rest of the drawing.

Blocking in and distributing space are integral steps in composing a drawing. While experienced artists may be able to do so mentally, it is still necessary to perform these steps.

STAGE 2:

LINEAR RESOLUTION

4. Once the plant's main stalks have been drawn, start to include some details, such as the small flowers and leaves that cover them. There is no need to draw them all, only those that are sufficient to "dress" the composition.

5. With a softer pencil than the previous one (a 4B, for example), create a very light shadow to emphasize shapes and volume, creating a subtle, nuanced shadow. It is not a question of drawing in chiaroscuro, but rather softly nuancing the shape. The paper seen in the image keeps the drawing from staining your hand.

6. The result exemplifies the process of composing and blocking in a drawing that has a very linear nature.

The linear style of an interior

Developing an agile and, to some extent, a carefree approach to drawing is one of the keys to achieving success in drawings based on line. The lines of the drawing are much stronger when drawn with a relaxed confidence than when they are the product of excessive rigor. The finished drawing will not lose its objectivity because of this light and relaxed approach. Instead, it will gain an attractive, simple quality.

An interior with a few pieces of furniture is an excellent subject for exploring the possibilities of a line drawing done in graphite pencil.

STAGE 1:
THE CENTER OF THE DRAWING

1. When no prior blocking in has been done, it is advisable to start the drawing from the subject's center, which normally coincides with the center of the paper. This way, there will be much greater control over the composition.

2. Start the drawing with a soft pencil (4B) to give visibility and strength to the central theme. As the lines do not rely on any shading for support, they must be drawn with abundant changes of direction and full curves.

3. The main lines of the objects that surround the central chair employ the same soft pencil. In everything surrounding the center, it is important to avoid details that accumulate too much graphic information and distract from the drawing's main focus.

Pure line drawing demands a light and uninhibited touch;
The lines gain a certain richness and the subject develops
in great detail as a whole.

STAGE 2:
THE SOFT LINES

4. Now, using a harder pencil (HB), develop all the details of the objects from the previous step. This way, you can introduce new aspects of the model without breaking the composition's linear harmony or overloading it.

5. The look of the drawing is much richer than what might be expected from the unadorned use of simple contour lines. In addition, the play between subtle details and more general objects successfully describes the space that surrounds the chair.

6. Finally, emphasize some darker accents to frame and lead the eye to the main subject of this drawing.

DRAWING IN PERSPECTIVE

*P*erspective is an integral technique for realistically representing objects in a three-dimensional way. There are many types of perspective; the most complex involve architectural spaces that encapsulate large spaces. However, the vanishing points and lines that characterize these representations of perspective are not applicable to all subjects, especially those consisting of objects that are too small for the convergence of the vanishing lines to be seen.

Leonardo da Vinci (1452-1519). *Catapult.* Ambrosian Library. Linear perspective was developed during the Renaissance in Italy, in architectural and technical drawings such as the one of this machine thought up by Leonardo da Vinci.

Giovanni Battista Piranesi (1720-1778). *An Ancient Port.* J. Paul Getty Museum. Architectural drawing requires the use of linear perspective more than any other kind of drawing.

Intuitive perspective

The simple representation of some objects in front of others already creates the sensation of spatial depth. In addition, when drawing similar objects of different sizes, the larger objects appear closer than the smaller ones. These intuitive representations of depth are adequate ways to render a subject and its surroundings. However, when it is a matter of organizing views with elements that feature straight edges, linear perspective becomes important; it is impossible to make a drawing look realistic without executing the general rules that determine the angle and direction of these straight lines.

FROM CLOSE UP AND FROM AFAR

The reduction in dimensions that, by effect of the perspective, is clear in a view of a building or a street, becomes imperceptible in the view of a box or a container. The logical thing is to use different formulae for representing perspective, depending on the subject matter.

Linear, or scientific perspective is based on the idea that the lines outlining space could extend beyond the drawing paper infinitely—objects get smaller the further they are from the viewer.

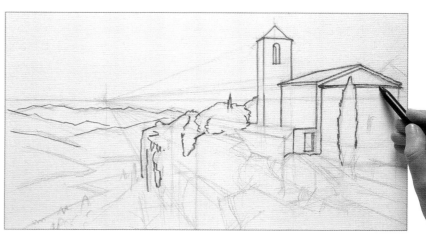

Perspective implements the way we naturally perceive space. Nature "hides" perspective and the artist reveals it.

Concepts and terms of perspective

To better understand the meaning of representation in perspective, it is useful to clarify concepts that, though simple enough, are better understood when seen in a drawing. These concepts are elementary, but, on many occasions, are only clear in an example.

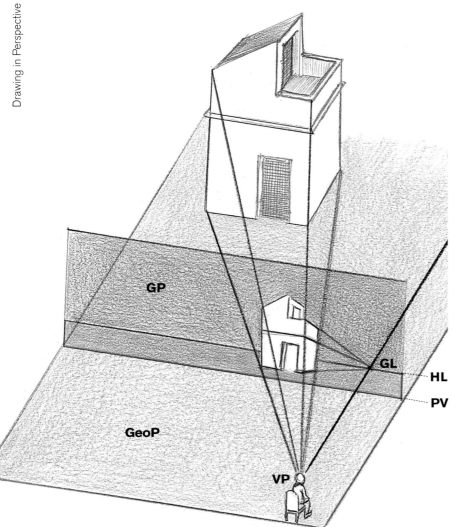

Diagram of the perspective view of a building, showing the following concepts: geometrical plane (GeoP), ground plane (GP), ground line (GL), point of view (PV), horizon line (HL) and vanishing point (VP).

Geometrical plane

This is the "floor" of the drawing. It is a fact that all representations of perspective are distributed on a horizontal plane. This is the geometrical plane and, like the horizon, can be explicit or implicit (visible or invisible).

Ground plane

This is the plane on which the represented objects appear. Ideally, it is the intersection of a vertical plane (like a wall in front of the observer) and the visual cone, at whose tip lies the point of view.

In this diagram the positions of the building relative to the ground plan and the point of view are clearly visible.

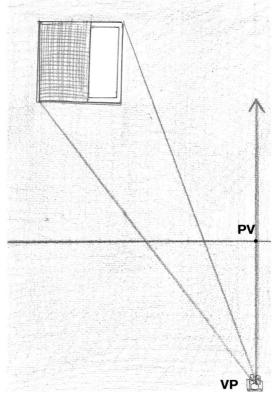

A view of the representation of perspective with the vanishing point, the horizon line, and the ground plane marked.

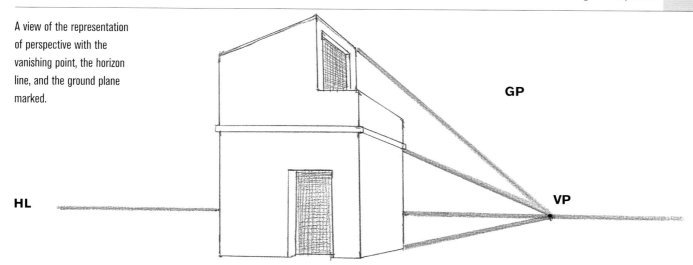

GP

HL

VP

Ground line

This is the line at which the geometrical plane and the ground plane intersect. The ground line, like every line that belongs to the ground plane, always appears in its "true dimension:" frontally and with no reduction in size due to perspective.

Point of view

This is the place from which the artist observes the scene: the vertex of the visual cone. It is truly a point and is equivalent to looking with just one eye. In a drawing, the vanishing point always reveals the position of the point of view.

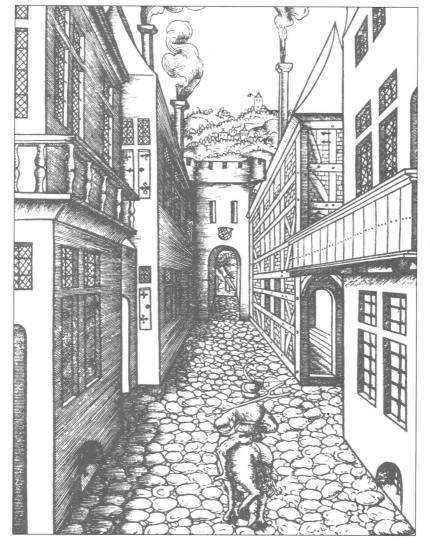

Engraving from the book *Leçons de perspective positive* (1576) by Jacques Androuet du Cerceau. Perspective of a single vanishing point located in the geometrical center of the drawing.

The horizon line

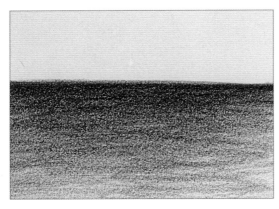

The horizon is the central idea of representation in perspective. The horizon line is, as its name indicates, a horizontal line, visible or invisible, explicit or implicit. It determines the position of all the objects, figures, or panoramas represented in the drawing. The horizon is also the place towards which any vanishing lines travel, to one or more points situated on this horizon. Even though the horizon is not a drawn line, a drawing should always suggest or imply its location.

The horizon line only appears explicitly and unmistakably in seascapes (or on plains without geographical interruptions).

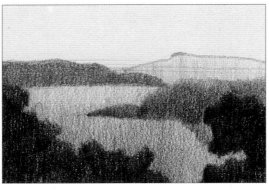

Many landscapes partially reveal the horizon line without explicitly showing it; it is easy to deduce its height in relation to the other elements in the drawing.

In many themes, the horizon line does not appear anywhere and an exercise of abstraction is necessary to deduce its height (always defined by the cut or convergence of the vanishing lines found in the theme).

Height of the horizon and height of the observer

The height of the horizon coincides with the position of the artist before their subject. A ground-level view requires the horizon line to be placed towards the top edge of the paper. Contrarily, a bird's eye view would place the horizon line towards the bottom edge of the paper. In a still life, the horizon often coincides with the top edge of the table on which the objects are spread out.

When objects, geographical irregularities, or buildings hide the horizon, the drawing's vanishing lines inform the placement of the horizon line. This height coincides with the height of the observer's point of view.

Invisible horizon

Often, the horizon line is not visible in the representation, but can be deduced from the vanishing lines marked by buildings, furniture, or pieces of buildings, such as cornices or moldings. The point at which two or more of these lines intersect indicates the height of the horizon. This does not apply to non-objective drawings, nor to drawings whose shapes do not abide by traditional methods of representation.

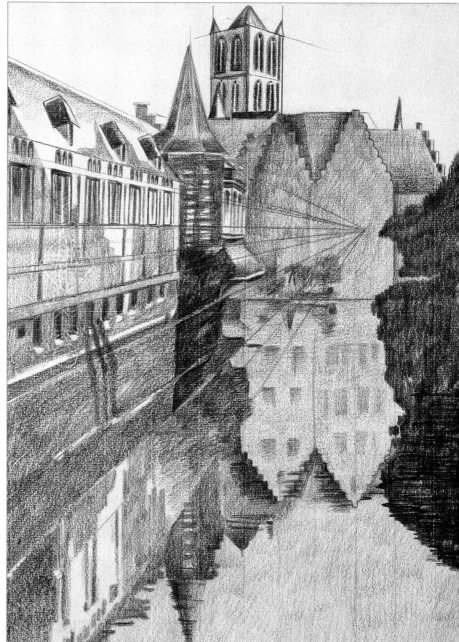

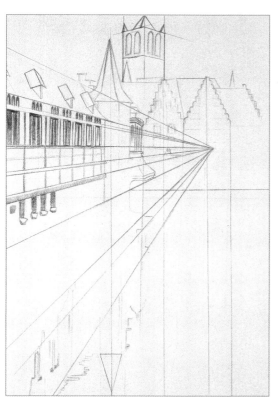

Vanishing lines and points

Vanishing lines are straight lines that intersect at a point on the horizon called the vanishing point. Vanishing lines are prominent in drawings that feature straight lines and edges. But vanishing lines can also be found implicitly in the drawing. The banks of a river, for example, are not at all straight, but the artist can trace a pair of vanishing lines to outline their line of perspective, erasing them afterwards.

What vanishing points are

Parallel lines seem to converge in the distance, in the way that railway lines seem to do. A vanishing point is point at which parallel vanishing lines meet. This trick is the basis of conical illusion, an illusion that captures the way we perceive space. The number of vanishing points determines the kind of perspective: frontal (one vanishing point), or oblique (two or more vanishing points).

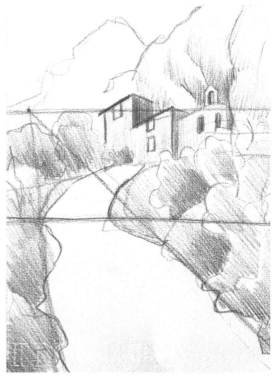

Some items in landscapes can suggest vanishing lines. A path drawn in perspective does not have to be completely straight to reveal the presence of these lines.

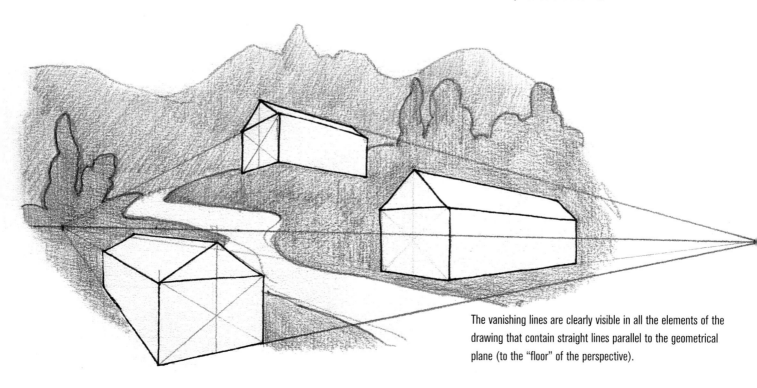

The vanishing lines are clearly visible in all the elements of the drawing that contain straight lines parallel to the geometrical plane (to the "floor" of the perspective).

PERSPECTIVE AND LANDSCAPES

Landscapes without buildings, while still subject to the laws of perspective, are rarely represented with linear perspective. The artist has to use their intuition and capacity of observation to resolve these kinds of drawings.

What vanishing lines are

Vanishing lines are the straight lines that converge at vanishing points. Any straight line in the subject that is parallel to the earth (to the geometrical plane) can be a vanishing line. In a frontal perspective, all vanishing lines converge on a single vanishing point; in an oblique perspective, the vanishing lines converge on two or three different vanishing points.

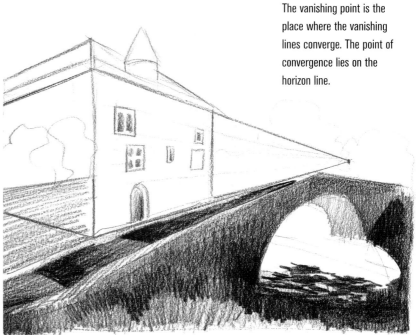

The vanishing point is the place where the vanishing lines converge. The point of convergence lies on the horizon line.

All items with faces and straight edges are shown in perspective by the convergence of these faces or edges at the vanishing point, which rests on the horizon.

Parallel perspective

Parallel perspective refers to a representation that does not rely on a vanishing point, and, therefore, does not employ vanishing lines. Because these parallel lines do not converge on any horizon, the vertical dimensions of the subject do not decrease as the object recedes into the distance. This perspective, also called axonometric projection due to its positioning of three spatial axes, is useful for creating an intuitive, clear and explicit drawing of all the elements of the scene.

Leonardo da Vinci, *Sketch for a composition*. Louvre Museum. In this drawing Leonardo used parallel perspective, a perspective with no vanishing points.

Graphic blocking in in architectural drawing usually employs axonometric projection that is often isometric.

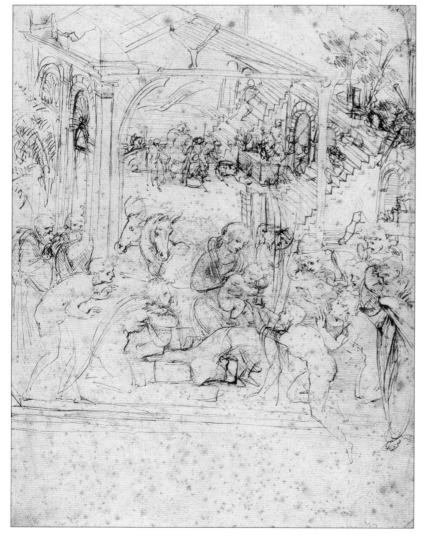

Cavalier perspective

Here, the horizontal and vertical dimensions (widths and heights) are proportional to the ground plane. The lines perpendicular to the ground plane (depth) appear in a diagonal tilted at 45° from the horizontal line and their dimensions shrink to two thirds of their original size. Expressed in terms of spatial axes, cavalier perspective results from keeping two of these axes (those that create the dimensions of height and width) at 90°, whilst the third axis forms an angle that is usually at 135° from the other two. Cavalier perspective can be used to draw a flat object three dimensionally.

CAVALIER PERSPECTIVE

This is a simplified version of cavalier perspective that respects all dimensions, and does not involve any reduction at all. The axes of breadth and height remain at 90°, whilst the angle of the depth axis varies depending on the drawing. This results in a distorted view of the subject. Cavalier perspective is also known as "military perspective," and its name comes from its use in representing fortifications.

Isometric perspective

Isometric perspective does not represent frontal faces, and the three axes of the drawing form angles of 120°. Each axis' reduction is identical (by a factor of 0.82) and affected by the perspective, meaning there is no "true" dimension. It is characteristic of representations of architectural interiors. Today it is widely used for computer-generated scenes.

Sketches for industrial engineering and elaborate diagrams of mechanical parts rely heavily on isometry.

Engraving from Sebastiano Serlio's *Second Book of Perspective* (1545). Unlike conical perspective, isometric perspective has no vanishing point.

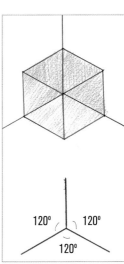

Cavalier perspective, like all axonometric projection, foregoes vanishing points: all the oblique lines are parallel.

With no reduction in size, a cube in cavalier perspective looks deformed.

Conventional two-thirds reduction in dimensions in perspective.

50% reduction in dimensions in perspective.

The isometric representation of a cube results in equal dimensions of all its faces. Isometry is based on three coordinate axes that form equal angles (of 120°).

120° 120°
120°

Conical perspective

A frontal view of the subject produces frontal perspective, that which contains just one vanishing point. The vanishing point is directly in front of the point of view.

This is the traditional perspective of drawing and painting: perspective with vanishing points. A conical projection forms this perspective. The image is projected on a plane (the ground plane) that penetrates the "visual cone," the tip of which attracts the viewer's eye, and the base of which contains the scene of the drawing. This means that the projection lines are not parallel, but that they converge. With conical perspective, these converging lines are equivalent to vanishing lines and the observer's eye lines up with the vanishing point.

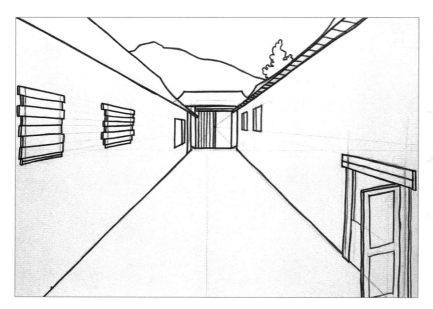

The frontal nature of perspective with just one vanishing point does not require that this point stay in the center of the paper: it may move, but too much displacement will distort the image.

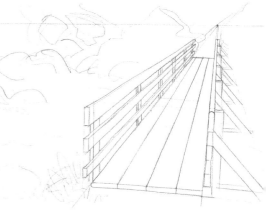

Frontal perspective, or one point perspective

This is the perspective that results when one of the sides of the object is parallel (in a frontal view) to the ground plane. The vanishing point, always located on the horizon line, coincides with the point of view, which naturally places it more or less in the middle of the paper. For this very reason, frontal perspective fails when the object is drawn far from the vanishing point; in this case, it would be more logical to represent the object with oblique perspective.

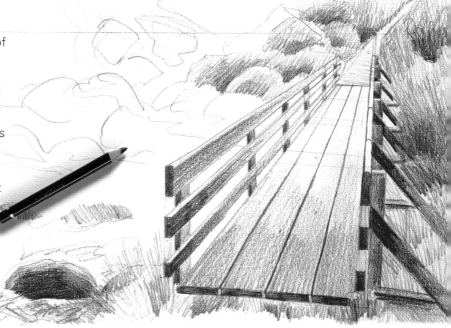

Frontal perspective is applied to items that are at any height above or below the horizon line.

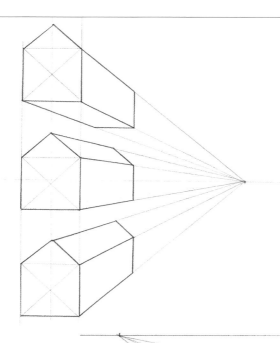

THREE VANISHING POINTS

When viewing objects from below, or above (bird's eye view), a third vanishing point located either well above or well below the horizon factors into the drawing. These perspectives are not very common, but must be treated correctly.

Oblique perspective, or two-point perspective

Since we do not usually see things from a completely frontal view, perspective in most cases will be oblique, representing an angled, or side view. Therefore, lines or faces perfectly parallel to the ground line will not appear. The vanishing lines of oblique perspective converge towards two different vanishing points located on the horizon line. Thus, perspective with two vanishing points can be understood as the combination of two frontal perspectives.

Oblique perspective is equivalent to a "displaced" view of the object: we see it from the side, obliquely. This perspective combines two points of view, thereby giving the drawing two vanishing points.

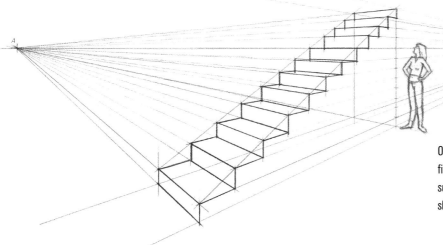

Oblique is usually the most natural perspective, the one that best fits the way subjects may be positioned (provided that these subjects are geometrical or can be reduced to geometrical shapes without any deformity).

Aerial perspective

This is the most characteristically artistic way to represent space. Progressively shading an object's contours and details and creating an atmosphere that comes between the object and the viewer creates depth and spaciousness. Aerial perspective is highly ef-fective in subjects that include considerable distances, particularly landscapes. Simply blotting out a middle-ground means that the foreground appears farther away from the background.

Aerial perspective is based on the steady reduction of the contrast and clarity of a shape's contours to make them appear farther away in space.

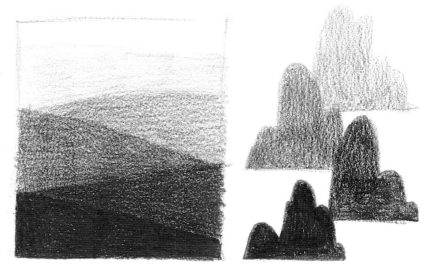

Different contrasts

Objects in the foreground must sharply contrast those in the background. A contrast in the foreground relies on black and white, whereas a contrast in the background will employ varying shades of gray. This muffled contrast creates depth. This is useful in drawing subjects in nature, and emphasizing contrast in a work reinforces the perspective.

Contrast is always sharper in the foreground than in the background. This basic principle of aerial perspective is especially clear in landscapes.

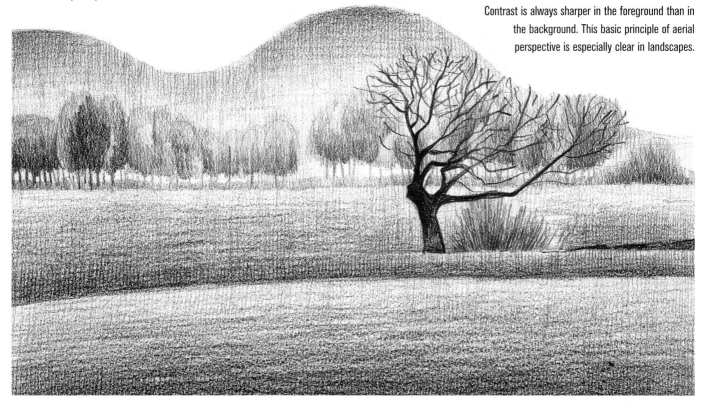

Aerial perspective is also useful in still life drawings; the contrast between clear and misty shapes, or between sharp and blurred profiles creates the feeling of air placed between the objects, and of atmosphere and space.

Loss of contours

Objects that are drawn with defined contours appear much closer to the viewer than those drawn less precisely. This is general rule is useful in creating linear drawings that exhibit little to no contrast between light and dark tones. Creating depth by varying contours applies to many subjects, but is especially helpful in creating landscapes.

Thomas Gainsborough (1727-1788), A *Lady Walking in a Garden with a Child*. J. Paul Getty Museum. The loss of definition and contrast, along with the carefree treatment of the background, creates a feeling of atmosphere and distance: the intended effect of aerial perspective.

An urban perspective

In urban views or panoramas that feature buildings, conical perspective is effective and easy to achieve. This town scene clearly suggests a frontal perspective, meaning one with a single vanishing point. The lines suggested by the cornices, windows, and eaves lead to this vanishing point and situate the vanishing line at the correct level.

STAGE 1:
THE VANISHING LINES

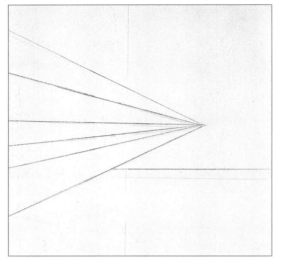

1. Fundamental vanishing lines, those that establish the position of the vanishing point and the horizon line, form the basis of the scene. Use a pencil that is not too soft, such as a 1B or 2B, to avoid marking the lines in excess.

This is an urban view observed from a leveled viewpoint, which allows the representation of the overall perspective to dominate.

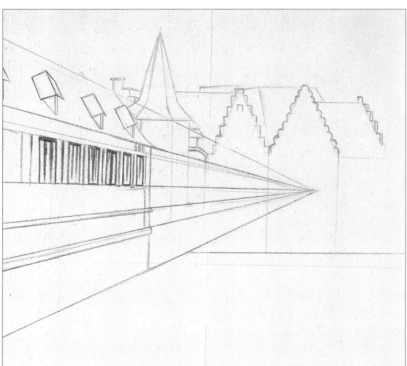

2. From the vanishing lines, construct the geometrical boxes that will form the buildings. Pay attention to their various sizes, so that everything fits inside the space of the drawing.

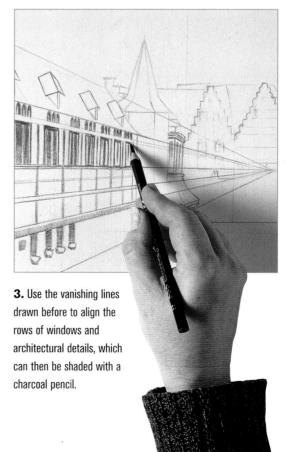

3. Use the vanishing lines drawn before to align the rows of windows and architectural details, which can then be shaded with a charcoal pencil.

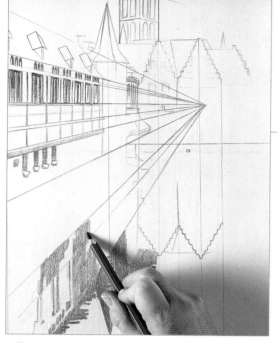

STAGE 2:
SOFT LINES

4. The lower vanishing lines correspond to the perspective of the reflections, which follows the same laws as the perspective of any other object. Shade them in with a charcoal pencil.

5. Little by little, fill in the whole scene with the relevant details, light, and shadows. Because of the network of vanishing lines drawn beforehand, the light, shadow, and details should be correct and consistent with the rest of the drawing.

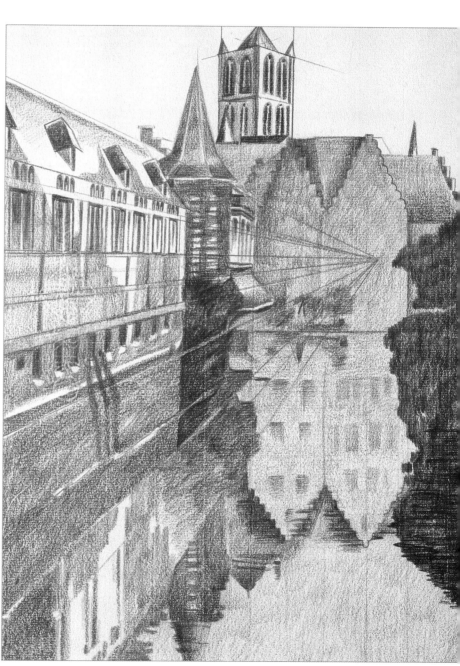

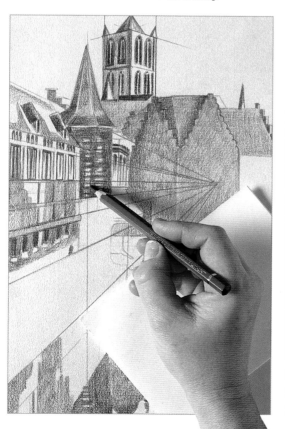

6. The architecture and its reflection in the water are now fully represented. All the significant details have been properly assessed and a coherent drawing, nuanced in a correct perspective, is complete. Work by Gabriel Martín.

The perspective implicit in landscape

When the theme that you want to draw does not clearly present the vanishing lines that determine a conical perspective, the artist must infer such lines, along with the other elements of perspective. This subject hints at vanishing lines, but the architectural items are very rustic and irregular, qualities which obscure the underlying geometry of their shapes.

THE SUBJECT

Here, the buildings are very irregular and the vanishing lines are not pronounced, although it is not hard to detect them from the tilt of the roofs and facades.

STAGE 1:
THE SEARCH
FOR THE
HORIZON

1. The main vanishing lines project from the roof and window of the house in the foreground. They converge at a point very close to the edge of the paper.

2. The other buildings pose no problems, as they appear in a frontal view and one simply has to mark their heights and proportions.

3. Once the whole drawing has been sketched out in sanguine, a stick of thickened charcoal can define the real contours of the items in the scene.

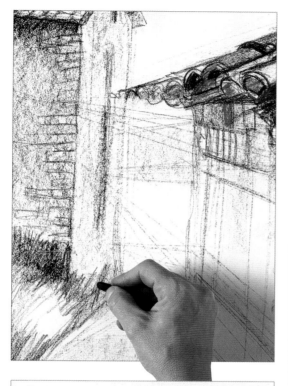

4. Applying the tip of the stick to the paper, draw in the tiles, taking care that their position is consistent with the actual subject's. Broad strokes create general shading.

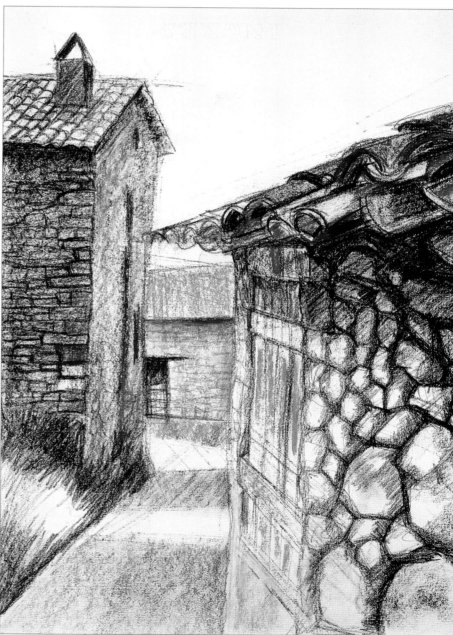

5. The combination of thickened charcoal and sanguine suits this motif very well, as the texture of the material (stones, wood, etc.) is rich and nuances the shadows.

6. Finally, the artist Esther Olivé de Puig concludes the drawing, having properly organized its perspective as well as the wealth of details that characterizes its walls and roof.

MODELING AND SHADING

Modeling is a process that highlights the volume of the represented subject matter. Shading creates a gradient of the lights and shadows of the subject matter. Because every manifestation of light affects the representation of volume, aspects of lighting and shading are interconnected and strongly linked. The essential difference between the two lies in the fact that modeling concerns every object individually, whereas shading takes rendering the entire scene into account.

Leonardo da Vinci, *Garment Study for a Seated Figure*, (1470-1484), The Louvre. The aim of the shading and modeling of objects is to affirm their presence in space and their three-dimensional volume.

Modeling gives objects volume, while shading adds nuances and value to the lights and shadows of the whole scene.

Volume and relief

The objective of all shading is to obtain a three-dimensional effect. Modeling also refers to the descriptive shading of the object's surfaces, and should create a convincing sense of solid body. This modeling involves directing a single source of light at a surface and darkening the surfaces that are farther away from this light. Be careful to avoid creating a clearly defined frontier between line and shadow.

In this drawing, the shading is, in reality, modeling, as the play of lights and shadows remains solely at the level of describing the volumetric shapes of the buildings.

Lights and shadows

All motifs and scenes can be understood as a particular combination of lights and shadows. Ideally, reproducing a scene's lights and shadows without paying too much attention to the realistic description of each object is enough to achieve a convincing overall representation. This was the focus of the impressionists, artists for whom the objective and realistic appearance of a subject was of secondary importance to their transformations under various conditions of light.

In this landscape, one can see general shading, which includes objects that have been modeled. The shading renders the representation as an overall unit with no distinction of parts.

Values

The term, values, refers to the relative degrees or intensities of light and shade. The more shaded a subject is, the greater its range between black and white will be. In theory, values are always single-color. In practice, the effects of sanguine, chalks, crayons, and pastels may also produce values, as they suggest light and shade with lighter or darker tones.

Degrees of gray

The values of a single color drawing are the variations in intensity of that single color that clarify or darken a single subject.. Working with graphite or charcoal, this color will be gray and these variations in intensity will be lighter or darker grays. The two extremes of the possible range of values are the color of the paper and the darkest tone obtainable by the single-color medium.

Drawing with just two values: the white of the paper and the gray of the penciled shadows. The result is schematic and plainly graphic.

This drawing contains three values: the paper and the two grays of the pencil. Though it is also schematic, the subject seems natural and has complex values.

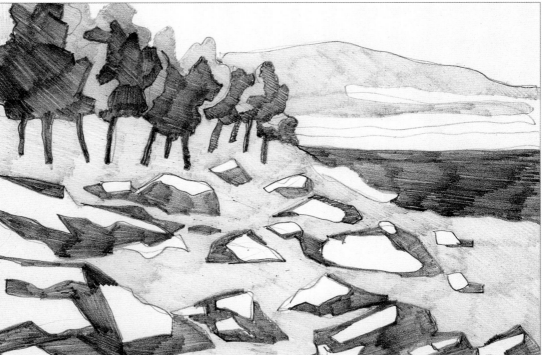

Values are always monochromatic (except for the color of the paper when using a colored paper), but it is possible to perceive values as different colors. The play of contrasts between lights and darks means that an expert eye can translate some values into colors. Artists have always.

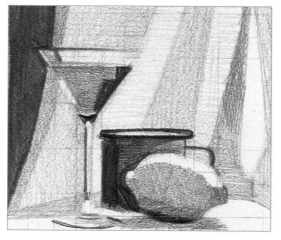

Light and value of objects

Shading involves establishing the value of each object (lighter or darker, depending on its actual color), meaning that shadows will appear differently on light objects than on dark objects. In practical terms, this results from creating a general evaluation the entire subject while ignoring the values of each object. During a second stage, the surfaces are darkened until they achieve the final distribution of tones in the entire drawing.

Here, the values of light and shadow have been separated clearly. In addition, the drawing's scale of evaluation includes all these values.

Working on colored paper, white can be included as an auxiliary value. Here, white chalk enriches the scale of values.

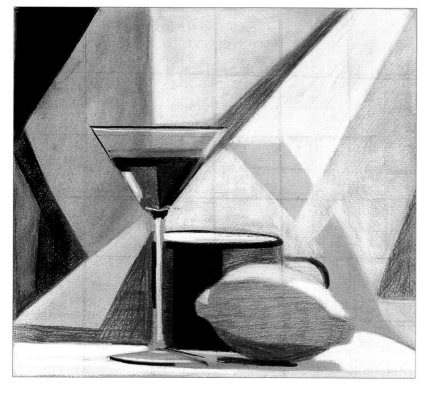

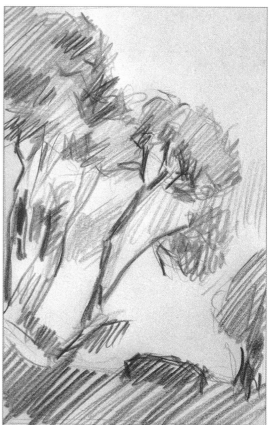

Instead of using all the different values in a drawing equally, artists emphasize some over others in order to create a harmonious play of values.

Light and chiaroscuro

Beyond shading and evaluation, chiaroscuro is an extraordinary visual effect that bridges drawing and painting. Chiaroscuro is not just a method of representing one or several aspects of the subject, but a genuine creation that involves the entire space in which the subject appears. It concerns atmosphere, light, character, style and a particular way of understanding drawing that distinguishes the artist's work as a genuine personal creation.

Chiaroscuro achieves the same coherence in a scene by means of a convincing representation of the light. Here, chiaroscuro helps to create a sense of realism. Work by Óscar Sanchís.

Based on a dramatic counter-position of pure white and saturated black, this work develops chiaroscuro energetically, demonstrating a good balance between values of light and shadow throughout the composition.

MASSES OF LIGHT AND SHADOW

Taken to an extreme, chiaroscuro blurs the outlines of the contours of objects and blends them into masses of light and shadow. Drawings created with chiaroscuro lose detail in favor of a quality of light and atmosphere that emanates throughout the whole drawing.

In a landscape, chiaroscuro emphasizes the light's direction. This makes the shadows very dense and they contrast with areas that are filled with light. Work by Gabriel Martín.

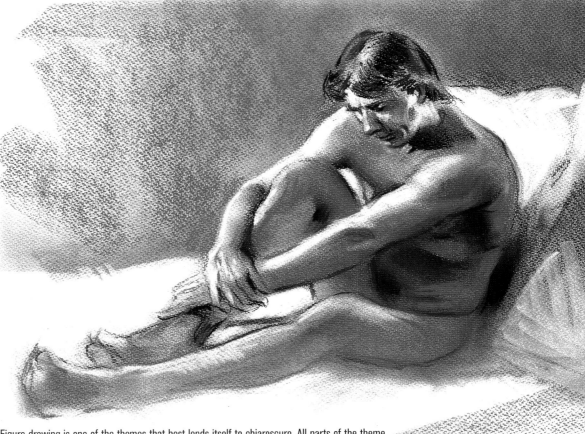

Figure drawing is one of the themes that best lends itself to chiaroscuro. All parts of the theme integrate into a single whole (the anatomy of the figure) and the lights and shadows organize around this subject without becoming dissipated by details. Work by Vicenç Ballestar.

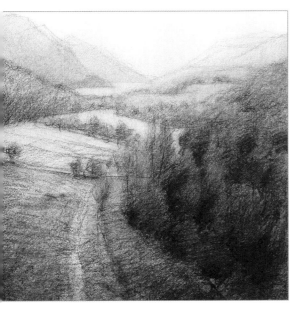

Balance between lights and shadows

Chiaroscuro is a method of shading that creates a balance between the lights and shadows of the work. This harmony requires each element of the drawing to be sufficiently modeled and shaded, as well as a convincing balance of values to be evident. To achieve this, it is necessary to understand the drawing as a complete whole, subject to one single atmosphere of lights and shadows.

Chiaroscuro and single colors

Chiaroscuro implies the exclusive use of black and white (the color of the paper and that of the medium employed), but it can also incorporate diverse tones, provided that they relate to the overall tone and do not stand out against it. That is, colors must be shaded towards black or lighten towards white (if white and black are the basic colors), to create a sense of cohesion in the drawing.

Valuing and shading techniques

Value and shading techniques depend on the procedure and medium employed to create a composition. The end result will vary depending on the materials the artist uses. Some artists prefer media that produce thin strokes (nib, pencil, etc.), whereas others lean towards more pictorial media that focus on mark-making, for example, with charcoals, sanguine, or pastel.

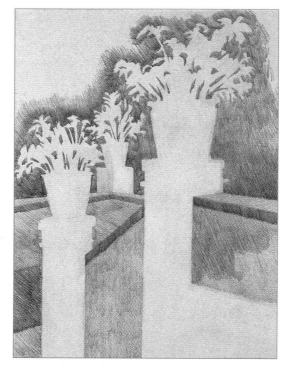

The graphite pencil is a good medium for rendering light, since it is hard to create dark tones with it. It is also ideal for refining values, as it does so with a greater delicacy than other media.

Charcoal is the darkest drawing medium. Its ease and rapidity of use produces the extremes in the range of values that should be established at the start of a drawing. This range extends from the white of the paper to the darkest tone obtainable by the charcoal.

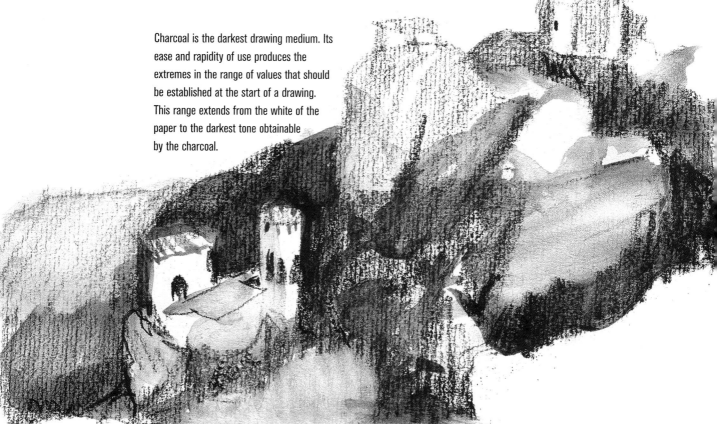

Creating contrast

Shading can create a stark or subtle contrast, depending on the procedure chosen. Pencil shading, especially when using hard leads, makes it much easier to move subtly between values, but will never create a drawing with strong contrasts. This calls for charcoal or India ink. Even so, a lighter medium's great subtlety and delicacy of strokes compensate for its less intense effect.

Media for making strokes and marks

Types of shading vary considerably, depending on whether an artist favors strokes or mark-making. Appropriate media for making strokes includes pencils, the lithographic pen, the reed pen, and small color sticks (pastel or wax). Mark-making media includes charcoal, pastels, and, in general, thicker sticks. Shading is always more convincing and definite when done with these materials.

Pencils are a stroke-making medium. Their advantage lies in the fact that the artist can work methodically, adjusting all the values to their exact tone and their precise placement in the drawing.

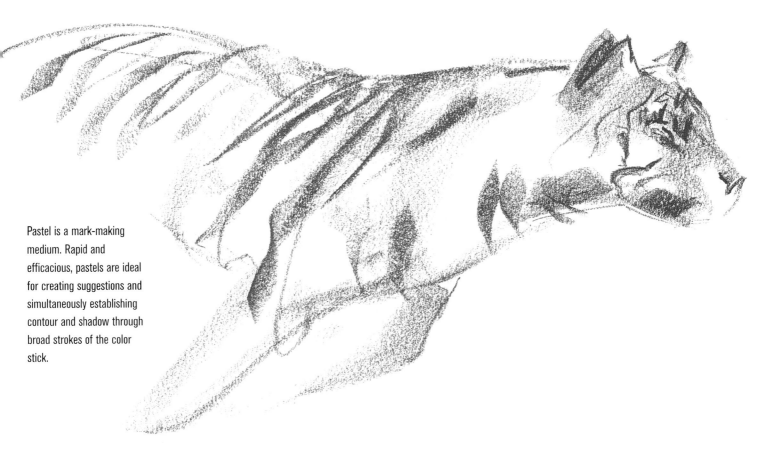

Pastel is a mark-making medium. Rapid and efficacious, pastels are ideal for creating suggestions and simultaneously establishing contour and shadow through broad strokes of the color stick.

Shading by hatching

Hatching exemplifies drawing techniques that rely on delicacy of stroke. Shading with pen, nib, or pencil necessitates hatching. This is a particular technique that not only repre- sents a value or tone in a composition, but also creates an illusion of texture. The combination of multiple hatchings creates works with very rich tonal value, suggestive of the quality of the sur- faces represented.

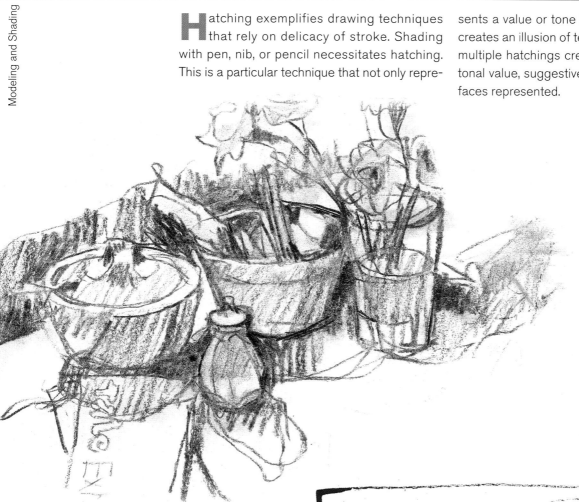

Pencil drawing that exhibits free, uncluttered hatching. This is the artists' habitual way of working when seeking a temporal, sketched-in effect: the lights and shadows are part of an intertwined mass of hatching that follows no regular layout.

The reed pen is ideal for hatching, but hatching lights and darks does not require a systematic approach and can be developed rapidly and uninterruptedly.

Hatching values

The density of strokes, which depends on the amount of pressure applied to the paper, and their vertical, horizontal, or diagonal direction determines the various intensities of shadow. The range of values can greatly extend if these two factors are combined. In addition, these techniques create a texture that adds a characteristic visual value to the drawing.

Pastel sticks are a mark-making medium, but they can also achieve light hatching, which, in just a few delicate applications, establishes the general values of the drawing.

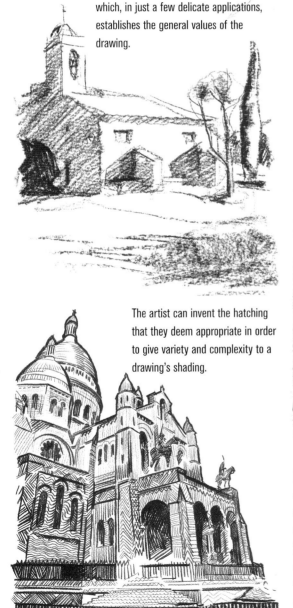

The artist can invent the hatching that they deem appropriate in order to give variety and complexity to a drawing's shading.

Details in the shadows

A drawing with cross-hatching always exhibits densely textured shadows. This creates the illusion that the drawing contains much more visual information and detail than it actually does. This is one of the great advantages of cross-hatching; by working slowly and patiently, the artist can determine the exact value of each area of light and shadow.

Peculiar cross-hatching with sanguine that suggests more detail in the shadows than they actually contain. This is the virtue of dense cross-hatching, which enriches the graphic texture of the drawing while simultaneously creating tonal value.

Shading by blending

Blending is a habitual resource for obtaining visual unity. Values merge with each other and light and shadow alternate continuously and fluidly. Therefore, it isn't necessary to define each form; the shapes are not self-containing, rather, one leads to another as if they were all submerged in a single light-filled context. Charcoal, sanguine, or pastel strokes leave particles loose on the paper, which spread and create graded marks on the paper.

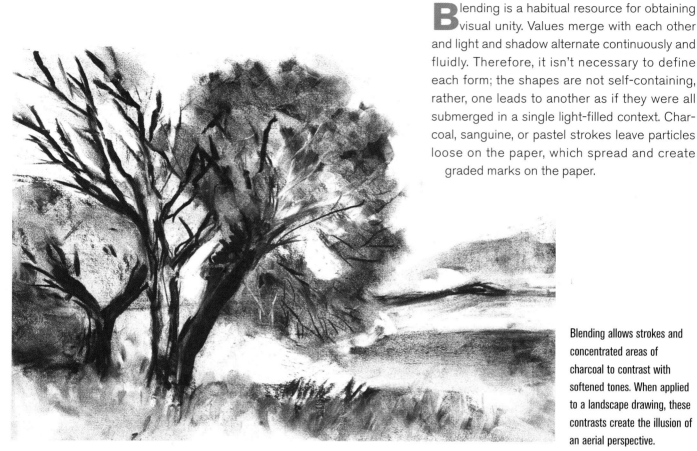

Blending allows strokes and concentrated areas of charcoal to contrast with softened tones. When applied to a landscape drawing, these contrasts create the illusion of an aerial perspective.

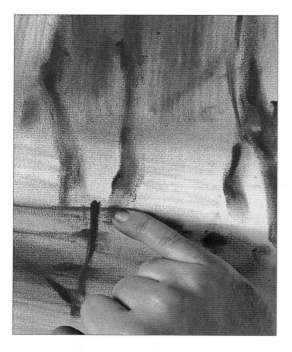

Blending with the fingers is the most direct and spontaneous way to adjust values and tone down extreme contrasts. It is ideal for rapidly created drawings.

Here, shading is global and the blending does not seek realism, but rather, a general tonal harmony.

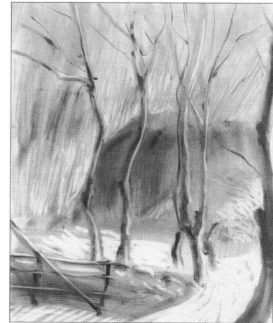

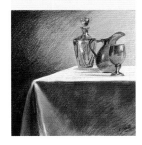

Blending techniques

Direct blending arises from the decisive applica-
tion of strokes with the stick pressed flat against
the paper. These marks are blended and the
trace left on the paper establishes an initial play
of light and shadow. Some added contours that
do not define the lines too strongly leave spaces
open so that the atmospheric unity of the draw-
ing becomes clear. Continue by applying more
marks to blur with the fingers. To finish, use your
eraser to locate the most prominent areas of
light in the composition.

A classic drawing subject is a cloth. The folds create plays of
lights and shadows that, properly drawn and evaluated, are the
starting point for working with the scumble, should you want an
accurate and realistic finish.

Media for blending

In sketches, studies, and small works, using the fingers or edge of the hand
can be the most comfortable way to blend. In more elaborate drawings of
medium size, the scumble can be advantageous, as it may define details. In
big works, a cloth can achieve blending during the drawing's initial stages be-
fore tackling its details.

Blending removes the trace of
strokes and creates a soft,
silky texture, through which
light appears, unifying all the
areas of light and shadow.

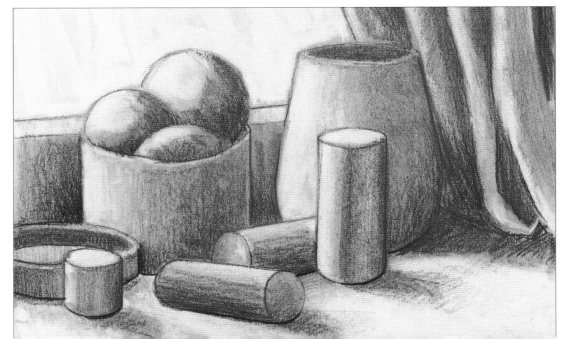

Simultaneous contrast

This method of modeling involves creating a contrast of light on dark to highlight points of relief in the composition, and ensures the unity of the drawing. The lighter or darker value in this pairing should starkly contrast its neighboring value in order to create a distinct border between the two contrasting values. As a result, this border becomes a line in the drawing, the limit of the represented shape.

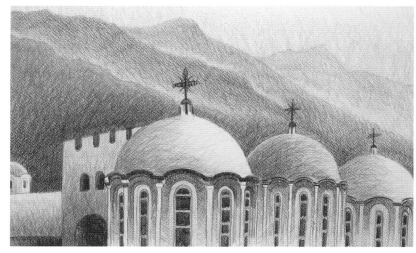

The planes of light and shadow combine so that the simple contrast between darker and lighter planes defines the shape.

In this drawing by Gabriel Martín, the principle of simultaneous contrast was applied systematically to all the shapes. The lighter tones border the darker ones, defining the contours more clearly than if a mere homogeneous lighting had been used.

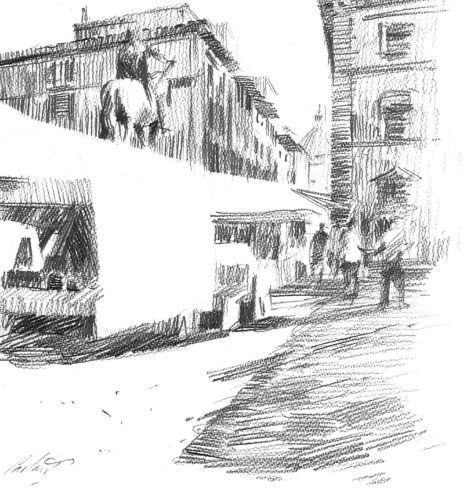

The entire highlighted perimeter of the jug strongly contrasts its background, almost creating a polar opposition of black and white.

Figure and background

To highlight the volumes of a drawing, there is no need to darken its shadows. Instead, darken the background on which they appear. Simultaneous contrast involves using both of these methods, so that the forms and the background on which they stand out gain value at the same time. Wherever a shape is lost against the background, darkening the background will re-emphasize its contours. This lightens the weight of the shadows and achieves a harmony of value.

Here, chiaroscuro emphasizes the use of simultaneous contrast, seen in the precise definition of all the contours. The general blurring reinforces the effect of light. Work by Joan Teixidor.

CONTRAST AGAINST BLACK

Simultaneous contrast can be fundamentally understood as drawing on a black background with a white chalk or pastel. Lights and shadows construct the drawing with no need for lines, as the contrasts create the contour.

Background tones

In exercising simultaneous contrast, the artist constructs the subject based on form, size, and distribution of its elements. Lighter hues appear next to shaded forms, and darker forms accompany light-filled areas of these forms. Therefore, the background's tonalities vary depending on the position of each item.

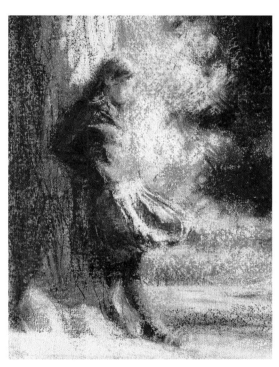

Simultaneous contrast can be nuanced to create more subtle contrasts, as seen in this work by Mercedes Gaspar. Light and shadow form a very rich fabric of nuances.

Very light colors nuance the entire cup to give its simple cylindrical volume unity and integrity.

An olive tree, developed with strong lines and textures

Shading by line is the most "pictorial" method of creating color values. This way of working suggests the characteristic qualities of painting, such as brushstrokes, colors, and experimentation with tone. The process, as seen in this exercise by Gabriel Martín, is very rich in varied values and strong graphic lines.

STAGE 1:
GENERAL VALUES

THE SUBJECT

The subject requires complex development. All the rich textures in the trunk and the leaves call for techniques that rely more on strokes than marks.

1. The initial lines of the drawing shouldn't define the shape. Rather, the strokes must leave numerous spaces white to facilitate the following process.

2. First, trace with charcoal and then blur with your fingers. Do not create contours by blurring; contours should be created by shading.

3. The softest spots are achieved by using the fingers. From the start, this gives an abundant range of various values of grays.

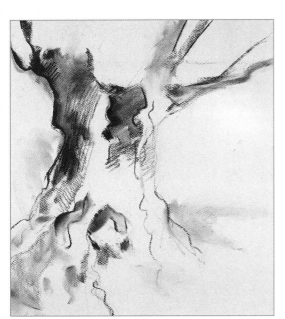

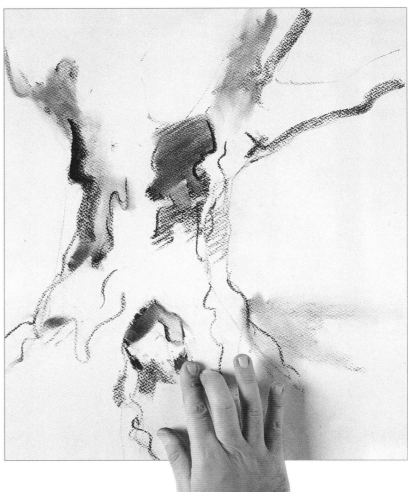

The rich play of values and nuanced shading adds a painterly, pictorial quality to the drawing.

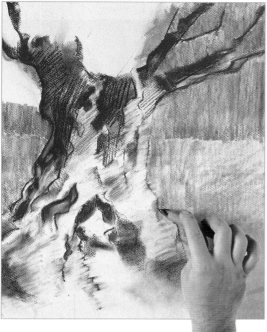

4. Once the drawing has advanced sufficiently and contains various types of strokes, use the scumble to tone down some parts and nuance the areas of the densest texture.

5. The eraser also plays an important role in nuancing the strokes. It can open up white sections so that the paper "breathes" between the hatching and the shadows. This gives the effect of light illuminating the trunk.

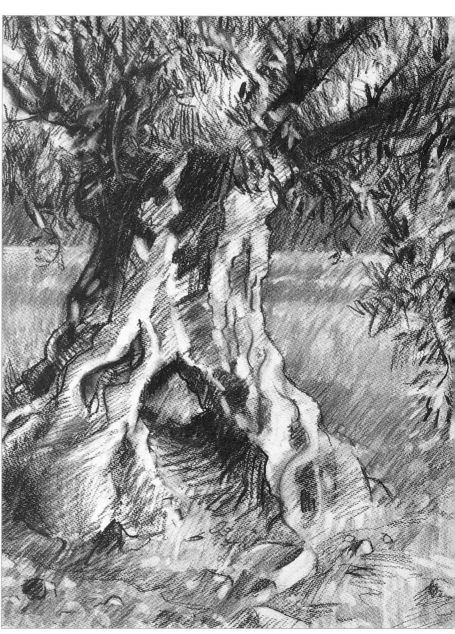

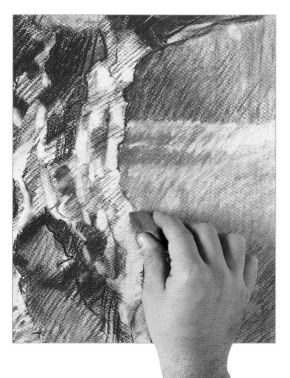

6. The final drawing is comprised of a dense surface covered with bold lines. The graphic wealth and great variety of different values contained in the drawing evoke the roughness and texture of the tree trunk.

Shading by hatching

Hatching is an appropriate technique when using drawing instruments that create fine or very fine strokes, such as pens, nibs, hard-lead pencils, etc. In exercise, the artist Almudena Carreño employs very sharp HB and 2B graphite pencils to accurately resolve a still life in chiaroscuro. Rulers and setsquares are useful for achieving a result that is as cohesive as possible – and also highly original.

THE SUBJECT

Strong chiaroscuro enhances the volume of these two small gourds, making the smoothness of one of them stand out against the roughness of the other. Hatching will emphasize these aspects.

1. The initial drawing should be very precise: if the contours and the areas of different shade are well defined, there will be no doubts regarding where to apply the strokes to establish values and model the shadows.

STAGE 1:
GENERAL IDEA

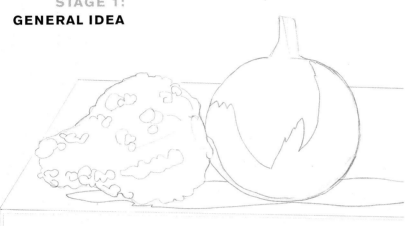

2. At first, use an HB pencil to create an initial hatching with long parallel, diagonal lines. Keep only the areas of maximum light in white.

3. The hatching lines should cross each other at right angles to create regular areas of differing value. The strokes will be darker and the hatching will create a darker shadow where the softest pencil has been used.

In this exercise, rulers and setsquares help to achieve highly precise and continuous cross-hatching, which occupies the entire surface of the paper.

STAGE 2:
DENSITY OF CROSS-HATCHING

5. In the last stages of hatching, softer lead pencils are steadily used to produce darker and darker intensities of shadow. Very brief strokes in the same direction as the rest of the hatching brings out the rough texture of the gourd.

4. The hatching continues, now vertical and horizontal. Little by little, the shadows darken. The lightest areas are spaces where new hatching has not been added.

6. The tonal scale and the gradient of the final drawing are very precise and occupy the entire drawing. Thanks to this very systematic way of working, a complex and developed drawing was achieved.

Backlight in a landscape

Backlighting is a light effect not used very often by artists, and rarely used when constructing landscapes. However, when incorporated with the traditional mediums of shading and modeling, it is an interesting experiment, as this exercise designed by Almudena Carreño makes apparent. The powerful focus of light is visible in the composition and dramatically emphasizes the strange and somewhat mysterious effect that this unusual point of view creates.

THE SUBJECT

The subject is a view of the desert: a rocky landscape with a few palm trees and small, cultivated fields. The sunset produces a spectacular blaze on the mountain that poses a challenge for the artist.

STAGE 1:

CONSTRUCTION AND EVALUATION

1. The start of the drawing is conventional: charcoal defines the the basic lines of the composition without developing too much detail, and leaves larger areas of the drawing for elaboration.

2. The darkest accents of the landscape intensify as if this were a topographical representation, as the stratification of the cliffs becomes clearly illustrated. Working with a sepia chalk stick, define the contours and shade.

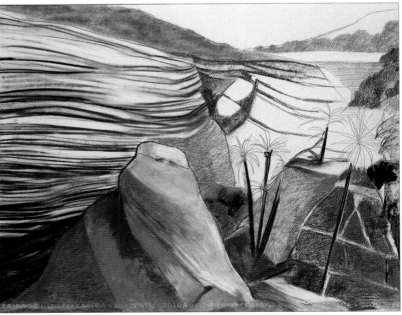

3. Apply sanguine over the sepia chalk. As sanguine is a warmer color, it is much more suitable for dealing with the parts of the composition that are nearest to us.

STAGE 2:
SOLVING BACKLIGHT

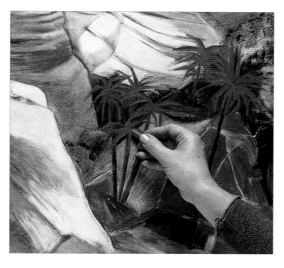

4. Working with the sanguine stick should be done meticulously, especially in the parts where detail is of primary importance, for example, the center of the composition, where the palm trees appear.

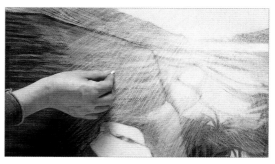

5. Once the shading is completed, hatching with white chalk creates the backlight represented . It is essential that the prior shading remains dark (to contrast with the chalk) and has been blurred well (so that the chalk strokes can easily be added on top).

6. The final result is highly original and, at the same time, very faithful to the subject. Successive hatching and strokes soften as the picture recedes from the light source. This is a fine drawing of an effect that is difficult to achieve.

STUDIES AND SKETCHES

*I*t is hard to say just when a drawing transforms from a sketch to a definitive work. Today, most artists practice drawing in an agile, uninhibited style akin to impressionist fluidity. The quick sketch or informal outline created before any subject can sometimes contain a certain expressivity that may become lost during patient development of a formal work. The simplest graphic mediums best convey this expressivity.

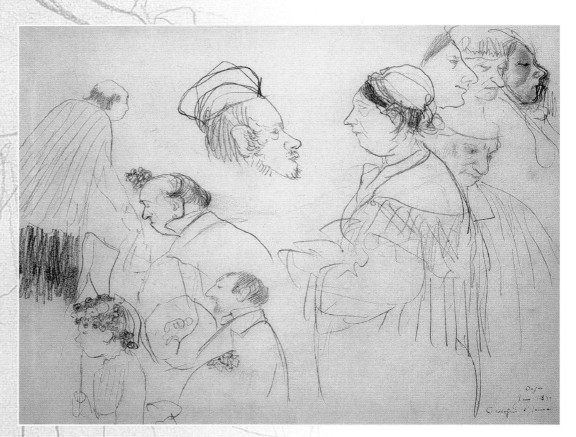

Edgar Degas (1834-1917),
Procession in Saint-Germain.
J. Paul Getty Museum.

Informal sketches contain a spontaneous graphic quality that is hard to achieve through a conscientious and thorough drawing.

Approaches to a subject

Drawn outlines usually serve as studies to prepare for creating a more developed work. Such studies are essential, as there are always new methods to try and discover. The study of a subject consists of sketches of all kinds, large or small, black and white or in color, allowing the artist to understand forms and experiment with composition.

Study of the negative spaces of the subject, which establishes the relationship between shapes and background in the composition.

This is the first of a series of sketches, all of them by Gemma Guasch, of a still life: each one examines a specific part and resolves concrete graphic problems, in this case, the linear qualities of the subject.

The line here is does not require evaluation or shading, due to the soft marks in the background that mimic the atmosphere surrounding the subject.

Notebooks

Artists should always have notebooks or small, loose pieces of paper on hand for quick studies or sketches. Often, the strokes that are made on the spot without thinking suggest new possibilities for the artist. These quick, informal works are achieved with a few lines to block in the drawing, and some straight and curved lines that distribute the volumes over the paper. It is never a waste of time to quickly sketch before tackling the definitive work.

This extremely brief sketch is enough to clarify the relationship between the contours of two of the objects in the still life.

Media for making sketches

The tools for making sketches must be simple and light, easy to carry, and not require reloading, handling, or accessories. This means that it is better to do without cloths, erasers, pencil sharpeners, or any auxiliary material. Remember, many of these sketches will be done in the street or country, or even in a museum or art gallery, places that require ease and accessibility of materials.

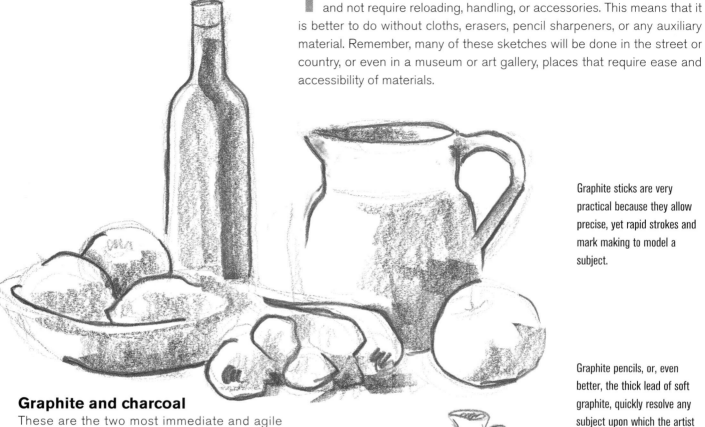

Graphite sticks are very practical because they allow precise, yet rapid strokes and mark making to model a subject.

Graphite pencils, or, even better, the thick lead of soft graphite, quickly resolve any subject upon which the artist may stumble.

Graphite and charcoal

These are the two most immediate and agile mediums for making sketches. The lightly metallic stroke of the pencil, which is much denser in soft leads, yields its best results when used in rapid sketches. Leads should be inserted in cases to avoid having to sharpen the tip constantly. Thickened charcoal lead that inserts into cases disperses a small amount of charcoal and produces strokes that are much finer than those achieved by traditional sticks.

Charcoal is perhaps the most effective medium for making rapid sketches, during which it is important to rapidly establish the general values of the lights and shadows. Work by Gabriel Martín.

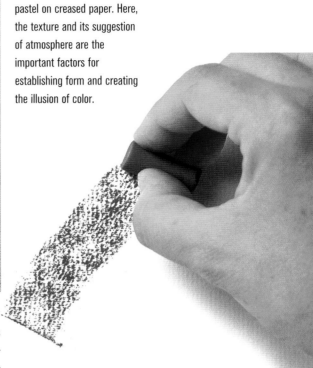

A sketch of three lemons in pastel on creased paper. Here, the texture and its suggestion of atmosphere are the important factors for establishing form and creating the illusion of color.

Writing mediums

Fine-point ballpoint pens offer an extraordinarily fluid and continuous stroke that, though lacking the vivacity a nib achieves, has an obvious advantage; they do not require reloading, and are therefore much easier to use. Marker pens can be considered the modern version of the reed pen and can be treated the same way as biros. Some artists use worn-out marker pens to achieve the irregular effect characteristic of reed pens.

Pastel sketches

Fully developing a pastel stick's strokes requires working on a large scale. Using one or two sticks of contrasting colors will rapidly and expressively capture a subject. Pastel is also an ideal medium to practice blocking in and coloring a composition, as it allows for rapid and highly visible adjustments in color and the positions of a subject. In addition, pastel pencils and hard pastel sticks are ideal for creating line sketches, shading or highlighting with hatching and making light marks. Don't forget to stabilize all pastel work with an aerosol fixative to prevent the pigment from rubbing off the paper.

The thin stroke of ballpoints can result in very lively sketches, rich in agile lines and light hatching. Work by Vicenç Ballestar.

Figure sketches

Sketching the figure is a classic exercise for anyone who draws or paints, regardless of their technical ability. Real models are ideal, but photos of clothed or nude figures are good substitutes. However, the artist must be careful to avoid creating a mere copy of a photograph, since capturing the essence of the figure's pose and movement is the main objective.

The best place to create rapid sketches of the figure is the street. Find a good place and try to quickly catch the characteristic gestures and attitudes of passers-by.

In sketching the figure, the natural expression of movement is more important than the exact representation of the anatomy or proportions of the figure.

"FROZEN" MOVEMENTS

If the artist is able to work in a school with real models, they will find it very useful to take "snapshots" or frozen movements seen with just a glance. These studies have to be done very quickly, and do not allow for any correction or erasing. If the result is undesirable, let it be, and move on to the next sketch.

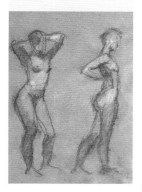

The figure in movement

The greater the artist's ability to represent movement, is the greater their ability to draw the figure will be. Drawing movement requires an understanding of the contractions and extensions that take place in the body, as varying contractions and extensions characterize all poses. A good way to study movement is to sketch the figure quickly (20 to 30 seconds at most), with the minimum amount of lines necessary to express the figure's pose.

Marks spread with a dirty scumble created a schematic of the figure's values.

Sketching a composition

In composition studies or outlines, the anatomy or movement of the figure is not as important as its location within the composition. Blocking in the figure with simple straight and curved lines can resolve this. It is always worthwhile to sketch this before formally beginning the drawing. It is sufficient to trace a box with similar proportions to those of the work we will study, and practice drafts in the box with just a few strokes.

A malleable eraser can modify the shape or position of marks.

Finish by accentuating certain contours and shadows in order to characterize the figure.

Landscape sketches

Sketching the landscape establishes order in a represented panorama, and connects, compares, and classifies the different sensations of light, form, and color in nature. There are several factors that create this order, namely, blocking in the composition, its proportions, evaluation, contrasts, and perspective. Properly and powerfully synthesizing these elements is essential.

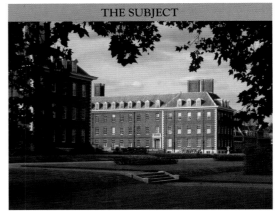

THE SUBJECT

This photo of buildings in a park, taken for a series of sketches, can give rise to various approaches that emphasize aspects of framing, questions of line, hatching, and mark making.

This sketch sought a balance between its various planes. The leaves at the top, developed with marks, emphasize the foreground.

Synthesis of the panorama

There are some landscape motifs whose perspective is unique and particular. In some cases, these are subjects with strong contrasts and a wide range of values In other cases, they are subjects that require a review and clarification of dimensions in order to represent what their defining features are. The secret of synthesis is to capture the characteristic factor in each natural motif and render it, setting the rest aside. The value of landscape sketches lies within this close attention paid to just one aspect of the subject.

A series of marks is the dominant feature in the shadow of the building on the left. Contrarily, the building on the right was created with very simple lines.

Comparing and contrasting

Regardless of framing or creating perspective, always try to compare the dimensions, values of light and shadow, and lines with each other. Electing to focus on some of these elements creates a landscape sketch quickly and effectively. If a characteristic aspect of the subject is, for example, a dark shadow that contrasts the rest of the subject, the artist may isolate this and enhance it in their drawing.

SKETCHING WITH MARKS

A mere smudge can be enough to suggest part of a landscape. Bear in mind that the capricious irregularity of nature mimics the somewhat random and brusque shape that a charcoal or ink mark may have on the drawing paper.

When working on color supports, the aid of the white pastel (or white chalk) pencil is necessary to give the sketch the required contrast of tones.

Landscape sketches based solely on line facilitate drawing in great detail, but will lack the peculiarity of sketches characterized by marks.

Hatching is the essential technique for creating zones of shadow in the landscape sketches based on line.

Urban sketches

The street is the stage of modern life, where the artist will most easily find subjects for their sketches. The discomfort of working conditions and the fleeting nature of scenes can often put people off. However, from time to time it is worth undertaking an activity that is both interesting and useful in terms of practicing sketches. These two exercises were done by Vicenç Ballestar.

SKETCH 1:
THE STATIC FIGURE

This drawing was done very quickly, as befits an urban sketch. The pencil was hardly raised from the paper and the form and gesture are resolved with admirable economy of means.

The underlying shapes conserve the elegance already present in the drawing. The body was given shape with just a few splashes of blue and black ink, with no need to work on the shading or modeling of the folds.

However common such a scene is, artists very rarely capture it. Here, this figure on the phone is worked out here with a few ink wash spots, preceded by a skillful drawing that organized all aspects of the drawing.

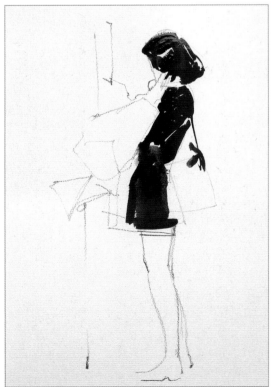

The space in which the figure appears can be explained in just a few lines of very faded ink. Thus, the sketch is perfectly framed.

THE SUBJECT

The drawing is a linear synthesis of both figures' movement. This interpretation captures the essential nature of the moment.

Of course, a photo conveys different information than a drawing; the photographer's still is different from the artist's drawing. Here, we will deal with a mother and her young son.

A few areas of watercolor enhance the basic volumes of the figures without obscuring the clear lines of the drawing.

SKETCH 2:
FIGURES IN MOTION

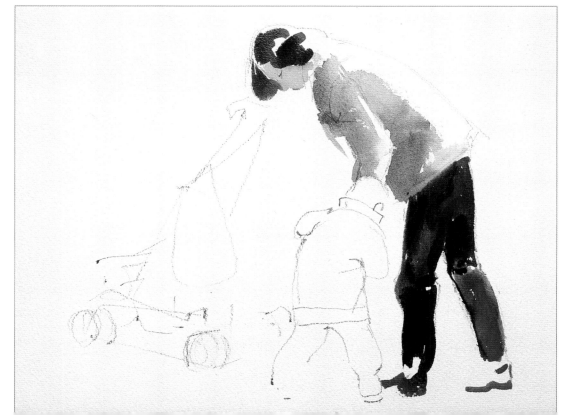

Some details are more than enough to characterize with greater clarity the figures and highlight their movement. This "immediate" sketch of an urban scene requires nothing more.

Sketch of a nude figure

A sketch can be many things, from a very quick outline to a complete drawing done calmly in just one session in front of the model. The work done in this exercise, by Vicenç Ballestar, is a drawing in its own right, but it is also a sketch done very quickly. The conservative lines and dramatic, yet minimal, development emphasize this. A work that seems unfinished is the intention.

ESTABLISHING THE POSE

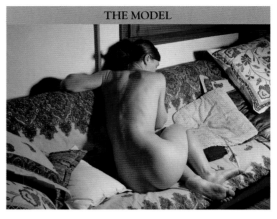

THE MODEL

Artists often focus only on the figure itself when drawing the nude human form. This representation of the model doesn't take her surroundings into account.

1. With sepia-colored chalk, roughly sketch in the pose, trying to keep all the parts in their right proportion. The lines must explain as much as possible with the fewest possible mediums.

2. Blend the chalk lines to create an initial first sensation of general volume. The work was done quickly to obtain an overall view of the body.

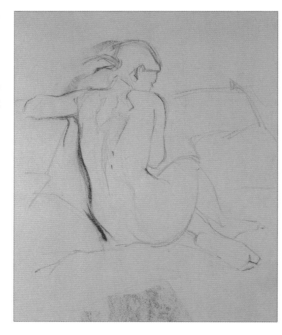

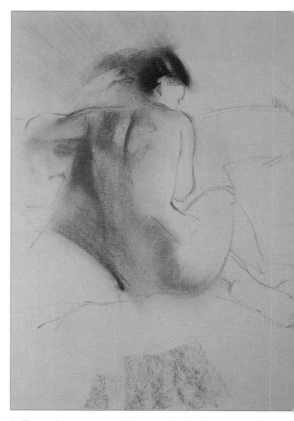

3. The work progresses quickly during the blending process. The chalk strokes are extended in order to create a convincing and coherent overall volume.

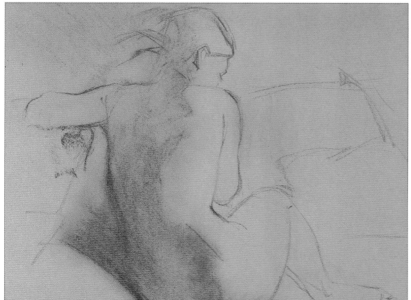

STAGE 2:
SUGGESTIONS OF VOLUME

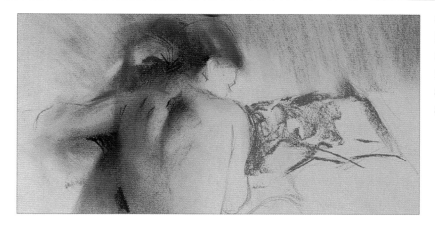

4. Energetic blending tones beside the figure suggests the plane of the wall. The subtle modeling of the back is sufficient to reveal show her anatomy clearly.

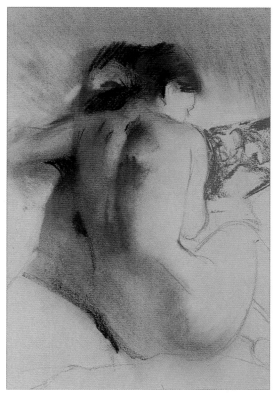

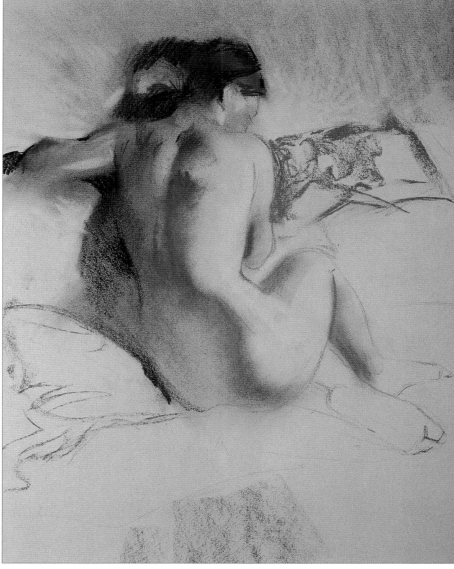

5. Reinforce some shadows on the back so that the shading does not take on too misty an appearance. This also creates a sense of strong illumination from the side.

6. The final drawing. The hips and legs are suggested more than fully rendered. This is an effect the artist was looking for: it emphasizes that it is just a sketch and allows the composition to be easily reconstructed and further developed.

EXPRESSIVE DRAWING

Art requires a distinction between copying and personal interpretation. Expressive drawing relies on all the skills, resources, and styles of an artist to transform a subject. In expressive drawing, the subject is not an object to be copied or replicated, but something that should be repurposed and recreated. Creative artists should not limit themselves to reproducing what appears before them, but instead should look for opportunities to let their own artistic vision and creativity flourish.

Henri de Toulouse-Lautrec, *Caudieux.* (1893). Musée Toulouse-Lautrec. Fantasy, even whimsy, are perfectly plausible starting-points if the artist confronts drawing as a genuine work of art.

A subject is something that the artist has to recreate by using all the resources and materials they have. In this process, subjective drawing becomes a genuine artistic practice.

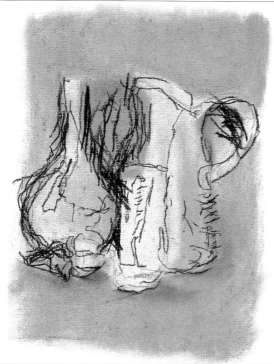

Here, the pencil line favors subjective sensitivity over accurate and realistic description of shapes. Work by Gemma Guasch.

The laborious composition of this drawing does not aim at a conventional finish, but rather a personal definition of the artist's style. Work by Pere Belzunce.

Personal style

Style can be defined as the set of technical abilities and aesthetic values that characterize an artist's work. In an artist's work, there are a series of constants that repeat; these define their style. One of these constants, perhaps the most important, is the way in which shapes are constructed. Full, rounded shapes characterize some artists' work, other artists stretch out their figures, while others are known for the softness or hardness of their outlines. Everything is valid as long as the work is consistent.

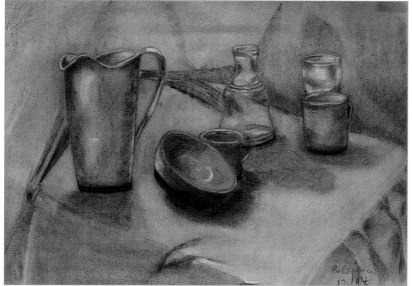

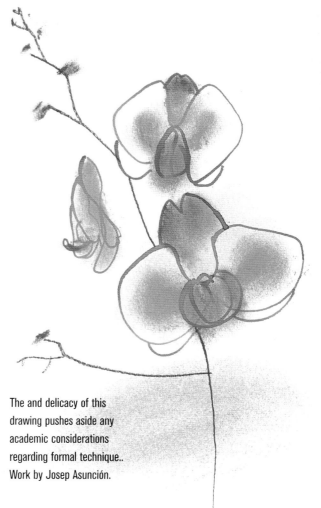

Expressive drawing

A drawing is expressive when it possesses internal vitality, when the subject appears as an animated grouping and not as pure representation. If artists capture the life of the subject, they have managed to be expressive. When the work is coherent and attractive due to its grace, elegance, originality, or any other virtue, then it is expressive, because these stylistic qualities make it a genuine artistic creation.

The and delicacy of this drawing pushes aside any academic considerations regarding formal technique.. Work by Josep Asunción.

Interpretation

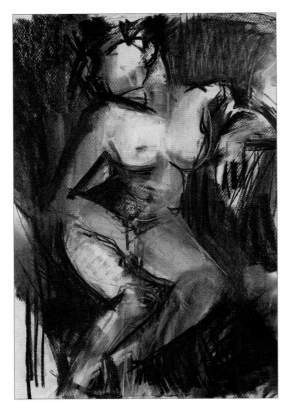

I f objective drawing aims to represent the subject on its own terms, interpretation involves translating the subject into the artist's own personal and subjective style. In general terms, three criteria form the basis of interpretation: exaggerating certain features of the subject, reducing them, or omitting them completely. These features, according to the artist's intention, may be shape, hue, light, or form. Altering these features still requires that the artist remains faithful to their own reaction to the subject, and not the literal details of the subject.

A traditional subject interpreted with mediums that are also traditional, in line with the particular rhythms of the artist's mood. The result is suggestively expressionist. Work by Josep Asunción.

This simple subject has given rise to the two interpretations, seen here, which take and exploit partial suggestions of the subject.

The natural softness of the subject is implicit in the light strokes of in India ink. Work by Gemma Guasch.

The silvery tone and the unstained purity of the piece of paper express the coldness of the snow. Work by Gemma Guasch.

Emphasis and reduction

Artists should express their personal impression by emphasizing those features they consider essential, reducing secondary ones and suppressing accessory ones. What is essential for one artist may be superfluous for another. Every experienced artist knows that their work often moves so far away from the actual subject that it can be hardly recognizable in their work. The important goal is that the artist's emotion prevails over faithful representation and that the drawing conveys this to the spectator.

The rhythm of the drawing

In music, rhythm is the repetition of one or several sounds at equal intervals. A rhythm can be extremely annoying if it does not incorporate variations. The same applies to visual rhythm. To be successful, a drawing needs repetition. For example, repeating the angle of a tree trunk or its branches in another part of the composition, or repeating the shape of one house in another distant house will enrich the drawing, and make it more visually interesting.

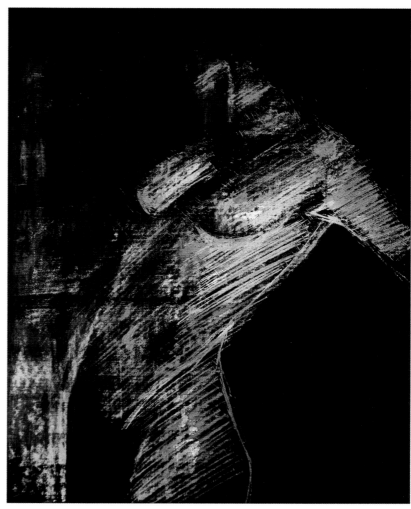

This drawing combines traditional chiaroscuro with a contemporary sensibility. Work by Josep Asunción.

The graphic game

Markers and other writing media offer opportunity for graphic experiment. The use of line and the light-filled color are the main features at work here. Work by Josep Asunción.

Some artistic mediums are graphic and monochromatic, rather than pictorial, although a subject may be better represented in paint or another color medium. The key to expressive drawing resides in combining and taking advantage of all the possibilities that these mediums provide. Accuracy can easily lead to stiffness and coldness in a finished drawing. Freedom and experimentation are the stamp of the creative artist who finds that a mere copy of the subject is not enough.

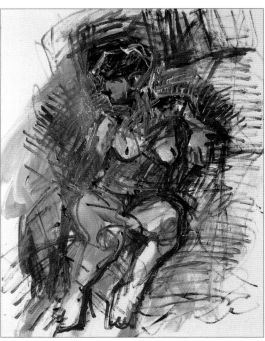

Crayons and oil pastel sticks are mediums halfway between the graphic and pictorial worlds. In This drawing they are employs them in full graphic force. Work by Josep Asunción.

Freedom of line

Experience in conventional drawing is the foundation of interpreting a subject. This means that the drawing's lines will be based on inspiration and experimentation, but will still capture the basic form of a subject, making it recognizable to the viewer. A fluid line is graceful and attractive, and can exaggerate certain features of the subject.

MIXED MEDIA

Mixed media combines various drawing media in a single work. In general, works in mixed media overlap dry and wet techniques (crayon and water color, pastel and ink etc.) and must be carried out so that some mediums highlight others without entering into conflict. It is a field suitable for all kinds of experimentation and boldness.

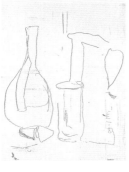

This simple subject gives rise to two very different graphic responses. The two are posed in personal, subjective terms, and are equally interesting.

The freedom of marks

Line-based drawings gain a graphic quality with marks. There are many possibilities for complimenting these types of drawings, all of which are based on using materials freely and spontaneously. Often, marks give better results when they are not used solely for describing shadows. Rather, they should create general contrasts throughout the drawing.

Charcoal and pastel worked on handmade paper emphasize the suggestion of vegetation texture in the subject.

Colder and more graphic interpretation, which clarifies the random twists and turns of this form, inspired by a plant.

The unfinished drawing

Suggesting forms without fully representing them is one of the attractions and charms of creative drawing, leaving the spectator to wonder about the form and complete it with their own imagination. This is an important factor in removing excessive literal representation from the work. Depending on the subject, some fragment or element can be left out in order to draw the attention of observers toward this point and allow their imagination to fill in the missing pieces. Suggestion is always more intriguing than the obvious, explanation.

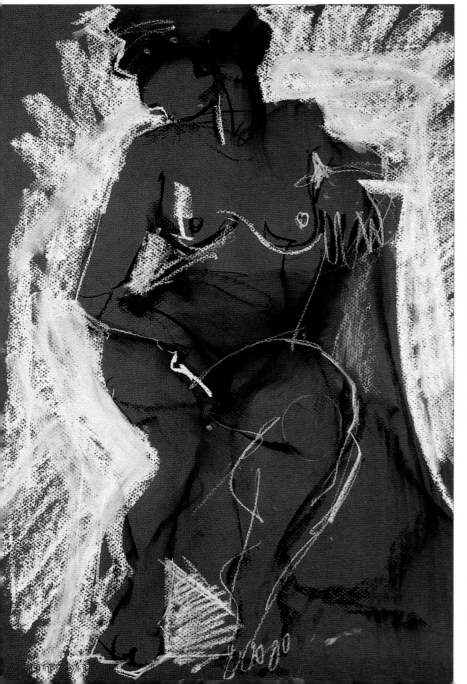

The play of color between the support and the pastel strokes is rich and suggestive. The unfinished portions of this drawing are positive elements in the work. Work by Gemma Guasch.

An unexpected contrast between figure and background is sufficiently achieves a vibrant expression that requires no further details. Work by Josep Asunción.

SYNTHESIS AND SUMMARY

Visual selection is basic to a painter's ability to work in an uninhibited and comfortable way, without constant corrections or changes that introduce confusion into the work. Unifying, summarizing and leaving the spectator to guess are essential concepts.

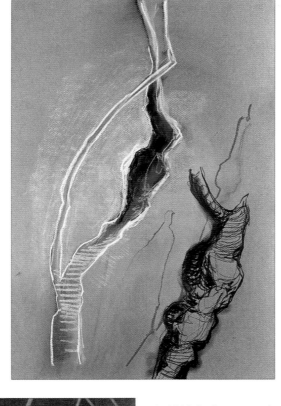

Graphic trial and error that actively seeks a solution instead of a definitive conclusion. It is artistically interesting, in spite of its unfinished nature. Work by Josep Asunción.

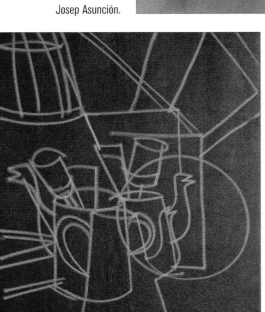

An initial plan for a geometric interior that features the relationships between form and space. The ambiguity as to whether it is part of a process or a final result adds to its appeal. Work by Josep Asunción.

The plainly unadorned geometric and linear form provides this still life with adequate vitality and visual force. If shading had been employed, it would disrupt the grace of this energetic drawing. Work by Josep Asunción.

Unfinished fragments

Unfinished forms do not necessarily mean that the artist was careless. Sometimes, leaving the form suggested rather than defined keeps the viewer's attention moving throughout a piece. However, this unfinished form must contain enough visual information to allow the viewer to understand it and reconstruct it imaginatively.

The unfinished form can appear in a secondary fragment of the subject, but the artist should not employ this as a way to avoid certain technical shortcomings.

Visual selection

When artists observe and study their subjects or models, they focus on and develop certain features that provide the most opportunities for artistic elaboration. The experience of drawing forces the artist to choose, for example, the features that best lend themselves to playing with hues and experimenting with mark making, leaving out the details that are less intriguing. Merely copying a subject may only engender inexpressive results.

Stylization and distortion

Stylization of form, seen in the peculiarities that appear in many great drawings, is sometimes deliberate and sometimes involuntary. The movement of lines and direction of strokes, for example, are aspects of a drawing that result from an artist's own inherent style. Elements of a drawing that aim to create unity and a general coherence are usually deliberate. This may lead to distortions that are, in reality, an aspect of the cohesion the artist seeks.

Marks dissolve contours. This is a representation of a figure whose features have clearly been distorted.

Conventional starting point: a correctly executed figure drawing can lead to an array of interpretations that feature various points of graphic interest.

Transformation as interpretation

Every interpretation inevitably results in some alteration of the objective appearance of the subject, depending on the artist's style. In this sense, all interpretation is, essentially, transformation. This also means that the more personal and subjective an artist's style is, the greater the ability to change, manipulate, and repurpose a subject will be.

This drawing synthesizes different examples of experimentation and illustrates graphic blocks that decisively depart from a conventional representation.

A monochromatic mark adds an interesting graphic quality to a subject.

Interpretation of the rhythms of the pose that adds supplementary interest to the graphic form.

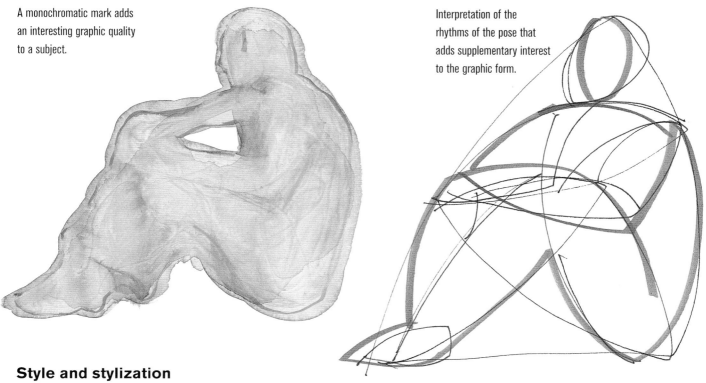

Style and stylization

Stylizing a subject does not necessitate distorting it, but, rather, subjecting its parts to a cohesive, formal, "law," or style. For example, if a painter's style is angular, all of their forms should reflect this tendency towards angular forms. Otherwise, the overall work may appear incongruent and inconsistent. Cohesion results from personal style attained after much practice and work, not the indifferent execution of techniques found in a manual.

The same still life recreated through bold marks that evoke traditional chiaroscuro, but in a highly stylized and personal manner. The subject is the same, but the artistic intentions are vastly different. Work by Josep Asunción.

This still life is interpreted very graphically yet with a light touch, combining lines with a marker and watercolor. Work by Josep Asunción.

Interpretation of a still life

For creative artists, almost any subject is a positive stimulus for combining resources, playing with a medium, and pushing the limits of the subject's form. Here, a still life provides a great opportunity to exercise these creative impulses. The subject features a plate of pomegranates, walnuts, and dry leaves, composed by Josep Asunción. The circular shape of the plate encapsulates all the elements of this subject, and, in turn, becomes the main focus of this work.

THE SUBJECT

The still life subject appears very simply: everything falls into place around the plate, which contains the main elements. The composition conceals nothing from the artist.

STAGE 1:
GRAPHIC DEVELOPMENT

2. A gray wash partly covers certain lines by blurring them with a damp brush. This effect is deliberate and softens the excessive hardness and precision of the ink strokes.

1. After drawing some axes in the middle of the paper in order to distribute the composition harmoniously, draw in the elements with a pen-nib from a bird's eye view, so that its entire form can appear in absolute clarity.

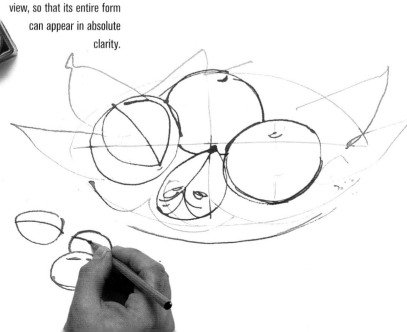

3. A new wash effect, this time in ochre, enriches the drawing and highlights the white areas at the center of each fruit. Extend the marks, paying attention to the contrasts without trying to draw the leaves realistically.

STAGE 2:
ASSESSMENTS AND CONTRASTS

4. Take up the nib again and highlight some profiles through simple hatching that only suggests the shadows (the hatching does not actually darken the shadows).
Reinforce this new graphic contribution with another wash that covers and unifies everything.

5. On top of the previous wash, now dry, make marks in ochre to outline the outer contours of the leaves and reinforce the three-dimensional feel of the drawing.

6. A large black mark in the center of the composition further highlights the areas affected by light, and creates a strongly contrasted area that conveys solidarity and three-dimensionality. This mark, not found in the original model, is a creative addition that adds volume to the work.

A floral interpretation

The irregular, capricious shapes of the flowers allow our imaginations to soar while requiring us to look for new ways of unifying and characterizing their complex appearance. Two possibilities for doing so will develop in this work by David Sanmiguel. Use a nib to apply black and red ink to create a graphic development full of very interesting paths and suggestions.

THE SUBJECT

The great many details in the subject make it complex. It necessitates an interpretation that primarily establishes the basic contours of the flowers and leaves the details for later.

STAGE 1:
GENERAL CONTOURS

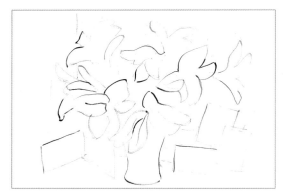

1. After an initial pencil (HB lead) sketch, go over the lines with a nib and black ink. It is important not to overload this initial drawing with unnecessary details, and to establish a simple structure that will develop and become more complex throughout the entire process.

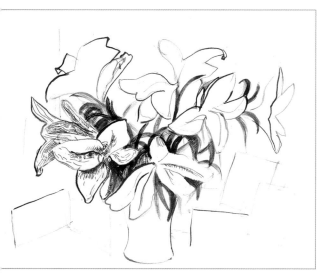

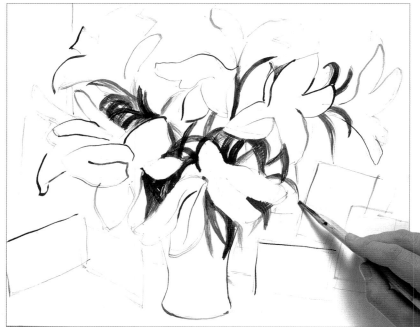

2. Without touching the interior of the flowers, draw the leaves and stalks with groups of strokes that are very close together to give the leaves a solid appearance. It is not necessary to draw them all, but make the group seem convincing.

3. Now start to draw the most significant details of the internal structure of each flower with red ink (burnt sienna).

STAGE 2:
FIRST HATCHING

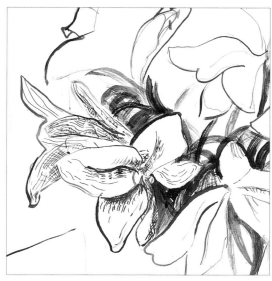

4. This hatching describes the interior of the flowers. This is not so much an exercise in shading with traditional hatching as it is an opportunity to create a spotted pattern that captures the texture of the petals.

5. Each flower receives a somewhat different treatment, depending on its shape and position. Avoid dense hatching that gives weight to the form. The nib work has to be delicate and light.

6. After working on the various areas of the bunch of flowers, nuance the background hues. Here, conventional hatching can darken and provide the background of the composition with a shadow.

STAGE 3:
LIGHTS AND SHADOWS

7. The nib can correct minor errors with a little white gouache to cover the areas to be modified. However, this is only possible when the lines of ink are thin. Otherwise, they may run.

8. When the gouache is dry, you can draw again on the corrected area with the nib, taking care not to scratch the layer of paint or accumulate ink in this area.

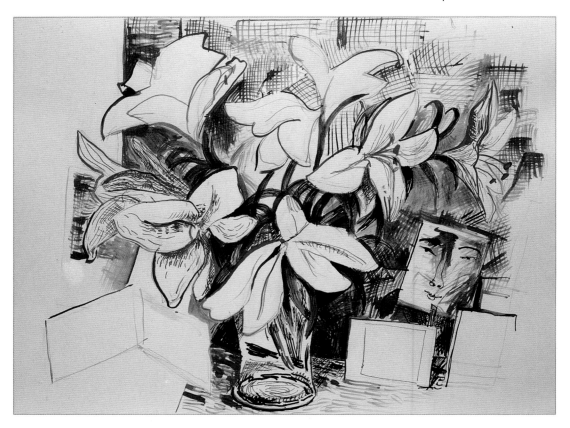

9. Apply the successive hatching to the background of the composition shading the zones that are next to the lightest parts of the bunch of flowers. This contrast highlights the light hues of the flowers.

STAGE 4:
THE FINAL TOUCHES

10. Concentrate on the secondary areas, the ones that surround the center of the composition, only at the end of the process. In this case, the cards and photos that surround the flowers can still be built up without acquiring too much detail.

11. It is neither necessary nor advisable to work on these details too carefully, since they are minor details of the work. Suggesting textures and patterns suffices; the viewer's imagination should do the rest.

12. At last, the work is finished. The drawing is the result of the artist's careful observation and free interpretation. The key to drawing creatively and imaginatively lies in the unification of these two factors.

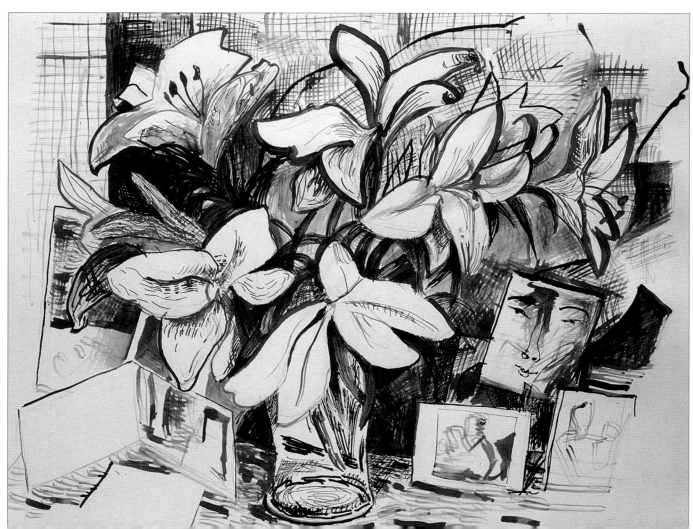

- **Still life drawings**
- **Landscape drawing**
- **Drawing animals**
- **Drawing the human figure**

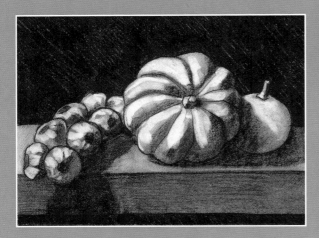

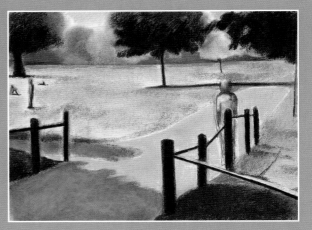

The final chapter of this book demonstrates the key points introduced in previous sections, while reviewing the characteristics of an array of artistic subjects.

Still lifes, landscapes, and figure drawings pose different issues, since each evokes very different feelings and emotions. The approach for tackling one of these types of drawing may not be right for another. In addition, the artist should not consider these subjects as absolutes, as there is an infinite amount of variations that can be made on each; the artist does not draw a generic landscape, but a specific landscape. To clarify this idea, this chapter details works that exemplify the endless possibilities for each subject, while covering several demonstrations that explain their technical development.

Each drawing subject should be treated with the appropriate technique and style. Because these styles suit some subjects better than others, it is important to establish these differences from the beginning. These pages aim to provide guidelines for the artist in making these stylistic decisions.

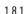

AWING
Subjects

STILL LIFE DRAWINGS

A composition arranges the elements of a drawing in an organized and harmonious way that is pleasing to the eye. A well-composed drawing is similar to a properly designed building whose many parts integrate naturally with each other. In a still life composition, this integration and design is crucial. The artist organizes the subject according to their preferences by choosing objects and arranging them. This process of planning and constructing a composition well before beginning the drawing is advantageous and provides for a myriad of artistic opportunities.

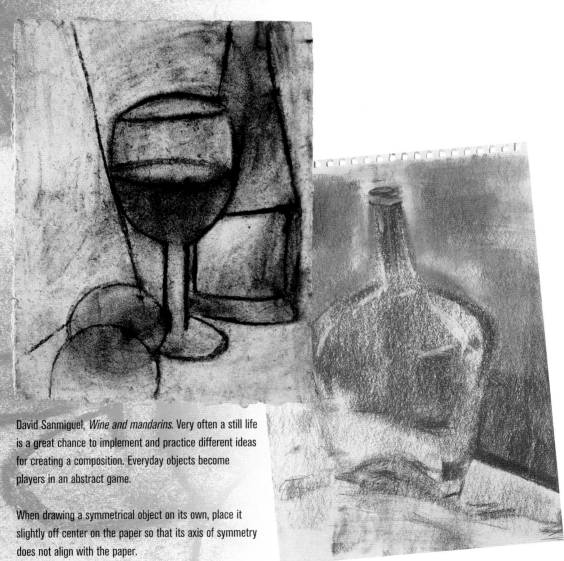

David Sanmiguel, *Wine and mandarins.* Very often a still life is a great chance to implement and practice different ideas for creating a composition. Everyday objects become players in an abstract game.

When drawing a symmetrical object on its own, place it slightly off center on the paper so that its axis of symmetry does not align with the paper.

In a still life, the composition begins long before the actual drawing does. The artist should thoughtfully organize their subject by selecting and arranging objects.

FREEDOM AND ASYMMETRY

An asymmetrical composition offers greater artistic freedom, as the distribution of objects is more intuitive and relies on various alternative procedures to achieve balance. Because asymmetry resembles our natural way of viewing the world, it evokes a sense of naturalism and realism. Asymmetrical works tend to demonstrate variety, movement, and spontaneity. However, asymmetry in excess can spoil the composition.

The displacement of objects and their forms appropriately disrupts the symmetry of this composition. Work by Esther Olivé de Puig.

Ordering the still life

The principles of unity (symmetry) and of variety (asymmetry) are essential guides for successfully approaching the composition and execution of a still life drawing. They are particularly useful in creating drawings in conventional formats. The subjects should not stand too close to each other nor be too dispersed, and should be proportional to the dimensions of the paper.

Two objects placed next to each other must have clearly defined and distinct shapes in order to avoid an unintended and unexciting relationship between them.

Symmetry and asymmetry

Symmetry concerns a balance of lines and shapes, from which the drawing gains unity. Symmetry and asymmetry are the two extremes between which stands a pleasing composition. Therefore, total symmetry and asymmetry are unadvisable. Symmetry is the easiest and most secure way to convey a sense of immobility, but puts the work at the risk of being less visually pleasing.

Dispersion and total asymmetry: the center of the composition is empty and the objects have very little relationship with each other. The composition's unity seems accidental rather than deliberate.

Organizing the still life

In composing a drawing, the simpler the subject is, the more freedom the artist will have. Ideally, subjects naturally give clues as to what format or composition would suit them best, but, more often, artists fit these subjects into a general composition to ensure the overall harmony of the drawing. Bear in mind that the format and dimensions of the paper affect the composition, and take the shape of the subject into account when choosing the format of your paper.

Still life drawings organized in orthogonal compositions emphasize the spatial clarity and order of "reading" each item in the drawing. Work by David Sanmiguel.

Orthogonal compositions

Orthogonal compositions organize drawings on the basis of a right angle, sometimes arranging subjects in an "L" or "U" formation. They establish a secure sense of balance in a drawing, particularly in those containing several different objects, and accommodate almost any type of subject. An orthogonal composition assumes a horizontal distribution of objects at the bottom of the drawing, with a sense of verticality on one of its vertical edges, or on both. The space left above the "L" formation of objects appears to have depth, providing a counterweight and balance to a basic subject.

Orthogonal composition (the marked presence of verticals and horizontals) is synonymous with stability and suggests natural ease.

OVAL COMPOSITIONS

The oval format evokes Romantic art, in particular, portrait painting, but there are also a lot of examples of still life drawings in this format. Ovals are not easy: the objects must fit into an unusual space framed by a curve instead of an angle. For this reason, curved items or items that can be drawn from ovals that harmonize with the composition as a whole are desirable.

Composition diagram dominated by right angles, featuring a frontal view.

Diagonal lines usually dominate the composition of still life items grouped around a dominant object.

Diagonal composition

For achieving depth and dynamism in a drawing, utilize methods that are strictly compositional, the simplest and most efficacious of which is diagonal composition. This entails diagonals crossing paper or a canvas to suggest depth. Artists use this type of composition when relying on a certain perspective in which the viewer's eye follows a trajectory to the back of the drawing.

Compositional diagram that combines a diagonal layout with the clear presence of the right angle.

Diagonal compositions project the still life in depth, translating the movement inside into a vertical displacement from one side to the other of the paper.

Still life subjects in nature

An everyday object can form part of a still life. By process of elimination, a still life is anything that is not a figure or a landscape. The combinations of disparate elements are infinite.

But there are many general guidelines for the artist that make the still life exciting and more interesting.

A grouping of vessels is interesting in itself, beyond any firm criteria of composition. These glass bottles create a very lively rhythm of lights and shadows.

Even one vessel, if expressed in an artistic way, sufficiently enlivens a composition.

Food and vessels

Fruit is not the only valid subject for a still life. A stroll through a well-stocked market can reveal an array of potential subjects. Meat, fish, and vegetables are great sources of inspiration. These are ideal subjects for a still life, because they provide a magnificent presentation and natural quality to a drawing. The wide varieties of textures and characteristics that fresh food conveys spark any artist's interest.

Food, especially fruit, is a recurring subject in classic still life drawings. But modern sensibility can adapt and renew these traditional subjects. Drawing by Esther Olivé de Puig.

Musical instruments

These are the classic motif of an infinite number of still life drawings by various artists. The variety and elegance of their shapes, tones, and materials makes them attractive subjects. Most classical instruments, particularly string instruments, make beautiful still life subjects. By incorporating one of them in a composition, the drawing gains complexity and significance, since traditionally, instruments represent the arts and artistic sensibilities.

Musical instruments are excellent subjects for a still life. This drawing utilizes metal instruments with sharp contours and a cold, bright tone.

Still life with flowers

Flowers are perhaps one of the most attractive subjects for a still life. They require little elaboration and their varied formal characteristics adapt to any artistic style. Drawing flowers can implement classical techniques such as blocking in, profiling their contours, and shading. However, the particular texture and consistency of petals and leaves also encourages a freer, more spontaneous drawing technique.

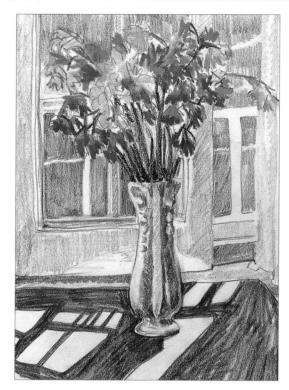

Flowers are sufficient as the only item in the composition. The enormous diversity of their shapes, sizes and colors makes up for the compositional simplicity of works such as this one, by Esther Olivé de Puig.

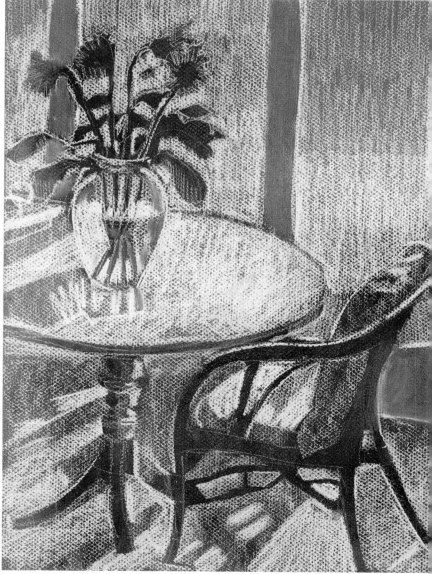

Although they may take on a role of secondary importance in other compositions, flowers take the lead in a still life.

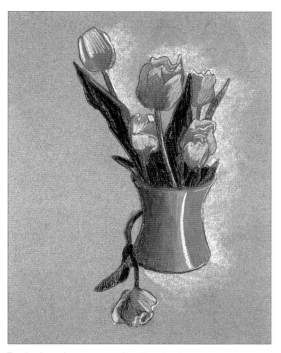

Tonal values characteristic of single-color drawings or drawings, like this one, can evoke the color of flowers with just three colors.

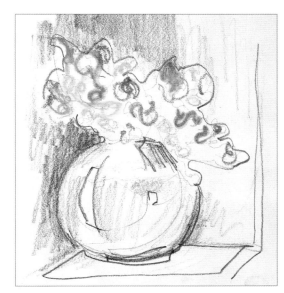

Freedom of line and marks are always good methods for drawing flowers.

Flowers invite artists to implement all the graphic whims that they are capable of: arabesques, free hatching, strokes in different directions, soft lines, marks, etc.

Shape and contour

In most cases the delicate tones of flowers require a minimal development of their shape, in order to avoid overshadowing and dominating the shadows that give form to the petals. To achieve this without weighing them down, darken their contours so that the interiors of their form appear highlighted in contrast. When blocking in and drawing, this darkening may simply require a light definition of the petals' contours until the shape can be surrounded with a dark area later, allowing the petals to stand out.

Graphics

Flowers may be no more than a scribble, or a group of scribbles, in the drawing. Floral form is so mobile and non-specific that a more or less ordered grouping of marks and lines can stand in for a representation of flowers. Free-flowing lines strongly suggest the character of the stalks, leaves and other details of the flowers. The best media for this treatment are the ones that permit the greatest precision and freedom of stroke, such as pens, nibs, marker pens, and lettering and writing instruments.

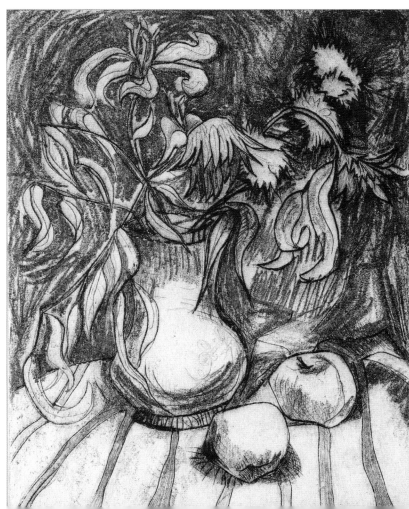

A composition in relief

This will be a simple drawing in terms of the general representation of the subject matter, but highly elaborate in its finish and final definition. It is a still life, based on a frieze. While it is not an actual frieze, it is informed by their typically long, horizontal planes. In addition, it relies on techniques that give it the illusion of being a sculpture in relief. This will become clear in the first steps of the drawing.

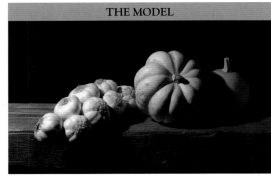

THE MODEL

Some gourds and a string of garlic on a shelf. A traditional subject organized in a traditional way. In addition, the strong lighting and chiaroscuro create an atmosphere that is appropriate for the appearance of the subject.

STAGE 1:
PLAN OF COMPOSITION

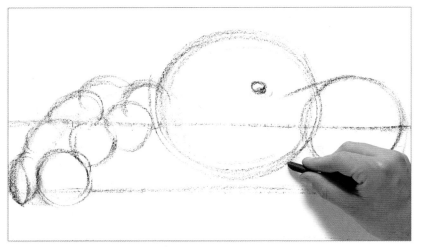

1. First, draw the general shape of the objects in the still life. This is a time to draft the composition and schematize it, rather than a time to represent the details of the subject.

2. Begin with a sphere as the basis for the gourd, upon which other volumes will be drawn. Without worrying about perfect geometry, trace meridian lines around the sphere.

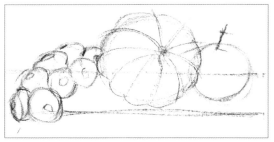

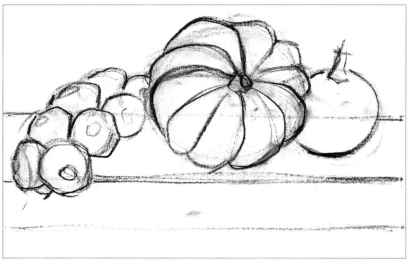

3. Then, press down a bit harder to make dark strokes that show the real outlines of the objects. This requires no detail at all, but all the items should be distinguished clearly.

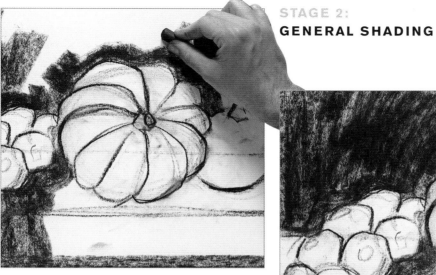

GENERAL SHADING

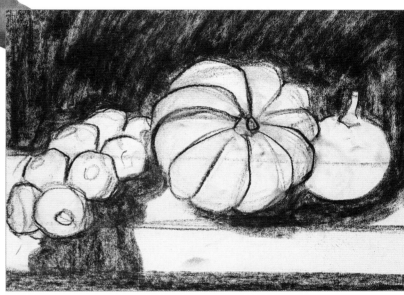

4. Cover the entire background with big charcoal marks. Work freely and loosely, rubbing the stick flat against the paper until you have reached the desired intensity of tone.

5. This is what the drawing looks like during this initial, general shading. Although it looks quite dark, bear in mind that rubbing your hand over it will lessen its intensity and create a smooth, shaded texture.

6. Blur the shading with your fingers. The charcoal dust spreads right across the paper, respecting the contours of the items in the still life.

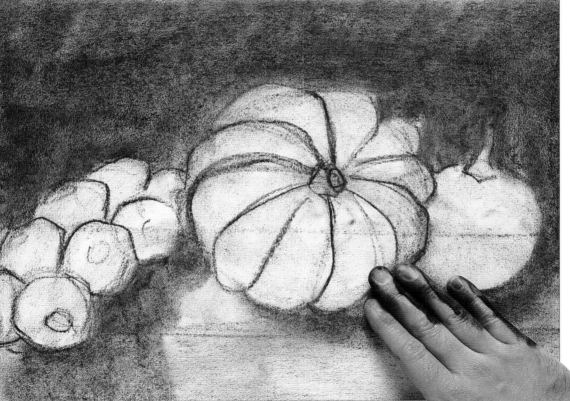

STAGE 3:
ADJUSTING VALUES

7. Here, you can see how the blurring of the charcoal creates a toned background on which it is easier to work and control the various intensities of the shading. After blurring, go over the lines again.

8. This new shading now seems more realistic and represents the items' own projected shadows. The process will be the same as before, except now, it will be important to consider the shape of the marks made.

9. Blur the previously traced shadows again, but this time, pay attention to the volumes of the gourds and garlic bulbs.

STAGE 4:
FULL CHIAROSCURO

11. Take care with the contours to make the chiaroscuro more effective. The areas of maximum contrast must set the deepest black against the brightest white.

10. After modeling each object in the drawing, darken the background of the composition with a charcoal stick, making definitive and dense strokes.

12. To reinforce the contrasts to the maximum, clean up the illuminated parts of the gourds and garlic bulbs with a rubber eraser. The finished work mimics the grandiose appearance of Baroque still life drawings.

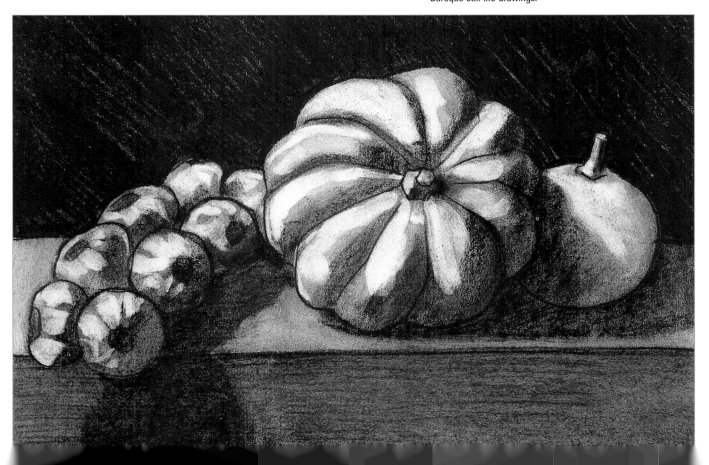

LANDSCAPE DRAWING

*L*andscape drawings express all of nature through its individual parts. The same basic principle of landscape art governs both drawing and painting: recreating a feeling of nature by giving priority to a set of features that the artist believes are significant, or fundamental. This selection of features is the decisive factor and must be based on experience and understanding the means of expression that are characteristic of landscape artists.

Titian (1480-1576), *Pastoral scene*, (1565). J. Paul Getty Museum. Classic landscape is always a secondary counterpoint to the main subject. In this case, the main subject (apparently mythological) is a vehicle for developing an idealized vision of landscape.

The landscape artist recreates a feeling of nature by emphasizing certain significant features and sidestepping others.

Landscape Drawing **195**

Selection and combination of items

Landscape drawing is based on the choice and combination of significant elements in the motif, changing their form and size according to a concrete principle of composition. In summary, every drawn landscape is a free interpretation of the motif, as every artistic work is. The practice of landscape drawing requires the artist to emphasize certain features, diminishing others, and eliminating some. These features are often concrete visual elements of the panorama. These alterations can be significant, and can allow for a deliberate exercise of autonomous composition based on real observation.

Paul Cézanne, *Landscape of Provence*, Kunstmuseum. Impressionist landscapes are based on recording apparently unconnected sensations of light and shadow that do not necessarily coincide with the objects in the landscape.

Impressionist drawing and constructive drawing

Open-air drawing favors landscapes based on capturing fleeting aspects of the motif chosen. In short, this is a drawing based on the principles of impressionist practice. Composed or constructive landscape style is similar to abstract painting, in which the artist combines memories of landscape with real perceptions, without concerning themselves with creating a realistic description. While a composed landscape does not capture the fleeting and temporal aspects of the motif, it is an accommodating way to work, both for painters who prefer to elaborate their works in the studio with observations from nature, and for artists who begin their picture in front of the motif and finish it in the studio.

The modern landscape artist can opt for one of the characteristic possibilities of landscape drawing (or a combination of the two) to achieve atmospheric unity, as the landscape reproduced here demonstrates. Work by Mercedes Gaspar.

Georges Seurat, *House beside a river*. The Metropolitan Museum of Art. The constructive landscape searches for formal clarity, sacrificing detail and the momentary play of light: bright contrasts and play of well defined lines.

The composition of the landscape

Landscape is not something that a view can capture, rather, it is a continuous and limitless spectacle. The artist must frame their drawing by selecting features and fragments of the landscape that best fit their intentions and visions for the work. To frame the drawing is to define its limits in accordance with its composition criteria.

The frame

Much of a drawing's attraction depends on how it is framed. Since every landscape always has its own peculiarities, choose one characteristic that is more interesting and relevant than the others. Depending on the landscape before which the artist stands, these frames can be vertical or horizontal, square or rectangular. The decision depends on the elements you choose to isolate. Vertically oriented subjects (trees, buildings etc.) are usually best resolved by vertical frames, whereas broader frames respond to more extensive and deeper panoramas.

To compose is to select, and to select one element is to discard or eliminate others. When you opt for a particular feature of the landscape, abstracting yourself from the rest, you are engaged in a genuine exercise of framing and composition. Work by David Sanmiguel.

The framing of the landscape does not necessarily have to include outstanding features of the view. Searching for corners hidden in the overall view can yield as interesting results as trying to represent broad panoramas. Work by David Sanmiguel.

PRACTICING FRAMING

Framing a landscape subject usually necessitates its simplification. The landscape as we initially see it at first is wrought with details that may conflict with each other, taking clarity away from the subject. In order to select the elements on which to focus, sketch several frames, each one focusing on a different motif.

The foreground and middle ground depend on the artist's choice of a frame and their position before their subject. In this drawing, the fragment of boat visible at the left of the frame emphasizes the foreground of the scene.

Gaining distance

To choose a good frame, it is essential to distance yourself from the landscape in order to clearly see its various facets. A broad panorama without too many visual obstacles in the way allows the artist to select its most attractive aspect. Normally, this means going up to high positions that let you take in a large amount of space with just one look. Once you have decided on the frame, then you may highlight, exaggerate, reduce, or eliminate any of its parts.

It is difficult to establish the frame of a composition after only one try. Most of the time, successive sketches and multiple studies of the motif resolve the frame.

Point of view and the horizon

The presence of the horizon is one of the basic features of a landscape representation. Whereas in other artistic subjects, the horizon is of secondary importance, in landscapes, the horizon is always present and determines the spatial depth of the subject, affecting the entire composition and suggesting what kind of drawing the artist must attempt.

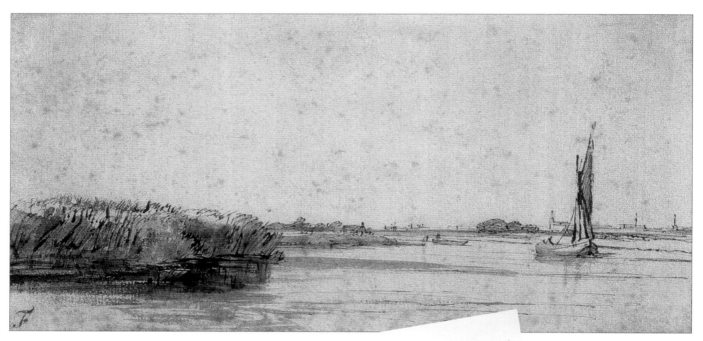

Rembrandt (1606-1669), A *Sailing Boat on a Wide Expanse of Water*, (1650). J. Paul Getty Museum. Low horizons characterize the classic Dutch landscape. The horizon line takes on absolute importance. In its presence, other items are of secondary importance.

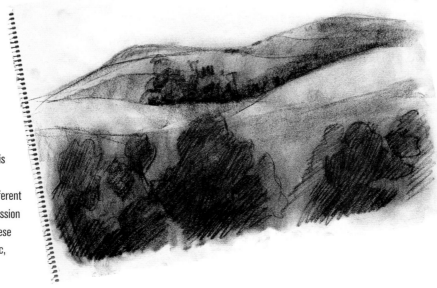

The landscape's horizon is rarely a straight line. Its undulations repeat in different areas through the progression of the drawing plane. These repetitions are a rhythmic, compositional element.

THE HORIZON AS A COMPOSITIONAL LINE

Whatever the position of the artist before the landscape, the horizon should not divide the paper in half, as this creates a symmetry that is rigid and static. Instead, a line that appears slightly above or below the middle of the paper creates a more attractive drawing.

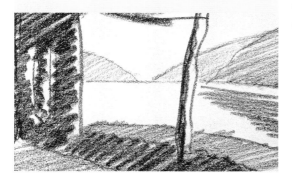

Low horizon

Space in landscape is organized around the horizon line. A low horizon line does not allow for creating successive planes and layers of landscape; the viewer's eye goes directly to the sky. A higher horizon line allows different sizes of trees, hills, and buildings to create depth of space. These landscapes suit wider formats best.

Landscapes with high horizons enable many compositional and spatial features to develop by playing with the abundant areas that can be worked on from the first to the final plane.

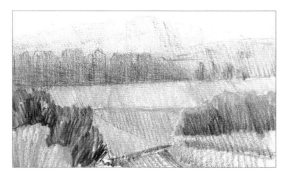

The horizon line may disappear due to the atmospheric perspective that obscures the boundary between the horizon and the sky and merges the two elements.

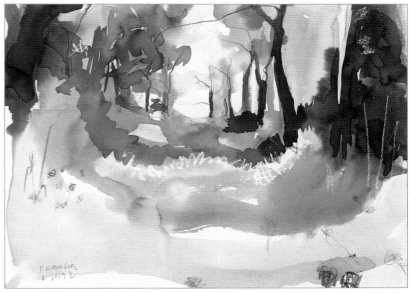

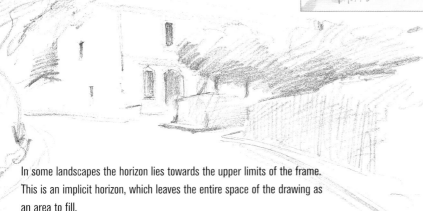

In some landscapes the horizon lies towards the upper limits of the frame. This is an implicit horizon, which leaves the entire space of the drawing as an area to fill.

High horizon lines

High horizon lines let the artist develop their subject all over the surface of the paper. In general, they suggest a view from a lower vantage point. This entails a stylization of the landscape that highlights all the peculiarities in the ground and expands the view of the landscape. It is possible to raise the horizon to the top of the frame, practically removing the sky.

Unifying the landscape

Every landscape subject can be reduced to a simple compositional frame that synthesizes the basic features of the motif. It is common to compose the drawing linearly, that is, to distribute the basic lines of the motif on the paper according to the basic compositional principles discussed earlier: avoiding harsh symmetry, adapting the horizon line to the artist's view, creating balance in the composition, etc.

Every landscape contains linear tendencies that organize the composition and serve as linear scaffolding for the synthesis of the whole.

Treetops and plants in general always require synthesis to resolve the problem of representing groups of tiny shapes. In this drawing, David Sanmiguel has used ink marks to resolve this issue.

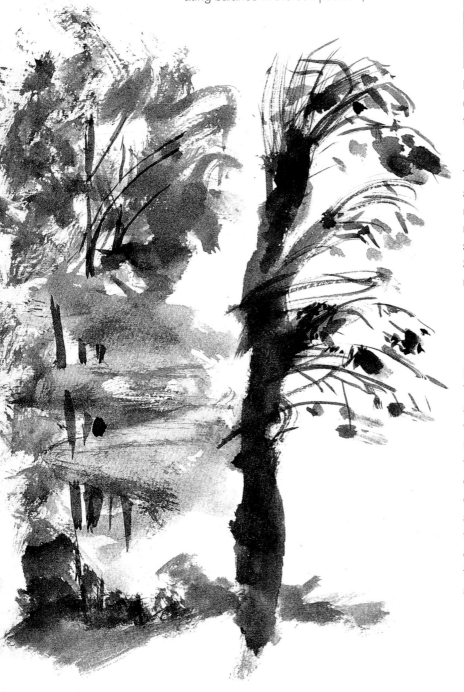

Profiles and directions

The shapes of the landscape can be reduced to a grouping of straightforward profiles drawn with simple straight and curved lines. Working up a drawing from the simple to the complex is the correct way to proceed. Before jumping to detail, establish and distribute the outlines and contours of all the objects to be represented. In addition, the profiles of these objects should refer to a central point of interest, such as a tree, cloud, or building. This achieves a hierarchy in the drawing instead of a mere amalgamation of strokes.

LINEAR LANDSCAPE

When working solely with line, the drawing acquires an ordered quality the shapes of the landscape are schematic, and the relationships between compositional lines are explicitly clear.

The synthesis of a landscape can be a purely graphic representation of its relevant features. In this drawing, Esther Olivé de Puig converts trees into signs and diagrams that make up a kind of drawn writing.

Groupings and distribution of shapes

It is not advisable to place the drawing's center of interest in the middle, because the viewer's eyes will go there first. By moving the drawing's focus to one side, you can lead the viewer's eye throughout the entire drawing. Placing the drawing's center a bit towards the left of the paper is a common and logical way to resolve this.

A good drawing that synthesizes its contents ultimately facilitates the addition of details and the opportunity for elaboration, since the artist is working with a solid and reliable plan.

Sketches are the best way to figure out how to synthesize the drawing, as they combine all creative tendencies and impulses.

Drawing the sky

The space of the sky, if we forget the clouds, is just empty space where it doesn't seem necessary to represent anything. Rather than making things easier for the landscape artist, this actually complicates the drawing process, as this empty space cannot be modeled like the rest of the landscape. The empty parts of a drawing can be enriched, depending on the artist's decisions. They can darken or lighten the sky to create contrast, create color gradients, and so on.

The sky's value must be consistent with the other values that comprise the landscape. Its tone must harmonize with the rest of the picture, regardless of the luminosity and shadings present in the various masses in the view.

Balance of tones

The contrast between the strokes and marks in a landscape and the space of the sky can work if the artist is careful to leave underdeveloped spaces on the ground too, which alleviate the heaviness of the darker areas of a landscape. If the land area is very dark, the artist should darken the sky as well, at least very lightly, to create a relationship of tones and general harmony.

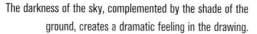
The darkness of the sky, complemented by the shade of the ground, creates a dramatic feeling in the drawing.

DRAWING CLOUDS

Clouds are one of the most appealing aspects of a landscape, as they reward the artist with the opportunity to freely exercise their own graphic inventiveness. Their changing, vaporous shapes evade rigid outlines. Instead, the artist may render them with alternating strokes, marks, blurring, and other techniques with total freedom. However, some initial profiles of the clouds are advisable, so that their representation is not completely subject to the artist's whims.

Gradients

When trying to create a drawing that demonstrates a unified balance of tone, making a light gradient in the sky is the most logical way of working. It is important that this gradient is lighter at the bottom, near the horizon, than at the top, since this a landscape appears naturally. Not only does this serve as a guide to create tonal harmony, but will produce realistic lighting effects.

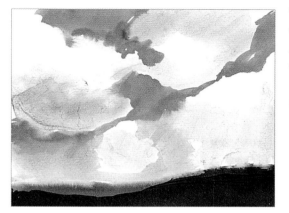

The clouds are independent volumes that must find their shape and form by contrasting the general tone of the sky. Darkening the sky's tone will highlight a cloud's whiteness.

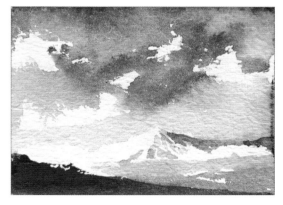

This wash confuses the marks of the sky and those of the landscape. The viewer must distinguish them by reconstructing, according to their imagination, the position of each part in the overall whole.

In this wash, the sky was resolved by spreading very soft marks of cold tones that contrast sharply with the darkness of the landscape, creating an effect full of light. Work by Vicenç Ballestar.

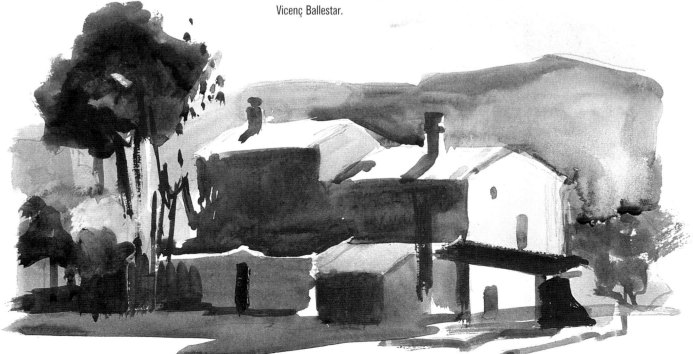

Drawing water

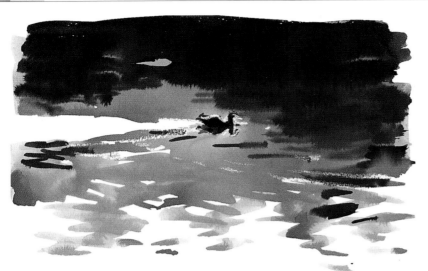

The shapes in the surface of water appear in the waves, which distort these shapes and convert them into a mix of lights and shadows. These waves can easily be represented by strokes or marks; the darker a reflection is, the denser the strokes and marks will be. They should also increase in size as they become close to the foreground. This means that the strokes will be smaller the closer they are to the horizon, since they will represent waves that are far away from our point of view. Avoid taking a blind, systematic approach by carefully observing the water's appearance, which is ever-changing and unique to each drawing.

The representation of water depends entirely on the values found, the right distribution of light and shadow and the rhythmic contrasts between light and dark tones. In this wash by Mercedes Gaspar, these factors are all resolved in masterly fashion.

Linear arabesques

Arabesques are linear filigree work or strokes curved rhythmically in various directions. Their ultimate purpose is to create a sensation of harmonious movement that both represents and elaborates. In a landscape, water evokes the richest arabesques that give free rein to the artist's fantasies and whims. In general, arabesques should accompany other mediums that give rigidity and solidarity to the representation of the water.

Representing water involves hatching with lines of different density, since there are no concrete profiles or contours in water; shapes are not enclosed in a recognizable, geometric way.

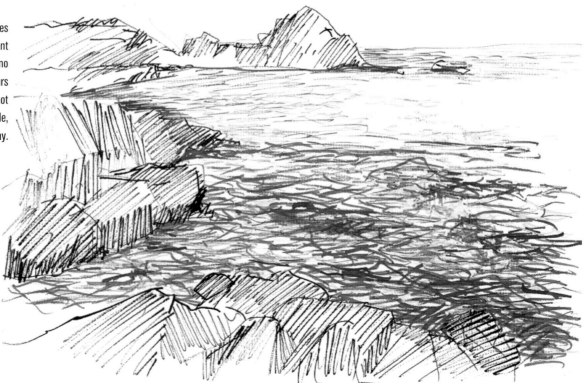

Objects in landscapes are always lit from above. The reflections of these objects show their undersides (inverting the image), which are the least lit part of the object. Therefore, in landscapes, elements that are reflected in water are necessarily darker. The higher our vantage point is from the water, the darker these reflections will be.

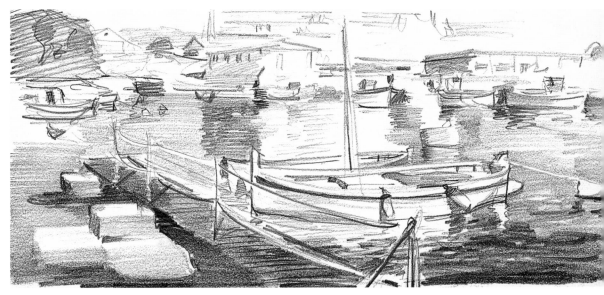

Reflections in the water repeat the shapes of the landscape in a distorted way but their values must be clearly defined and presented in order to be recognizable. Drawing by Óscar Sanchís.

Highlights

Highlights represent the brightest parts of an object, and can be left blank. These areas must be distributed according to the placement and representation of waves. Highlights should be much broader in the foreground than in the background, seeming to disperse the closer they are to the viewer.

Strong contrasts in tone are the key to representing water surfaces in an attractive way. The appearance of blank paper must not interrupt the sinuous marks. Work by Vicenç Ballestar.

In this study of composition, the strong contrasts between the spots of the wash and the white of the paper describe the water surface.

Sky and atmosphere in a landscape

A broad panorama almost always implies a high horizon. This is the case in this exercise, which shows a very extensive landscape, taken from a somewhat raised point of view. The picture covers long distances and is marked by a great mountainous undulation. Apart from these composition factors, this charcoal drawing gives you the opportunity to take part in the process of representing the air, known as aerial perspective. The representation of morning mists creates distance and places large expanses of clouds between the planes of the landscape.

THE SUBJECT

Morning mists are the clearest and also the most romantically suggestive example of aerial perspective. In this landscape, these mists occupy the most distant areas of the scene, which will cause a gradation from dark to light in the values of the landscape.

STAGE 1:
SOFT TONING

1. The preliminary drawing puts forth the general lines of the motif with marks, above all, the various areas defined by the undulation of the hills.

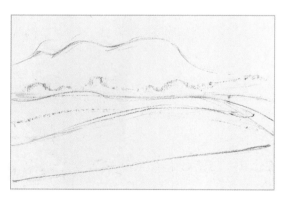

2. By applying the flat stick to the paper, extend the gray areas. These give soft toning or general value, avoiding sharp contrasts.

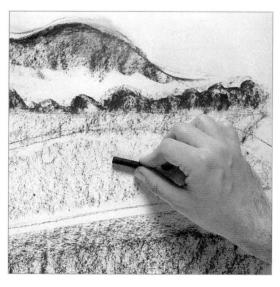

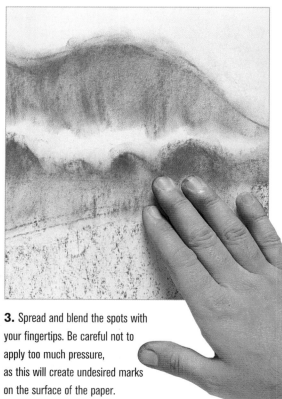

3. Spread and blend the spots with your fingertips. Be careful not to apply too much pressure, as this will create undesired marks on the surface of the paper.

STAGE 2:
VEGETATION

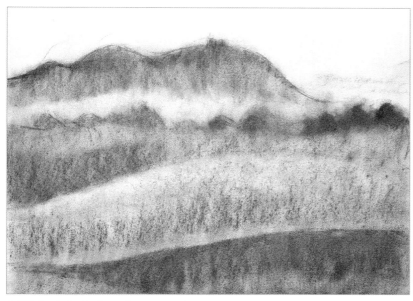

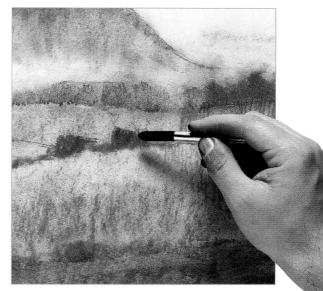

5. New applications of charcoal further define the details of the trees that poke out behind the hills. Don't get lost in detail; these are simple marks whose importance lies in their size, as their dimensions indicate their distance from the viewer.

4. This first laying in of tone demonstrates that the closer the plane is to the viewer, the deeper the tones of the drawing will be. This is also a result of the drawing's initial shading.

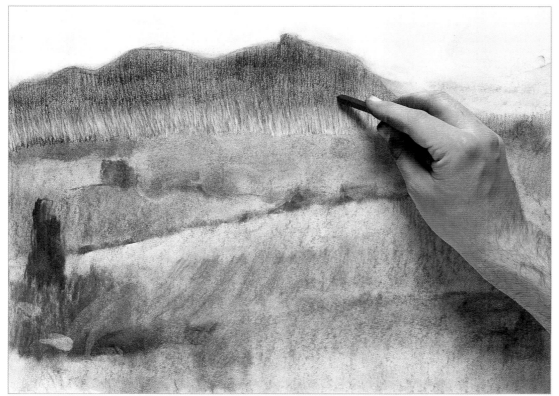

6. To accentuate the effect of aerial perspective, darken the crest of the mountain that encloses the landscape. This dark tone, dying out slowly towards the bottom, creates the effect of mist and distance.

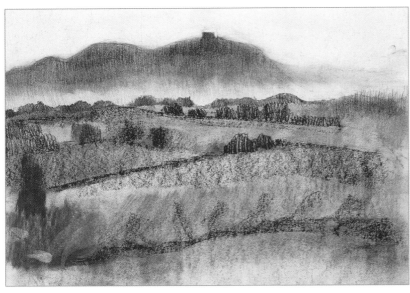

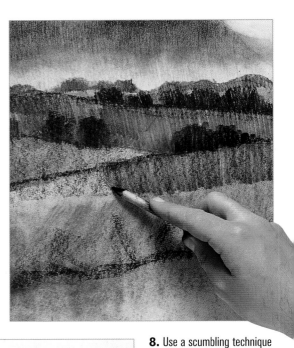

STAGE 3:
CONTRASTS

7. The landscape after the general lay-in is completed. Note the interesting effect of distance that has been created, which will be reinforced by contrasts.

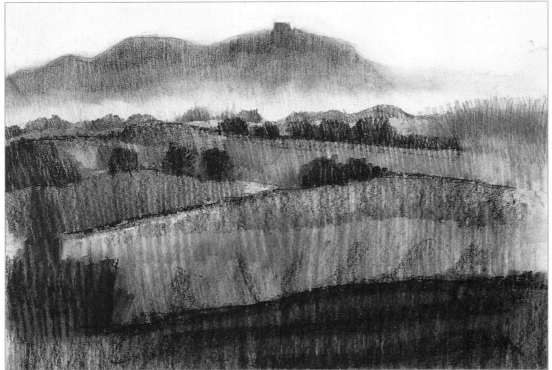

8. Use a scumbling technique to extend the strokes covering the middle plane. This darkens the charcoal considerably by pressing its particles into the paper.

9. Darkening the foreground strengthens the landscape and gives a sensation of depth. In addition, this emphasizes the misty area on the horizon.

10. When the scumble is very dirty with charcoal, its tip can be used to draw the branches of the tree in the foreground. The branches should be very dark lines that stand out against the rest of the scene.

STAGE 4:
THE FINISH

11. The final result is rich in tone, but also light and not heavy-handed. This is the effect that was originally intended: strength in the foreground and mist in the distance– a perfect example of aerial perspective. Work by Gabriel Martín.

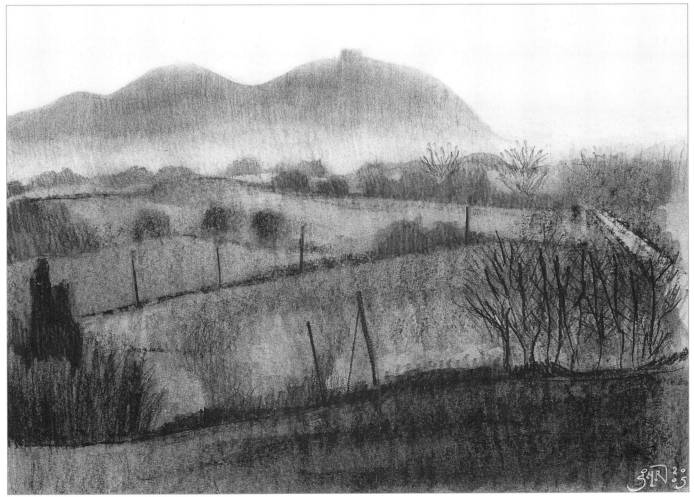

From value to color: a park

This exercise shows the narrow frontier that separates shading with gray tones (drawing in black and white) from shading with color. The colors that are going to be used are, in fact, closer to grays than any other color. The chalk sticks used are green, but very close to neutral tones. The order of work is the same as with charcoal. The difference lies in the translation of color to value.

THE SUBJECT

Parks are an ordered version of landscape. The lines are clearer and better defined, and order (a certain order) already exists. In a park you don't have to look too far for subjects that are just waiting to be transformed into drawings.

STAGE 1:
PLAN OF COMPOSITION

1. For the initial drawing, use a hard pale-green pastel stick. If black were used, the lines would be too visible or would dirty subsequent tones. This green acts as a medium gray.

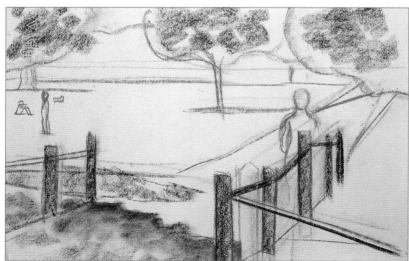

2. Spread some very simple charcoal spots create initial shading. Given that this first shading must be soft, it is important to rub the charcoal stick on the paper lightly.

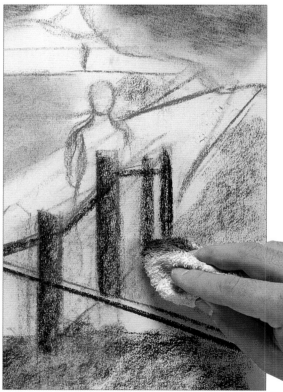

3. Spread the spots with a clean cotton cloth. Not only was charcoal used, a sepia chalk stick to achieved warm shading (the gray of charcoal is a cold tone), as well.

STAGE 2:
ADJUSTING THE SHADED MASSES

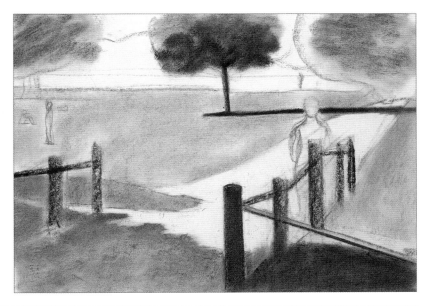

4. The layout for the composition divides the landscape into masses or blocks that are more or less enclosed by lines. Each segment of the drawing has its own, unique value. This drawing employs a small scale of grayish greens. Each tone is blurred after it is applied to the paper.

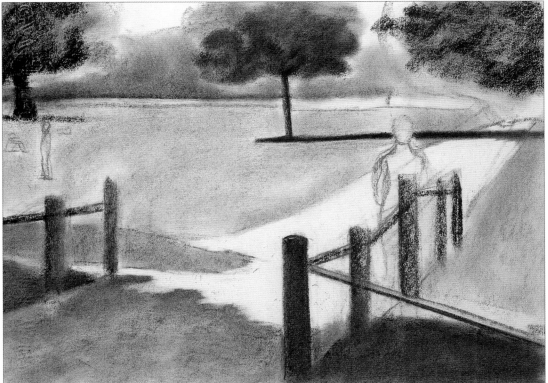

5. The strong contrast of the foreground in shadow makes the rest of the composition more distant and opens a broad visual space, consistent with the spaciousness of the subject.

6. Draw the figure schematically, without details. Aim to achieve a static silhouette that harmonizes with the peacefulness and the little emphasized relief in all the planes of the landscape.

STAGE 3:
DEFINING THE SHAPES

7. Fill in the entire landscape. Darken the last lines of trees that close the composition's space in the background to reduce the excess contrast they previously had with the trees in the middle ground.

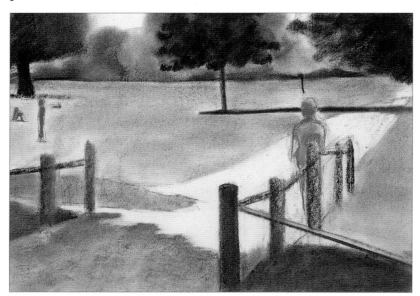

8. Go over the supports of the handrail again with a pressed charcoal stick. The objective is to achieve perfectly black outlines that stand out against the subsequent planes of the landscape.

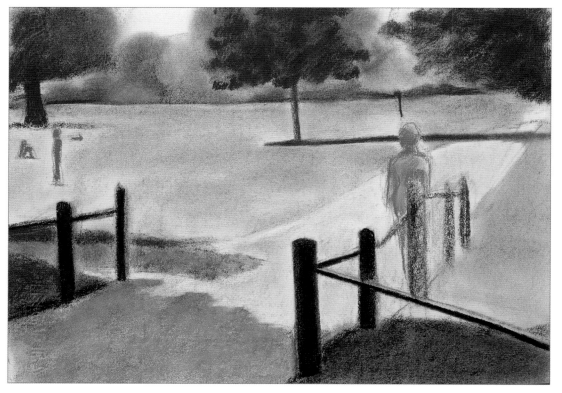

9. At this stage, make sure to nuance the whites in the composition (sky and path). These areas are too stark and break the general tonality of the picture.

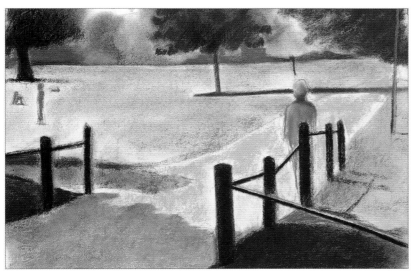

10. Cover the small spaces open to the sky with gray spots which, when compared to the warm greens of the general color scheme, look bluish.

11. Here, the drawing is almost finished. Note the importance of the small figures that appear in the middle ground of the composition; their small size indicates the scale of the distances in the drawing.

STAGE 4:
THE FINAL NUANCES

12. After the final blending, the drawing is now finished. The final tones in the shadows of the foreground that were previously too dark for the surrounding tones now fit in harmoniously.

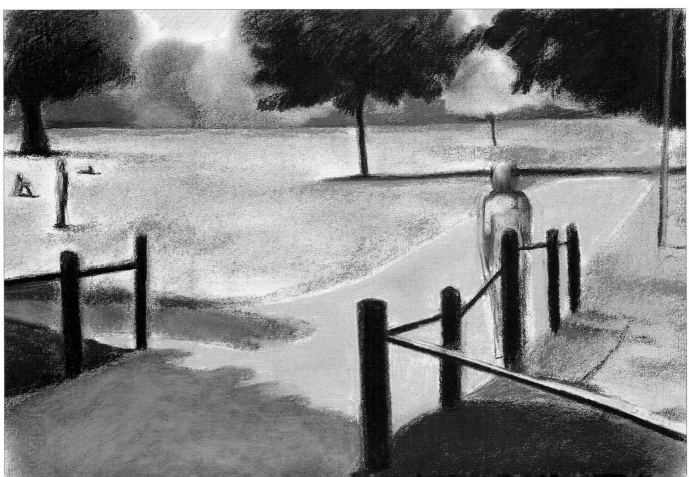

DRAWING ANIMALS

Drawing animals can provide a wide array of new possibilities that are unique to this type of subject. Domestic or wild, animals are fascinating for any artist interested in movement and the organized arrangement of individual volumes within a whole shape. The study of an animal's form is a challenge in itself but is also highly recommended, as it develops the ability to observe and describe shapes and textures, capacities that are invaluable to an artist's work.

Leonardo da Vinci,
Studies of horses. (1490).
Royal Library, Windsor Castle.
Leonardo was moved by scientific as much as artistic curiosity.
His magnificent studies of horses are both scientific analyses and artistic rehearsals for his composition of equestrian monuments.

Animals provide subjects that particularly suit artists interested in movement and the organization of bodies in motion.

Drawing Animals **215**

Domestic animals

Dogs, cats, domestic, and farm animals are accessible for any artist. There is even an artistic genre that focuses on these subjects: pets. A favorite animal is a subject as interesting as any other, although it requires a particular approach. Animals move constantly, and it can be difficult to capture them in one position. Unless you work from photographs, the drawing must be planned in a way that captures the overall shape of the animal and its characteristic movements. Features such as fur and its color deserve special attention, which can be practiced in studies that focus on one characteristic of a particular animal.

Domestic animals are the most comfortable option for artists. They offer many more possibilities than what may seem likely, as drawing mediums and various points of view allow for vastly different interpretations. Work by Ramon Noè.

Farm animals are excellent models: accessible and relaxed. The artist has sufficient time to draw them by studying their anatomy in full detail. Drawings by Ramon Noè.

Anonymous, *Dragon.* Fantasy also has its place in the realm of animal drawings. Dragons were a common fantasy throughout the Middle Ages and the Renaissance, which gave rise to a myriad of fantastic beasts.

Zoos provide wide range of inspiration for the artist who loves drawing animals. The detailed study of each of them is outstanding practice for animal drawings. Drawings by Ramon Noè.

At the zoo

Zoos are great places for artists to gain inspiration. Every type of animal calls for a different drawing technique based on line, mark making, stroke, or hatching, depending on the skin, feathers, or fur of each animal. Proportions vary enormously and test the artist's ability to observe and capture details. In a short time the general form must be resolved in order to characterize the animal clearly.

Useful diagrams

Each animal requires a particular schematic foundation. Such a foundation can only be created through attentive observation and by trying various solutions that, each time more closely resemble the animal's anatomy. In practice, it is helpful to work with general diagrams that approach the shape of the animal and make adjustments to achieve a sketch of its shape.

Geometric diagrams with straight lines are the simplest and best permit the artist to make sure the proportions are correct.

Diagrams with ovals are very easy to draw and are advantageous, in that they immediately suggest the volume of the animal.

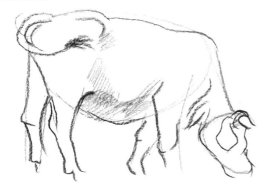

The drawing of the animal's contours follows naturally from a diagram based on oval shapes.

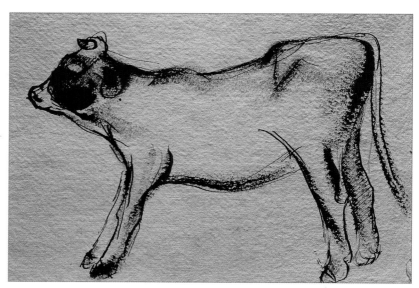

Diagrams with straight lines are very suitable when the drawing of the animal doesn't require foreshortening or difficult perspectives.

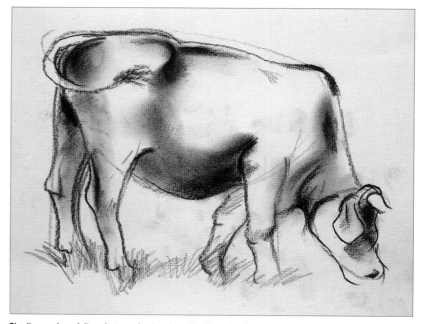

Shading and modeling that emphasize the animal's real volume are extremely valuable additions to a composition.

CONTINUOUS LINE DIAGRAMS

This "scribbling" can be very elegant, since the vibrating agility of the line gives them a lively and mobile look that responds to the suggestion of movement implicit in every animal form.One long stroke or flourish can synthesize many animals.

Diagrams with ovals

A grouping of ovals of different sizes can easily create an initial approach to an animal's anatomical form. As organic shapes are always rounded (and tend towards the oval), these shapes evoke the anatomy well before the more developed shape of the animal appears. The artist must concentrate on achieving shapes in proportion with these ovals (for the head, trunk, and limbs) before concentrating on particular parts of the anatomy. If this is done, then it is quite easy to correctly represent the real contours.

A few hatching strokes suffice to suggest the volumes that order and underpin the lines of the diagram.

These are loose, quickly drawn sketches made with a marker.

Angular diagrams

Squares, triangles, rectangles, and trapezoids are other shapes to use when making diagrams of animal anatomy. Although they do not suggest volume (the thickness of the animal's body), they do offer a more precise depiction of its proportions. The straight lines that make up these figures serve as guidelines and measures; they can easily be compared to each other to ensure that they are consistent with the proportions. This makes the mental calculation of divisions much easier (the body is three times the size of the head, twice the length of the legs, etc.). Finally, it is easy to remember and repeat these general diagrams in later drawings.

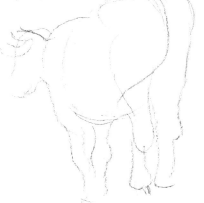

Experienced artists are able to go beyond the initial, schematic framework of their sketch and create lines and shapes that more closely resemble an animal's anatomy.

Shading and modeling adapt completely naturally to the lines of the preliminary drawing, provided they were traced correctly.

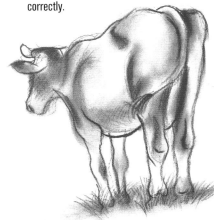

Sketches and notes from nature

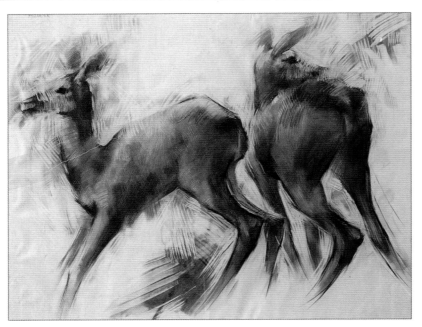

The basic interest in drawing animals lies in capturing their movement, their particular personality, the vitality, tameness, or wildness that characterizes them. Usually, sketches and studies done rapidly achieve this much better than highly rendered works, which may compromise the potential vivacity of these drawings with excessive detail. In drawing animals, the artists must observe the qualities that characterize the breed or type of animal before they can focus on what distinguishes one specific animal from the rest of its breed. Therefore, sketches or notes are always invaluable.

Sometimes lines and marks are unstable and do not completely describe the shape of the animal, but even so they express the movement of this animal very well. Drawing by Joan Teixidor.

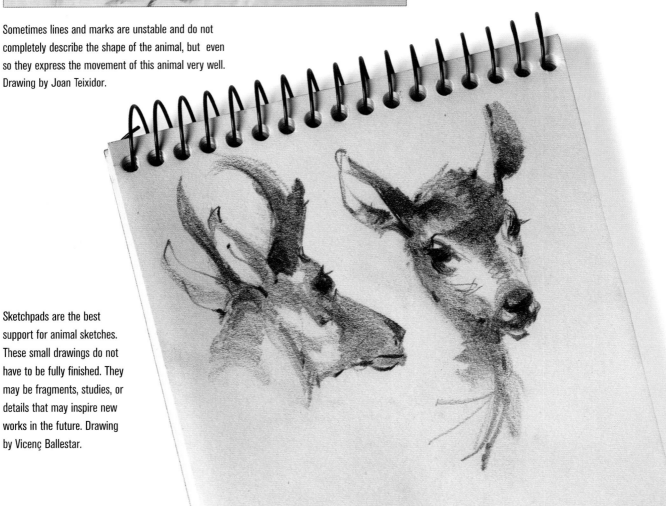

Sketchpads are the best support for animal sketches. These small drawings do not have to be fully finished. They may be fragments, studies, or details that may inspire new works in the future. Drawing by Vicenç Ballestar.

A drawing with very conservative and economic strokes. Just a few lines render the animal's shape, and even its fur.

A few lines

The sketches that characterize an animal with very few strokes have a unique style and grace. These can be done in pencil, pen, or nib strokes; the latter is ideal for suggesting movement and vitality. Leaving a part incomplete precludes a final definition of the form and evokes the temporal and fleeting moment of the drawing. This effect arises spontaneously when working from life and is convincing when done deliberately.

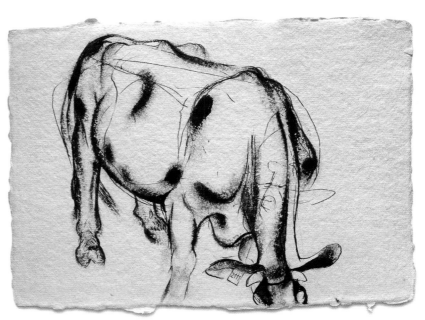

Marks, lines, arabesques, trials, and corrections. Everything works well in drawing animals. The apparent chaos lends itself to a coherent work.

A few marks

Animal sketches done with just a few lines or strokes are similar to sketches achieved solely by marks, done in pastel or charcoal. Spreading a spot may evoke an animal's shape better than a detailed description of its anatomy. On occasion, spots create accidental effects that the artist could not have achieved through meticulous and conscientious work. Agility in drawing is key. By practicing and creating studies, artists will inevitably experience fortunate "accidents" that will work to their advantage.

Sometimes chance leads to happy results. The unpredictable movement of animals often creates effects that the artist could not have imagined or planned.

The practice of sketching

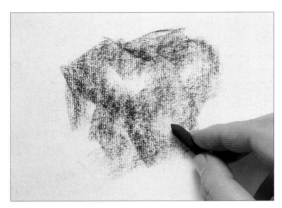

Rapid observation of the animal translates into very loose marks that approach the shape of the subject. Charcoal is the best material for this.

There are as many methods for creating sketches as there are types of artists. Some start with a line that very closely resembles the model that they later enrich with shades and accents. Others merely summarize the form, or establish a linear framework very rapidly. Rather than one standard practice for sketching animals, there are various methods that produce drastically different results.

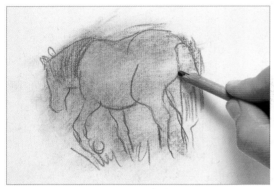

Here, the artist finds contours that best express the animal's movement in marks, defining them quickly with a charcoal pencil.

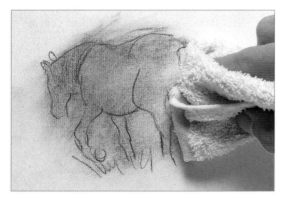

The contours are blended with a cloth and the pencil strokes remain mostly unaltered.

The result is a spontaneous sketch, but one that possesses a sufficient degree of precision and definition of line.

In drawings with nib or reed pen, the line dominates, while the underlying frame of the drawing, however general, is always based on a group of lines.

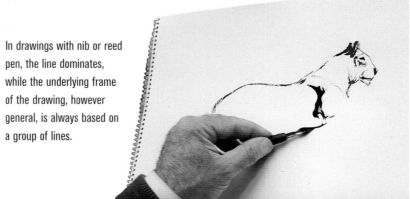

From marks to lines

Thinking of the drawing as making a series of rapid marks and finding the line in them proves to be one of the most effective techniques for taking notes for drawing animals (and sketches in general). Marks translate the rapid movement of animals well. In addition, their ambiguous forms give the artist the option of choosing different linear solutions for each spot or group of spots. A procedure of this sort appears in these pages together with other options for carrying out the interesting and enjoyable exercise of sketching animals.

Ink creates bold marks. Although the procedure is similar to using charcoal, an ink drawing's line is more dominant.

Both of the sketches shown here were achieved with simple marks and line work. In both, the charcoal marks not only enable the artist to sketch in the actual contours, but also function on their own to suggest the overall form and volume of the animal.

It is possible to achieve thicker lines by working with a nib or reed pen. The change in thickness depends on the rhythm of work and the movement or position of the animal.

Drawing a cow with sanguine and sepia pencils

The texture of an animal's their skin, feathers, or fur are among the many interesting features that attract artists. In this drawing, artist Vicenç Ballestar concentrates on the very thorough representation of the thick fur of a cow. The backlight in the image accentuates the particular features of the hair that require more delicate work.

THE SUBJECT

The artist will use sanguine and sepia pencils to draw this cow, combining the two tones to obtain a rich array of warm, nuanced tone.

STAGE 1:
DRAWING AND FIRST MARKS

1. This initial drawing could be considered a finished line drawing. Approaching the drawing this way will resolve important issues of form before you attempt to draw the fur.

2. To make the contours of the shape stand out, shade the exterior of the cow with energetic sanguine strokes, blending them with a cotton cloth.

3. Blend the stripes drawn earlier on the cow to create a general evaluation of the most marked volumes of the animal.

STAGE 2:
DETAILS AND FINISH

4. Cover the entire background by making marks in sanguine. These marks should not have a uniform tone, but instead, should feature dark, blended areas created with a sepia stick.

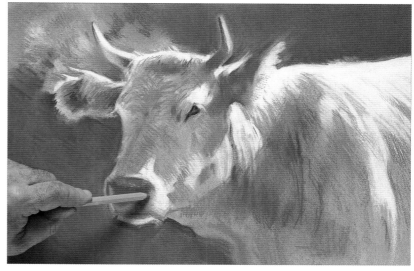

5. Resolve the internal details of the muzzle and the head with the tip of the pencil (both sanguine and sepia). Do this over previously blended areas.

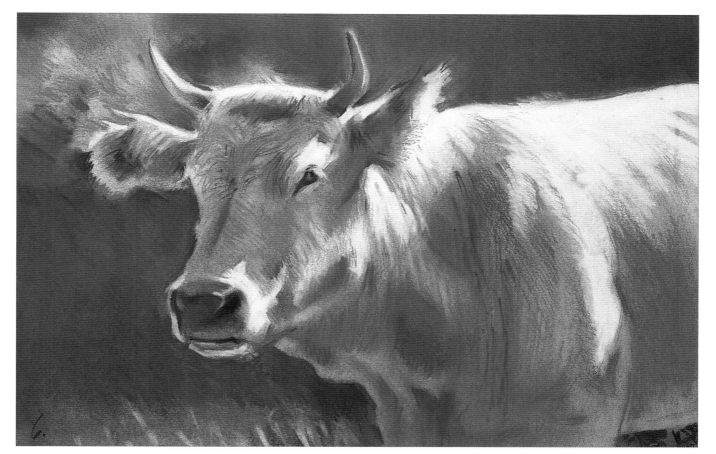

6. The drawing shows a high degree of finish. A combination of strokes and blended marks, in which sepia and sanguine were mixed, effectively conveys the texture of fur. A perfect realistic portrayal and a powerful sense of three dimensions dominate the drawing.

DRAWING THE HUMAN FIGURE

An ability to draw the human figure well is a fundamental skill of the artist, the root from which the majority of their abilities stem. Mastering this skill means possessing a sufficient understanding of human form to be able to tackle any other subject. This is why, from very ancient times, figure study has been considered the essential subject for teaching drawing and, by extension, painting. Drawing the figure involves all the skills of representation and provides endless possibilities for developing a personal and creative style.

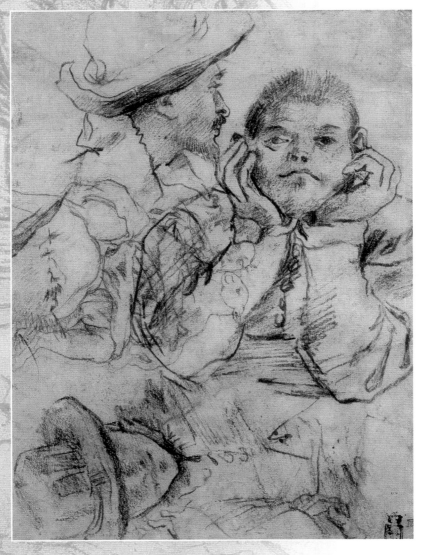

Annibale Carracci (1560-1609). *Studies of Heads*. J. Paul Getty Museum. Traditionally, figure drawing was considered the basis for all drawing subjects.

Dominating the art of figure drawing requires a thorough understanding of form.

The nude

The nude is the essential artistic subject for all figure drawing, as it best delineates the lines, forms, proportions, and expressivity of the human body. Different ideas and attitudes towards the nude have dictated how the human figure has been portrayed throughout history. For example, the ancient Greek's notion of the nude differs from, and even opposes, attitudes held during the medieval era, which differ from ideals of the nude from the Renaissance. These ideas can be understood more clearly by studying representations of nude rather than clothed figures. When artists today draw the nude figure, they express, consciously or unconsciously, a general conception of the figure that goes beyond a mere representation of a model. The mentality or artistic style that characterizes an era or an individual artist determine this representation.

THE FIGURE AS A SYMBOL

A countless number of works throughout history feature the human figure as their central focus. Western art, Greek, and Latin mythology, and the Bible have provided painters with human subjects over the centuries. The human body has been, for art, a vehicle for portraying ideals, strengths, shortcomings, and aspirations of humanity.

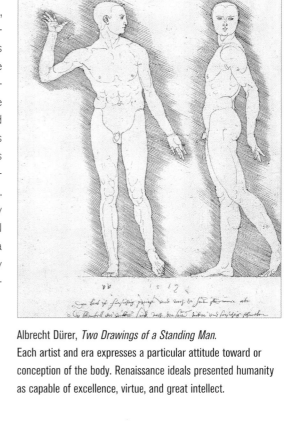

Albrecht Dürer, *Two Drawings of a Standing Man.*
Each artist and era expresses a particular attitude toward or conception of the body. Renaissance ideals presented humanity as capable of excellence, virtue, and great intellect.

The practice of figure drawing has a formal, academic component, which necessitates proficiency before progressing to personal and creative solutions.

Leonardo da Vinci, Figure studies for *The Adoration of the Magi* (1480). Musée Bonnat. The figures of the great masters contain ideas about human beings. Each movement and each expression emphasize both the artist's mentality and the historical period in which she or he worked.

Proportions and outlines

Traditionally, the height of a standing figure is seven and a half times the height of their head. In reality, this may vary between six and a half heads for short figures and almost eight heads for very tall figures. Of course, this only applies to standing figures. In other cases, rather than working from set rules, artists work with schematic models with which they can frame the human figure in relation to very simple forms.

Standing female and male figures equal a total height of about seven and a half heads, though they may reach eight heads.

Female and male figures

Proportions are similar for female and male figures. Both men and women are between seven and eight heads tall. However, women are proportionally smaller than men. Therefore, although the ratios of a male's anatomy are similar to those of a female's the female figure will be slightly smaller than the male figure. The shapes involved in female anatomy differ from male anatomy, as well. The more rounded and curved shapes of feminine contours determine a different anatomical outline for the female body than the male body, one that is based on straighter lines.

Simple diagrams

To understand the figure as an organic yet proportional whole, diagrams and models offer invaluable help. There are very simple models that explain the proportions of the figure, the best of which is a jointed doll. A jointed doll's proportions are the same as those of a real live model. Art supply stores sell these dolls, which are made of wood and have joints that the artist can manipulate in order to study different poses. However, with or without a dummy, sketch the basic anatomical structure of the figure when beginning a figure drawing.

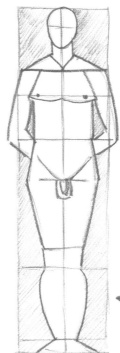
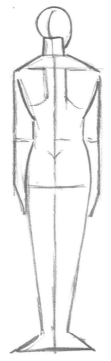

These drawings show the schematic form of proportions for the male figure. The bilateral symmetry of the figure means its main forms can be ordered around a central axis.

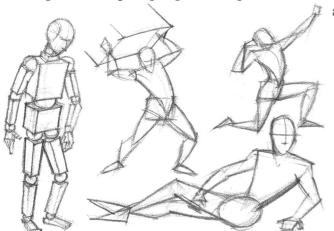

This diagram was drawn from the jointed tailor's dummy. The parts of the dummy give the artist a good view of the real proportions of the figure.

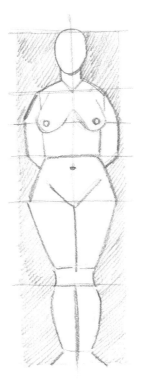

The female figure ordered around its axis of symmetry is different from the male figure. The area of the waist and hips is wider than the other parts of the body.

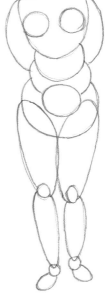

Possible diagram based on ovals that approaches, with some accuracy, the shape and proportions of the female figure.

The figure in general terms

Any figure drawing is based on a harmony of the prominent shapes in a figure, the more forms that add visual interest to the drawing, and the overall presence that the model transmits. Synthesizing these elements is incredibly useful for the artist, because it provides a work method that will capture and represent any type of figure. This approach transmits all the necessary information regarding the model's movements and gestures to the viewer, while still providing the artist with the opportunity to either develop the work in greater detail or respect the immediacy of the sketch or study.

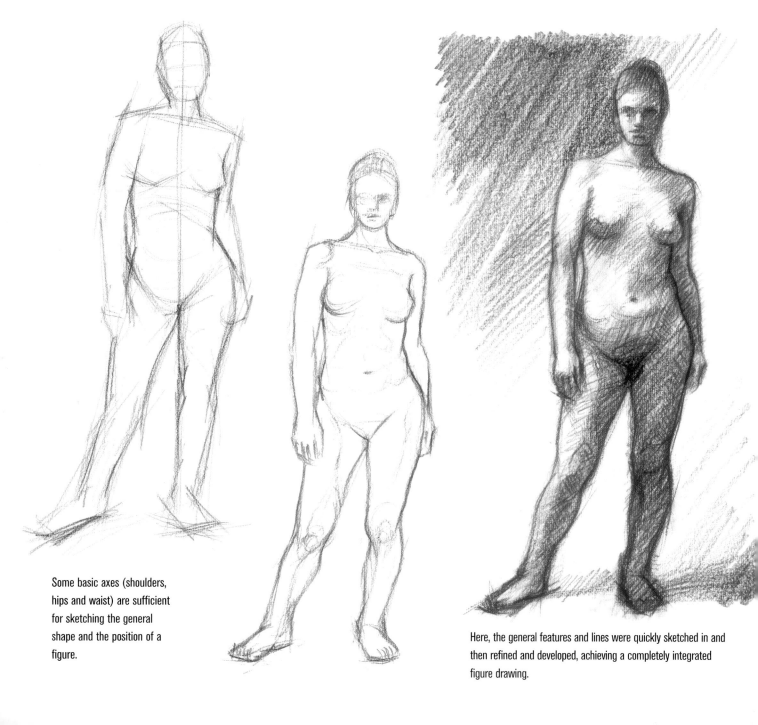

Some basic axes (shoulders, hips and waist) are sufficient for sketching the general shape and the position of a figure.

Here, the general features and lines were quickly sketched in and then refined and developed, achieving a completely integrated figure drawing.

Austerity of material

A secret for developing the ability to easily harmonize a figure's multiple forms is to work with very elementary media. Pencil and paper, a brush and ink, or a ballpoint pen will capture only what is necessary. With these materials, artists must to search for the essential details and ignore the superfluous.

Synthesis of line

To synthesize the lines in a drawing, you may work with either a very fine tool, such as a nib or ballpoint pen, or with a thicker tool, such as a marker pen, charcoal stick, or brush. When working with a medium that produces a thin line, work quickly without raising the pencil from the paper, and without shading. Simply follow the contours of the subject with a continuous line or strokes that suggest the form. When working with a medium that yields a thicker line, try to establish the pose of figure or figures with only a few strokes that suggest the general distribution of volume, light, and shadow. These are two equally valid approaches that depend on the preference of the artist.

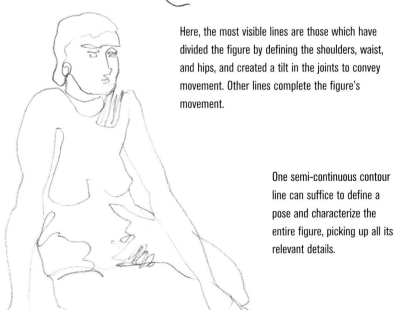

Here, the most visible lines are those which have divided the figure by defining the shoulders, waist, and hips, and created a tilt in the joints to convey movement. Other lines complete the figure's movement.

One semi-continuous contour line can suffice to define a pose and characterize the entire figure, picking up all its relevant details.

Areas of wash can replace lines, and may define the volumes of the body much more effectively.

Capturing Movement

apturing movement can preclude capturing anatomical shape. Sketches or drawings of figures in motion may seem to commit major anatomical errors, as movement elongates and distorts a figure's shape. Because of these distortions, the artist can convey a certain dynamism in their drawing. Representing movement in a perfectly proportioned figure is very difficult, since these types of drawings provide a finite, closed representation of the figure; any addition or transformation would seem artificial.

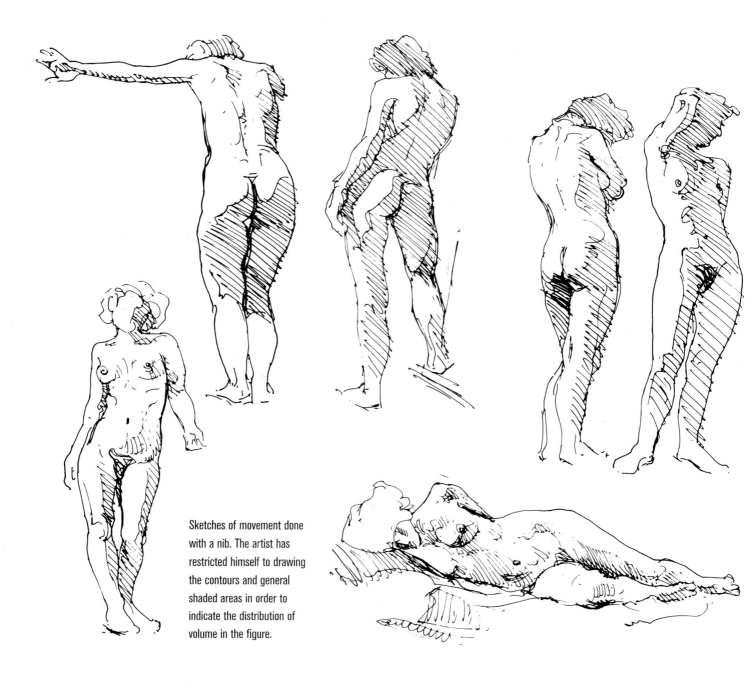

Sketches of movement done with a nib. The artist has restricted himself to drawing the contours and general shaded areas in order to indicate the distribution of volume in the figure.

THE LIFE OF THE LINE

Often, the trajectory of just one line explains much more than a grouping of many strokes. If this line is energetic, it will transmit a sense of vivacity to the figure that it represents. Working with line mediums, such as pen or marker pens, require the artist to express a complex whole through a filigree-type drawing. This means that the line's twists and turns must convey enough visual information to give the drawing life and complexity.

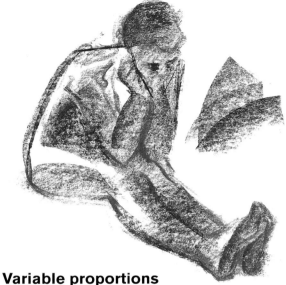

Sketches of movement do not aim to produce a drawing that is complete and detailed, but rather a dynamic approach to conveying the appearance of a body in motion.

Variable proportions

If we understand the figure as a changing form rather than a static construction of unchanging proportions, we will have taken a fundamental step towards capturing movement. The practice of drawing means that an experienced artist can intuit the proportions of the human figure and draw from memory or imagination, while still drawing the proportions correctly. However, the habit of perfect representation may be counterproductive when trying to convey a sense of life and dynamism. The artists who can free themselves from objective representation can vary the proportions of a figure, exaggerating certain features while suppressing others.

Often movement sketches, as in this example by Óscar Sanchís, are much more interesting than finished works, due to their unadorned and essential appearance.

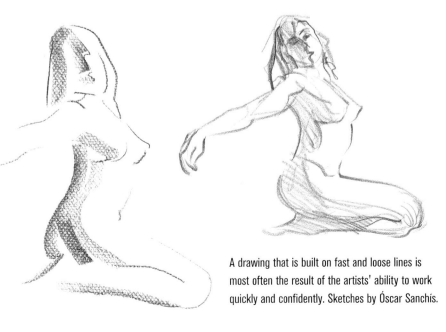

A drawing that is built on fast and loose lines is most often the result of the artists' ability to work quickly and confidently. Sketches by Óscar Sanchís.

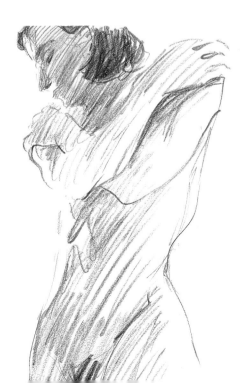

Process of constructing a figure

These two brief demonstrations explain the development of a figure drawing from start to finish. There are many possible starting points. Here, we will use a diagram based on the axes of movement; rather than focusing on shapes, we will focus on the positions of the limbs throughout the figure.

THE MODEL

Achieving the full stability of the figure in this pose is most important. Weight has to be distributed logically according to the support and arrangement of arm and leg joints.

AXES AND CONTOURS

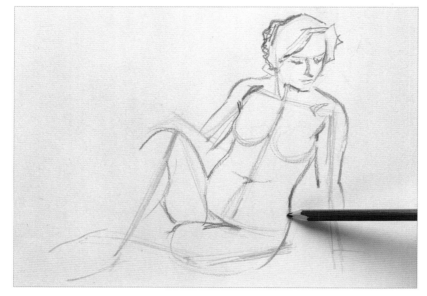

1. The initial sketch will reflect the solid support of hip and thigh and the direction of the torso's weight on the supporting arm.

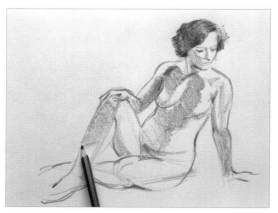

2. Emphasize the figure's contours by filling in the outlines. This outline only describes the positioning and proportions of the figure; the shadows that fall on the body are the product of direct observation.

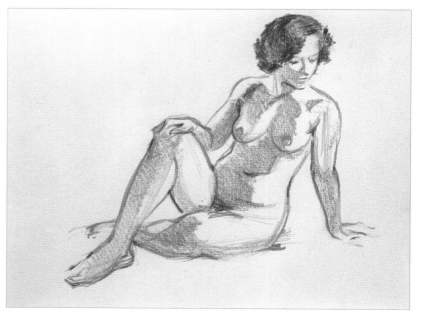

3. Finally, shading adds realistic volume to the figure. You must fill in the shaded forms only during the final stages, since they are contingent on the figure's pose.

THE MODEL

The model's slim build helps us understand his axes of movement. Each joint is clearly visible, making it much easier to sketch the preliminary diagram.

FROM DIAGRAM TO DRAWING

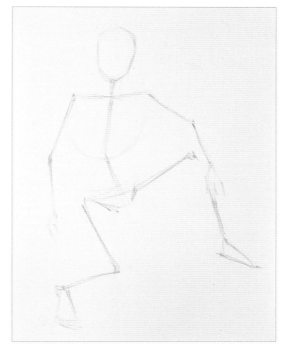

1. Basic linear diagram of the pose. Here, the joints are connected to each other by straight lines that also define their proportions.

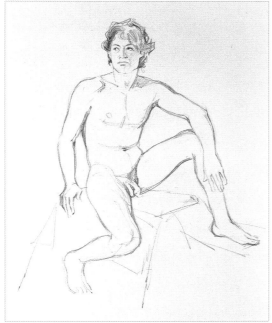

2. A very detailed pencil drawing resolves all the positioning, proportions, and relationships between the limbs of the figure.

3. A nib and colored inks completed the drawing, giving value to the shadows and lighter areas of the figure. The nib cross-hatching only treats the body's most shaded areas.

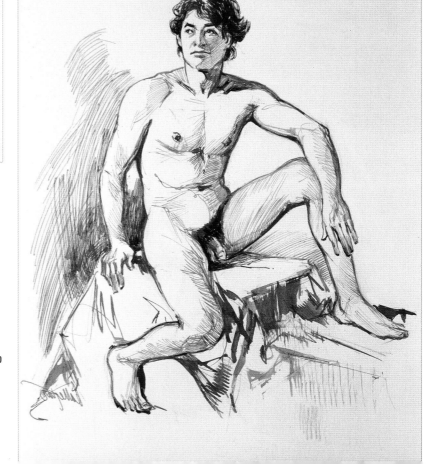

Drawing a nude with sanguine

A figure drawing can be composed slowly or quickly. This is not only contingent on taste or artistic style, but also on the model's pose. While dynamic poses require anatomical information to be collected rapidly, compositions of static poses must be more careful and meticulous, since the end result should look stable and calm. This will be the approach of the following demonstration.

THE MODEL

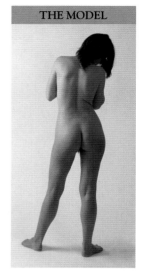

For this session the model has changed position several times and the artist, Joan Sabater, has made some sketches. After choosing one of them to develop further, he created the drawings on these pages.

STAGE 1:
BLOCKING IN AND FIRST MARKS

1. Block in the drawing using charcoal, pressing very lightly on the paper so as not to dirty the sanguine strokes that will come later. This blocking in should remain faithful to the figure's proportions.

2. Next, mark all the areas of the figure that are in the shadows by rubbing softly with a sanguine stick. Emphasize the marks on the spine and the buttocks.

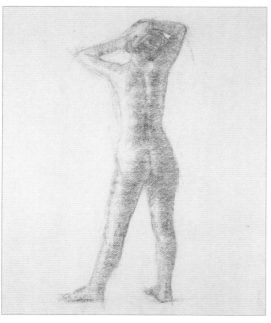

3. Here, blend blur the sanguine spots with your finger. This achieves an effect that is softer and more compact than the previous sanguine strokes. Blending allows the drawing to progress naturally.